CONTEMPORARY ART IN NORTH AMERICA

black dog publishing
london uk

06 FOREWORD

ESSAY

16 CONTEMPORARY ART IN THE UNITED STATES AND CANADA MICHAEL WILSON

ARTISTS

30 ALLORA AND CALZADILLA
34 MARTIN KERSELS
38 RYAN TRECARTIN
40 MATTHEW BARNEY
44 PAUL MCCARTHY
48 ANDREA FRASER
50 DEXTER SINISTER
52 CENTER FOR LAND USE INTERPRETATION
54 MARK DION
58 OSCAR TUAZON
60 PAE WHITE
64 RIRKRIT TIRAVANIJA
66 SARAH SZE
70 JESSICA STOCKHOLDER
72 RACHEL HARRISON
74 TOM FRIEDMAN

76 ROBERT GOBER
80 FRED WILSON
82 ARTURO HERRERA
84 JIM SHAW
88 JOHN CURRIN
92 KERRY JAMES MARSHALL
96 GLENN LIGON
100 CHRISTOPHER WOOL
104 RAYMOND PETTIBON
108 JULIE MEHRETU
112 MATT MULLICAN
114 MARCEL DZAMA
118 FRANCES STARK
122 ELLEN GALLAGHER
126 WADE GUYTON
128 RICHARD PRINCE
132 JONATHAN HOROWITZ

134 MARTHA ROSLER
138 KARA WALKER
142 CHRISTIAN MARCLAY
146 TONY OURSLER
150 RODNEY GRAHAM
154 SUSAN HILLER
158 PAUL PFEIFFER
160 JOSEPHINE MECKSEPER
162 ROE ETHRIDGE
164 BERNADETTE CORPORATION
166 CHRISTOPHER WILLIAMS
168 MICHAEL SNOW
172 CINDY SHERMAN
176 SHARON LOCKHART
180 JEFF WALL
184 RONI HORN
186 STAN DOUGLAS

APPENDIX

190 THE NEW YORK CANON JERRY SALTZ
198 CANADIAN CULTURAL POLICY: A METAPHYSICAL PROBLEM KEN LUM
206 BOUNDARY ISSUES: THE ART WORLD UNDER THE SIGN OF GLOBALISM PAMELA M LEE
210 ART IN THE FIELD OF ENGAGEMENT MARTHA ROSLER
212 LESSONS OF THE CLASS OF 90: SITING RECENT ART IN LOS ANGELES JAN TUMLIR
219 WHEN THOUGHT BECOMES CRIME CRITICAL ART ENSEMBLE
221 CONTRIBUTORS
222 ARTIST BIOGRAPHIES
231 SELECTED BIBLIOGRAPHY
233 INDEX
239 ACKNOWLEDGEMENTS

FOREWORD

As found throughout the ARTWORLD series, defining a particular region's contemporary art scene by a select number of artists and theorists is a particularly challenging exercise. Often considered as the 'centre' of the artworld, North America's wealth of artists and galleries, and continually fervent art market—discussed in Michael Wilson's insightful introductory essay "Contemporary Art in North America and Canada"—presumably makes it the ideal subject area for a study such as this; however, for these reasons alone, assembling such a study is more than complicated.

As with the previous titles in the series, we have attempted to move away from any stereotypical interpretations of the area in question. Fluid geographical definitions are once again highlighted, and whilst the United States and Canada are classified here together as "North America", national and regional differences must be realised. Ken Lum broaches this topic in detail, principally in relation to Canada, within his essay "Canadian Cultural Policy" proposing that "at this point in time in the context of a globalised contemporary art scene the question of defining art as an outcome of national character is outdated". Also discussed throughout the book are the individual contemporary art scenes of both the West and East Coasts of the United States, as explored by Jan Tumlir and Jerry Saltz respectively; however, so as to avoid geographical groupings in relation to the work, and to further creative discussion, the artist profiles have been organised by medium, rather than geography.

From the Canadian Photoconceptualism of Rodney Graham, to the Realist painting of John Currin; and the digitally manipulated practice of Wade Guyton, to the politically driven work of Martha Rosler, *Contemporary Art in North America* features a diverse range of artists, chosen according to their international standing and lasting relevance—decided upon with thanks to the book's advisors John Slyce, Neil Gall and Rut Blees Luxemburg. Represented by a selection of each artist's work, the book displays pieces of historical importance, alongside more recent works, some of which have previously not been shown outside of the studio.

Alongside the above, a number of artists not featured within the profiles are used within the Appendix to illustrate reprints of essays and articles by leading academics, critics and theorists on the subject in an attempt to contextualise the practices of those artists featured. Largely North American artists from earlier generations, these individuals, collectives and their practices have been used in accordance with their perceived lasting influence on today's art scene. On a separate note, it must also be mentioned that whilst we approached many artists to be involved within the project, several of them did decline, not respond or charged fees beyond our means for the use of their work in this volume.

Contemporary Art in North America should not be read as a comprehensive survey, but rather as a particular introductory 'take' on the subject. And whilst we have tried to be as representative as possible in portraying North American contemporary art, it would be impossible to say that our survey is either exhaustive or exclusive. Instead, the book should be viewed as a contribution to further debates and discussions centred on contemporary art, that aid the reader in their own exploration of the subject.

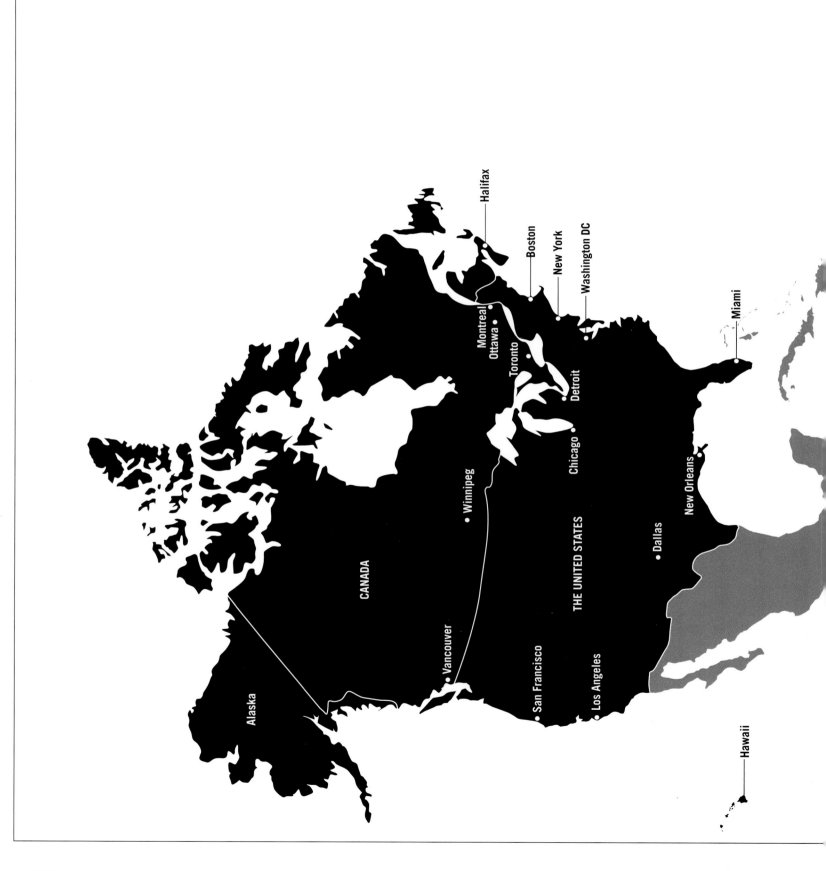

Halifax

Boston

New York

Washington DC

Miami

Montreal

Ottawa

Toronto

Detroit

Chicago

New Orleans

Winnipeg

CANADA

THE UNITED STATES

Dallas

Vancouver

San Francisco

Los Angeles

Alaska

Hawaii

TIMELINE

1950s

MAY 1950
—"The Irascible Eighteen", a group of avant-garde artists including Jackson Pollock, Barnett Newman and Mark Rothko protest the conservative curatorial practice of the exhibition American Painting Today at the Metropolitan Museum of Art in New York.

JULY 1950
—President Harry Truman sends air force and navy to Korea where the first significant armed conflict of the Cold War is taking place.

NOVEMBER 1950
—President Harry Truman approves production of the hydrogen bomb.

JANUARY 1951
—The Museum of Modern Art exhibits the group show Abstract Painting and Sculpture in America and the symposium What Abstract Art Means to Me, with Willem de Kooning and Robert Motherwell.

JUNE 1951
—The New York School, associated with the post-war New York avant-garde, Abstract Expressionist artists, was acknowledged with various exhibitions, starting with the 9th Street Art Exhibition in June 1951, curated by Leo Castelli. The exhibition featured works by Jackson Pollock and Willem de Kooning, among others.

JANUARY 1952
—The Second World War hero and retired army general Dwight D Eisenhower takes office as the 34th US President.

JUNE 1952
—The Immigration and Naturalization Act removes racial and ethnic barriers to becoming a US citizen.

DECEMBER 1952
—The American critic Harold Rosenberg coins the term "action painting" in an essay titled "American Action Painters" published in *ARTnews*. The term is later to be known as Abstract Expressionism.

1953
—Robert Rauschenberg erases one of Willem de Kooning's drawings as an act of art.

JULY 1953
—Fighting in Korea ends.

AUGUST 1953
—The United States Information Agency is established to promote the anti-Communist Cold War ideals of American democracy and capitalism through "cultural diplomacy". The agency exports several travelling exhibitions of modern art throughout the 1950s.

MAY 1954
—Racial segregation is ruled unconstitutional in public schools by the US Supreme Court.

SEPTEMBER 1954
—US Congress approves the first civil rights bill since reconstruction with additional protection of voting rights.

MARCH 1954
—Black Mountain College in North Carolina closes after 24 years. It had attracted many major figures in the emergent American avant-garde art scene, including Abstract Expressionist painters Robert Motherwell, Willem de Kooning and Franz Kline.

FEBRUARY 1958
—The so-called Space Race begins as the United States launches Explorer One three months after the launch of Sputnik One by the Soviet Union.

JULY 1958
—Nasa is founded.

JANUARY 1959
—Alaska becomes the 49th state.

APRIL 1959
—Harold Rosenberg publishes *The Tradition of the New*, an anthology of his art criticism. (Two years later Clement Greenberg publishes the anthology *Art and Culture*; together these works set up the central dialectic of Abstract Expressionism—that between form and action).

AUGUST 1959
—Hawaii becomes the 50th state.

OCTOBER 1959
—The Guggenheim Museum moves into its new building designed by Frank Lloyd Wright.

1960s

1960
—Greenberg's debate-shaping essay on Modernism "Modernist Painting" is published clarifying many of the ideas implicit in "Avant-Garde and Kitsch", his groundbreaking essay written two decades earlier.

SEPTEMBER 1960
—Charlotte Willard publishes "Women of American Art" in *Look* magazine, one of the earliest discussions in the popular media about the gender gap in the US art world.

NOVEMBER 1960
—John F Kennedy is elected 35th President of the United States.

JUNE 1962
—The glossy art magazine *Artforum* is launched.

JULY 1962
—Andy Warhol's *Campbell's Soup Cans*, a key work of Pop Art, highlighting the post-war American's obsession with consumerism, is exhibited at Ferus Gallery, Los Angeles.

JULY 1963
—Romane Bearden, Norman Lewis, and others begin the activist collective Spiral, to "examine the plight" and role of African American artists within the art world and the place of art in the broader civil rights movement.

NOVEMBER 1963
—John F Kennedy assassinated.

1964
—Victoriatown—better known as Goose Village—located outside of Montreal, is demolished. Criticising living conditions, Montreal city officials decide to bulldoze Goose Village to the ground in time for the opening of Expo 67, leaving only the fire station, train station, and the Black Rock memorial standing.

JULY 1964
—African Americans gain the right to vote with the passage of the 24th Amendment of the US Constitution.

OCTOBER 1964
—"Optical Art" as a term is coined by *Time Magazine*.

APRIL 1965
—Students demonstrate against the war in North Vietnam in Washington, DC.

AUGUST 1965
—Race riots in Watts, Los Angeles.

MARCH 1967
—The "Summer of Love" begins in San Francisco as part of the Free Love Movement.

APRIL 1967
—The 1967 International and Universal Exposition, or Expo 67, is held in Montreal, Canada, with the theme of "Man and His World". Running until September, Expo 67 was considered one of the most successful world fairs to date, bringing a record number of visitors to the city.

JANUARY 1968
—Bruce Nauman holds his solo exhibition at Leo Castelli; along with artists such as Eva Hesse, he becomes part of the Process Art movement focusing not on the end product, but on the act of 'creating' art.

JUNE 1968
—Andy Warhol is shot by Valerie Solanas, founder of SCUM 'the Society for Cutting Up Men'; he is taken by ambulance to Columbus Hospital where he is eventually revived.

1969
—General Idea forms in Toronto.
—The Nova Scotia College of Art and Design in Halifax emerges as a highly influential art institution internationally. The period that follows is often referred to as NSCAD Conceptual Art.

JANUARY 1969
—A pioneering group exhibition of Conceptual Art, 0 Objects, 0 Paintings, 0 Sculptures, is mounted by the New York dealer Seth Siegelaub.
—Art Workers Coalition is founded in New York. The group calls for exhibition opportunities for artists of colour and women artists, and expanded legal rights for all artists.

JULY 1969
—Apollo 11 is launched from Cape Kennedy in Florida; Neil Armstrong becomes the first man on the moon.

AUGUST 1969
—The Woodstock music festival is held in upstate New York.

1970s

1970
—Growing environmental awareness spawns earthworks, sculptural projects on the scale of the landscape itself; known examples include Robert Smithson's *Spiral Jetty* made from rock and earth at the Great Salt Lake in Utah.

JANUARY 1971
—Linda Nochlin's *ARTnews* essay "Why Have There Been No Great Women Artists?" confronts the institutional sexism of art historians and critics.
—The Toronto gallery A Space organises workshops introducing video to contemporary artists.

APRIL 1971
—The exhibition Contemporary Black Artists in America opens at the Whitney Museum of American Art.

NOVEMBER 1971
—The term "Post-Minimalism" is coined by critic Robert Pincus-Witten to describe the work of Richard Serra and Eva Hesse.

FEBRUARY 1972
—The Canada Council establishes its Art Bank programme.

APRIL 1972
—General Idea publish the first issue of *File*, their influential magazine.
—The Guggenheim, New York, infamously cancels Hans Haacke's show, on the grounds of "artistic impropriety" due to the possible connection between real-estate details revealed in the exhibition and museum trustees.

JUNE 1972
—The Watergate scandal involving President Richard Nixon begins.

NOVEMBER 1972
—US troops withdraw from Vietnam; President Gerald Ford declares the war officially over in 1975.

SEPTEMBER 1972
—AIR Gallery, the first cooperative gallery for women artists in the United States, opens in New York.

JULY 1973
—Robert Smithson dies in a plane crash while inspecting sites for his work *Amarillo Ramp* in Texas.

SEPTEMBER 1973
—The Kitchen Center for Video, Music, and Dance opens in New York, giving video art an institutional space between visual, film and performance art.

1974
—General Idea found Art Metropole in Toronto, Canada; an organisation devoted to collecting, publishing and distributing artists' books, multiples, audio and video.

APRIL 1974
—Chris Burden takes performance art to a new extreme, when nailing himself to a Volkswagen Beetle in *Trans-fixed*.

AUGUST 1974
—President Richard Nixon resigns.

OCTOBER 1976
—MoMA PS1 is founded by Alanna Heiss; it is one of the oldest and largest institutes in the US dedicated entirely to contemporary art.

1977
—Cindy Sherman creates her landmark *Complete Untitled Film Stills,* 1977–1980, a series of 69 photographs of Sherman dressed as B-movie, foreign film and film noir actresses; her work raises challenging and important questions about the role and representation of women in society, the media and the nature of artistic creation.

JANUARY 1977
—The New Museum opens under the guidance of former curator at the Whitney Museum of Art, Marcia Tucker.

SEPTEMBER 1977
—Marianne Goodman Gallery opens on 57th Street, New York.

1979
—Sherrie Levine rephotographs images by Walker Evans as a way of questioning the originality of art; artists like Levine, Dana Birnbaum and Barabara Kruger will become prominent in the Appropriation Art movement over the next decade.

SEPTEMBER 1979
—Paul Wong and others organise the Living Art Performance Festival in Vancouver.

1980s

JUNE 1980
—The Times Square Show takes place. Curated by artists, and held in a two-floor former bus depot and massage parlour on Times Square. The show included works by then unknown artists Jenny Holzer, David Hammons, Jean-Michel Basquiat, Keith Haring, Kiki Smith, Walter Robinson.

NOVEMBER 1980
—Ronald Reagan is elected 40th President of the United States.
—Metro Pictures opens in New York.
—The first exhibitions of Neo-Expressionist art are held in New York; artists associated with this movement include Julian Schnabel, David Salle, Eric Fischl and Jean-Michel Basquiat.

NOVEMBER 1982
—Maya Linn's *Vietnam Veterans Memorial,* with the names of the dead inscribed in a polished black granite wall, is unveiled in Washington DC following extensive criticism.

MAY 1984
—MoMA mounts An International Survey of Recent Painting and Sculpture. Out of 169 artists exhibited only 19 are women. As a result, the Guerrilla Girls are founded by a group of almost 100 feminists who wear gorilla masks in public, protesting against the exhibition.

SEPTEMBER 1984
—Brian Mulroney wins the largest Conservative landslide in Canadian history and is elected Prime Minister.

JULY 1984
—Fredric Jameson publishes the essay "Postmodernism, or the Cultural Logic of Late Capitalism" in the *New Left Review,* as the debate over postmodernism extends beyond art and architecture into cultural politics, and divides into two contrary positions.

1985
—The Los Angeles County Museum of Art organises an exhibition of works by Barbara Kruger, an artist associated with what is sometimes dubbed the "pictures generation".

1986
—Adrian Piper conceives her work *My Calling (Card) #1* by handing out cards printed with the words, "Dear Friend, I am black I am sure you did not realize this when you made/laughed at/agreed with that racist remark."

AUGUST 1986
—Jean-Michel Basquiat dies at the age of 27.

OCTOBER 1987
—Worldwide stock market crash signals the beginning of the 1980s recession.

1987
—Andres Serrano creates *Piss Christ*—a photograph of a small plastic crucifix submerged in a glass of his urine; it is publicly attacked by the US Senate as blasphemous with Serrano consequently receiving death threats.

FEBRUARY 1987
—Andy Warhol dies on 22 February after being administered an overload of fluids during a routine gallbladder operation.

MARCH 1987
—The first ACT-UP action is staged as the AIDS crisis reignites activism in art.

1989
—The Culture Wars begin. Members of the conservative Ronald Reagan administration attack artists and academics, criticising their work as "subversive" and "indecent", looking to Andres Serrano's *Piss Christ* as example. Senators began to protest against the National Endowment of the Arts (NEA), calling for national funding to be reconsidered, ultimately in hope of the NEA being made redundant, however to no avail. Discussions over the national funding of the arts continue over subsequent years—see January 1996.

MARCH 1989
—After a nine year long court case, Richard Serra's controversial *Tilted Arc* is removed from Federal Plaza, New York.

JUNE 1989
—A Robert Mapplethorpe exhibition at the Corcoran Gallery is cancelled, the gallery fearing the loss of grant money from the NEA.

1990s

MARCH 1990
—The National Gallery of Canada comes under prolonged attack for spending $1.76 million on a painting by American Barnett Newman.

AUGUST 1990
—Iraq invades Kuwait triggering the first Gulf War and US operation Desert Storm in 1991.

1991
—Jeff Koons' Made in Heaven opens at Sonnabend Gallery. The show features 31 works depicting Koons and his wife, Ilona Staller, the Italian parliamentarian and porn star known as la Cicciolina (Little Fleshy One) having sex. The show creates a sensation but the art world rejects Koons, believing he has taken his ideas of exploitation too far. He is left out of all international surveys, including Documenta.

MARCH 1991
—Jana Sterbak's exhibition of a dress made of raw meat at the National Gallery of Canada draws media attention and is accused of wastefulness.

1991
—The Canadian Art Foundation is formed in Toronto.

1992
—Rirkrit Tiravanija exhibits his first solo show Untitled (Free) at 303 Gallery. The work consists of Tiravanija placing all the contents of the gallery in the main space, then setting up a makeshift kitchen in what had been the dealer's office. For the entire month, Tiravanija or an assistant served free Pad Thai to whoever stopped in.

APRIL 1992
—In a groundbreaking intervention, Mining the Museum, Fred Wilson transforms the Maryland Historical Society's collection to highlight the history of slavery in America.

MARCH 1993
—The Canada Council announces serious funding cutbacks.

MAY 1993
—Jean A Chalmers Awards are given to Jeff Wall and Francois Houdé for visual arts and crafts, respectively.

1994
—The first of Matthew Barney's *Cremaster Cycle*, 1994–2002, *Cremaster 4*, is released; the *Cycle* consists of five feature length films exploring the processes of creation.

SEPTEMBER 1994
—Kara Walker gains art world attention with her debut at the Drawing Center in New York, *Gone, An Historical Romance of a Civil War as It Occurred Between the Dusky Thighs of One Young Negress and Her Heart*. The work is a narrative panorama cut by hand in black paper silhouette.

APRIL 1995
—The Alfred P Murrah Federal Building in Oklahoma City is bombed by Timothy McVeigh and Terry Nichols.

MARCH 1996
—The Royal Art Lodge is founded in Winnipeg, Canada, by Michael Dumontier, Marcel Dzama and Neil Farber, among others; with an emphasis on small-scale drawings and paintings.

JANUARY 1996
—United States Congress cut the NEA funding to $99.5 million as a result of pressure from conservative groups.

MARCH 1997
—Willem de Kooning dies, having suffered from Alzheimer's disease since the late 1980s.

1999
—FAILE, a collaboration between Patrick McNeil and Patrick Miller is begun; it gains recognition for its use of stencilling and flyposting in the increasingly established arena of 'street art'.

2000s

FEBRUARY 2000

—Foreign Minister Lloyd Axworthy defends Nadine Norman's performance *Call Girl* at the Canadian Cultural Centre in Paris, from charges of indecency and mismanagement of funds.

JANUARY 2001

—George W Bush is elected as the 43rd President of the United States.

SEPTEMBER 2001

—Four passenger planes are hijacked by terrorists on 11 September and deliberately crashed into the World Trade Center Towers in New York, the Pentagon in Washington, DC and an open field in Pennsylvania.

SEPTEMBER 2001

—The PBS series *Art:21—Art in the 21st Century* premieres; it is the only series on US television to focus exclusively on contemporary visual art and artists.

OCTOBER 2001

—The war in Afghanistan begins.

OCTOBER 2002

—The smallest exhibition space in the world—The Wrong Gallery—opens at 516A1/2 West 20th Street, comprising of one square metre of exhibition space. It later closes in September 2005, the famous doorway temporarily being hosted by the Tate Modern, London, during the same year.

OCTOBER 2002

—The term "Mission School" is coined to describe a group of artists associated with the San Francisco Art Institute, taking inspiration from the bohemian 'street' culture of the Mission District. Mission School artists include Chris Johanson, Barry Mcgee and Margaret Kilgallen.

FEBRUARY 2003

—Space Shuttle Columbia breaks up on re-entry. Seven crew members are killed and all shuttle operations are stopped for the next two years.

MARCH 2003

—The Iraq War begins with the invasion of Iraq by the US and Allied forces.

MAY 2004

—Steve Kurtz, a member of Critical Art Ensemble, is arrested under a suspicion of 'bioterrorism'. Kurtz was cleared of the bioterrorism charges in July 2004, but the case dragged on for another four years.

NOVEMBER 2004

—President George W Bush is re-elected.

AUGUST 2005

—Hurricane Katrina wreaks havoc on the Gulf coast.

MARCH 2006

—Canadian conceptual artist, Michael Snow's work is included in the Whitney Biennial.

FEBRUARY 2007

—Jeff Wall retrospective surveying his career of three decades opens at MoMA.

SEPTEMBER 2007

—A financial crisis in the US triggers a worldwide recession.
—Richard Prince retrospective opens at the Guggenheim.

NOVEMBER 2008

—Barack Obama is elected as the 44th President of the United States.

MAY 2009

—President Barack Obama adds Glenn Ligon's *Black Like Me* #2 to the White House collection of art.

SEPTEMBER 2010

—Allora and Calzadilla are chosen as the United States' representatives for the 2011 Venice Biennale, the first time an artist collaborative have been chosen.

NOVEMBER 2010

—Conversations about Canadian Contemporary Art: Artistic Practice at Home and Abroad symposium at the National Gallery of Canada, Ottawa, featuring guest speakers Ken Lum, Denise Markonish and Adam Budak.

DECEMBER 2010

—In an unexpected move, MoMA announces that the exhibition Abstract Expressionist New York featuring works by Jackson Pollock, Mark Rothko and Robert Motherwell will be sent to the Art Gallery of Ontario, Canada, to be displayed in 2011.

ESSAY

16 **CONTEMPORARY ART IN THE UNITED STATES AND CANADA**
MICHAEL WILSON

CONTEMPORARY ART IN THE UNITED STATES AND CANADA
MICHAEL WILSON

IN THE CLOUD

Contemporary art in the United States and Canada in the early years of the twenty-first century is sufficiently diverse that critic Jerry Saltz was able to write, introducing a list of key moments in the New York scene of the past 40 years, that it was allowable to abandon the idea of readily traceable development in favour of the image of "an expanding and contracting cloud that has broken free of linear progress, something that grows in all directions at once".[1] While his characterisation was written with one particular city—albeit a hugely influential locus of creative endeavour and the acknowledged centre of the art market—in mind, the metaphor of the "cloud" (now familiar from its use in information technology) might equally be applied to the development and influence of art in these two nations as a conjoined whole.

But America, while dominant, is not—even in an increasingly globalised art world—'everyplace'. It may contain multitudes but its conditions are, though diverse, nonetheless specific. What Saltz's cloud signifies is thus not a lack of identity, but rather the evolution of an increasingly complex and necessarily hybrid set of identities. Yet while MoMA founder Alfred Barr's infamous flow chart of creative influence may have been long-since and rightly discredited as an exclusive and falsely linear micro-history, the plotting of routes between past and present remains an irresistible and not altogether counterproductive impulse—even when 'clouded' by intermingling and fragmentation. Attempted continually, and in spite of prevailing theoretical orthodoxies, it is an exercise that can be instructive even when its ends hang loose.

The relationship between America and Canada as art world powers reflects its real-world equivalent. While American artists feel free to confront or ignore questions of national identity according to their perceived appropriateness at specific junctures, their Canadian counterparts have more often been forced into a direct confrontation with local geography and history by virtue of their country's comparatively marginal status. At best, this has produced a productively critical and formally progressive art; at worst, it has exacerbated an internationally replicated process of ghettoisation. In a 2010 symposium at the National Gallery of Canada, Vancouver-based artist Ken Lum cited Marshall McLuhan's assertion that Canada had no national identity and that this was a good thing.[2] As something of an underdog, Lum implied, Canada might have less to lose and more freedom to experiment. Canadian artists continue to spread their wings, but international success has been intermittent as many elect to—in the words of curator Denise Markonish—"hunker down", privileging production over interaction.

America itself at the fag end of the noughties is a strange burg. Of course, it was ever thus, but a sampling of recent events and non-events beyond the purely cultural arena demonstrates that the country's unfortunate reputation for confusing fact, with a distinctly unlikely brand of fiction, remains unrivalled. As I write, Governor Sarah Palin creeps closer to a Presidential run via the curious device of dispatching wild moose on her own reality TV show, while the leader she would seek to depose, Barack Obama, appears increasingly dispirited as compromise begets compromise. Midterm elections see the Republicans gain control of the Senate as the Tea Party Movement's campaign against common sense gathers a worrying momentum. And what flickers of resistance to such radically reactionary tendencies do appear seem largely relegated to a hobbyist interzone: witness the entertaining but ultimately inconsequential ripple made by the Invisible Committee's *The Coming Insurrection,* an insurrectionary booklet that scored an on-air denouncement by conservative talking head Glenn Beck but which now props up tables in museum bookstores.[3]

CON AND NEO-CON

It is arguably a mark of this innate conservatism that painting remains a key ingredient of America's artistic landscape in particular. But it is also an indicator of artists' irrepressible ingenuity that the retrogressive impulse is continually incorporated into the substance of what they make, not merely as source material for post-postmodern pastiche, but in a variety of ways that, when successful, invest contemporary practice with a genuine feeling for the richness of its heritage. And while this backward glance is not always trained on figuration, American and Canadian painting both now feel more crowded with people and buildings, flora and fauna than they have since before the dawn of Abstract Expressionism. Abstraction in general persists, but is drained entirely of the fervour that characterised its mid-century incarnation, now just one tool among many (and, at worst, a mannered niche concern) rather than an argument or end in itself.

Of course, the validity of a partial return to conventional picturemaking—however that term is understood—is frequently and fiercely contested. New York painter John Currin has been a particular locus of debate on the subject, his cause not helped by his own periodic admissions of traditionalism. Flirting openly with classicism, caricature, and pornography, Currin has drawn fire and praise in equal measure since his 1992 solo debut—an exhibition that famously prompted *Village Voice* critic Kim Levin to appeal for a boycott. Socially ubiquitous and commercially hyper-successful, Currin has joined the likes of Jeff Koons and Matthew Barney as a member of American contemporary art's super-elite. But while his political incorrectness may be dumbly provocative, the extent of Currin's influence remains open to question. Other painters less insistent on self-consciously anachronistic technical refinement have produced work with far greater resonance among communities of artists and viewers.

The Mission School, a loose-knit collection of artists based in and around San Francisco, has achieved this, in part through an embrace of the aesthetics of American folk and outsider art. Coupled with an immersion in elements of American street culture—graffiti and skateboarding in particular—they allude not to the elegant styles and

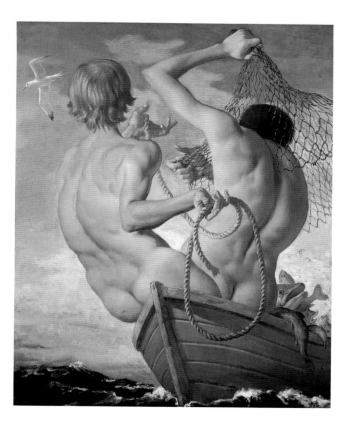

personalities beloved (ironically or not) by Currin and his admirers, but to a more down-home history centred on a quirky, semi-rural milieu. Scene kingpins like Barry McGee, Margaret Kilgallen, and Chris Johanson have honed and popularised a distinctive visual language inspired by comic-book illustration, hobo iconography, and handmade commercial signage that, while it may have slotted effortlessly into Western youth culture, has also accrued respect from a critical-curatorial establishment sensitive to its demonstrable art-historical connections with tendencies from late-1960s Pop to mid-1990s Abject and Slacker art.

The latter movements—allied phenomena informed by a blend of self-conscious impurity, self-deprecating humour, and fetishisation of the disenfranchised and debased— continue to inform the work of painters like Sean Landers and Brian Calvin, as well as, more subtly, Carroll Dunham

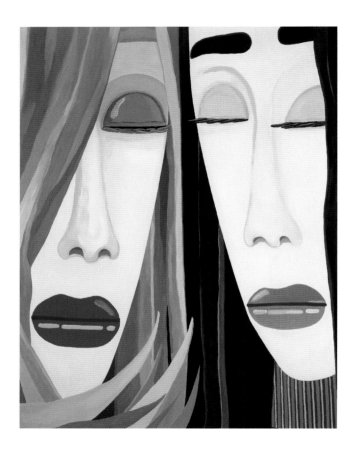

and Raymond Pettibon. Landers is perhaps the most influential of the bunch, a master of inconvenient and uncomfortable truths who makes use of embarrassment as a medium unto itself. Best known for text paintings in which run-on monologues riddled with cynicism, self-doubt, and snark are spelled out (often inaccurately) across the canvas, Landers has also mined art history for source material. A 2001 exhibition at Andrea Rosen Gallery in New York, for example, featured a series of paintings based on canvases by Picasso, presented with supreme irreverence by Landers as props designed to boost his own reputation to the level of his purported hero's.

Younger Los Angeles painter Brian Calvin also embodies some of this contradictory spirit, wielding considerable effort in the service of a can't-be-bothered aesthetic. His deceptively simple, cartoon-like images of lank-haired, doe-eyed figures doing very little of anything are the product of a highly developed sensitivity to composition and atmospherics that gives the lie to their subjects' lazy poses. If Calvin's canvases often evoke the lackadaisical sensibility that was a key ingredient of Grunge—perhaps the last great American pop-musical form of the twentieth century—they also represent an investment in the craft of figurative painting that is as respectful of its forebears and as judicious in its borrowings as were Grunge's biggest bands. And as with all the painters cited here, the influence of Pop Art, its style and sensibility, is pervasive. Indeed, the impact of Pop on current painting, with its appropriation of images and forms from the mass media, now seems even more significant than that of Minimalism, Conceptual Art, or other forms framed at their inception as post- or non-painterly.[4]

THE LENS CRACK'D

If contemporary American and Canadian painting is characterised in part by a more-or-less self-conscious nostalgic bent, photographic practice has taken a variety of different tacks, split between a search for new subjects, a rigorous deconstruction of process, and a thoroughgoing interrogation of these aims' myriad contexts. While sleek, large-scale colour photography remains the default mode for internationally marketable work (its continued ubiquity at art fairs sealing the deal), and has suffered

some backlash as a result, it is also a sufficiently broad and still-developing field that even art historians like Michael Fried, whose book *Why Photography Matters as Art as Never Before* appeared in 2008, have latterly felt inspired to rejoin the contemporary-critical fray.[5]

While the influence of Gregory Crewdson's highly elaborate faux-cinematic panoramas was inescapable in the early 2000s—in no small part because of his professorship on Yale's then-hot postgraduate photography course—it is other artists with rather cooler approaches who have emerged or endured as the most interesting at decade's end. Los Angeles-based Walead Beshty is a case in point. Turning away, in his most recent work, from figurative imagery altogether, Beshty has immersed himself in the medium's still under-explored potential for a kind of conceptual abstraction. Grounding

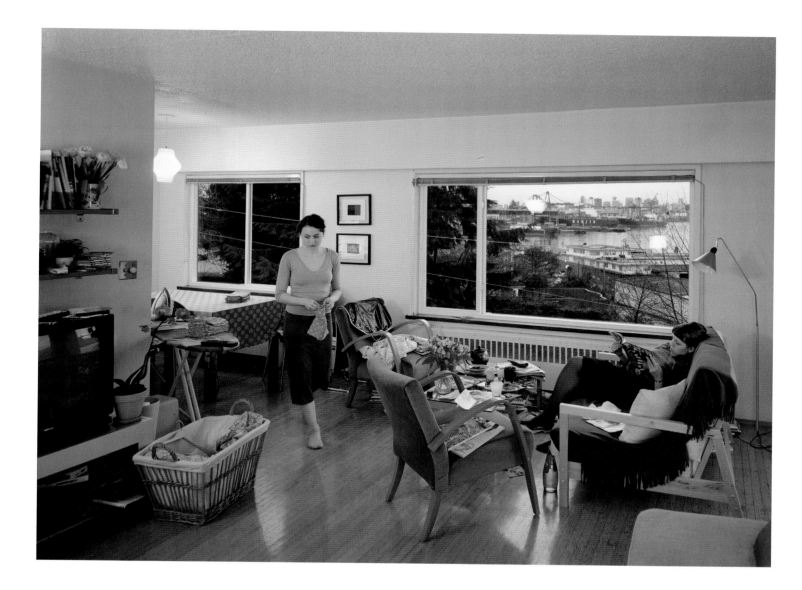

an outwardly decorative project in an investigation of the ways in which material and retinal phenomena interact, the artist also gives the operation of chance a revitalised creative role. In the 2008 Whitney Biennial, Beshty exhibited a series of prints made using film damaged by airport X-ray machines, outwardly simple works into which he folded a rich conversation about the medium's history and the effect of societal impositions on the production and reception of art.[6]

In the work of Christopher Williams, this field of inquiry is approached with a more tightly controlling hand, in ultra-deadpan photographs with exhaustively taxonomic titles. Appropriating the conventions of various subgenres, from commercial stock photography to scientific documentation, Williams engineers a highly reflexive, almost pathologically self-conscious system of images. Employing an emphasis more common to installation and performance artists than to photographers (it is telling that he refuses the last designation), Williams integrates elements of site- and time-specificity into his prints, often presenting subtly altered versions thereof in accordance with their conditions

of display. And while concentrating on the contexts of gallery and museum, he has also, occasionally, exploited the possibilities of other arenas; for its April 2006 issue, for example, *Artforum* printed two separate covers, each featuring a different image by Williams of the same simpering model. In his essay on the artist in the same issue, Bennett Simpson writes: "If there is an affective logic to such work, it does not depend on the subject matter's rationality, but on distinctions among images, a kind of playful noise discovered in the process of viewing."[7]

Williams' approach, as Simpson also points out, derives in no small measure from those of his high-Conceptualist teachers at CalArts in the 1970s—John Baldessari and Douglas Huebler among them. Its links with the Conceptual photography that emerged on the west coast of Canada under Jeff Wall's influence are evident too. While the practice of Roe Ethridge is also comparable to theirs in its reliance on appropriation, it diverges from it in adopting a freer and more enigmatic approach to the final image or combination of images. Ethridge not only borrows from magazine photography but also produces

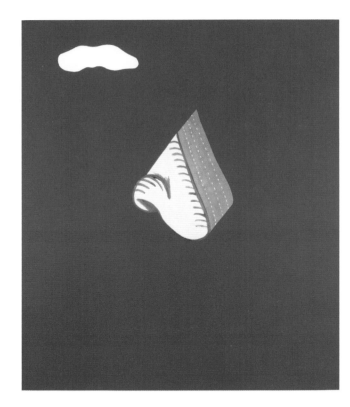

but to focused customisation and integration into larger interconnected systems.

What artists have taken from the expansion of the Web is then not only an increased awareness of the digital, but an enhanced sensitivity to the power of what Claire Bishop characterises as the"social turn".[8] A new cadre of collaborative groups emerged with particular force around mid-decade, and their visibility has held firm. As the explosion of blogging and social media have deepened the crisis of criticism by encouraging trained commentators to question the validity of their profession, so that unregulated democracy has prompted a corresponding interrogation of established creative hierarchies across all forms. But while the drive toward collaboration and communication naturally occurs in an atmosphere of inclusiveness, it has in some cases done so via the ironic usage of signs and rituals that connote its opposite. The Bernadette Corporation, for example, knowingly exploits the power of destabilising power of uncertainty and anonymity, producing work that blurs the boundaries between original and appropriated, individual and group, art and non-art. Founded in 1994, the New York-based group remains strategically indeterminate, addressing questions of identity by obfuscating its own. Moving from fashion to film to literature—the 'collective novel' *Reena Spaulings* (the fictional heroine's name is also that of a Chinatown gallery) is perhaps its most successful project to date—the Corporation is hardly 'open' in the conventional sense. In its self-conscious mystery, however, it establishes and operates in a more egalitarian and productively critical space than do many individual artists.

Established in the same year as the Bernadette Corporation, the Center for Land Use Interpretation eschews the shadowy profile of the former, but depends on a similarly knowing exploitation of the visual and verbal languages of large-scale governmental and commercial bodies. Describing itself on its website as "a research and education organization interested in understanding the nature and extent of human interaction with the earth's surface, and in finding new meanings in the intentional and incidental forms that we individually and collectively create", the Center's

it himself, and while Williams begins with an outwardly uninflected dismantling of such blandly 'functional' or overtly styled shots, Ethridge locates himself in the midst of a rush of meaning that ensures every element is unstable from the outset. In the artist's mismatched sequences, images belonging to avowedly separate genres seem to infuse each other with new stylistic and narrative life. There is method to this madness, but it is altogether more elastic than Williams' or Beshty's. Even those American artists who have used photography specifically to explore altered psychological states—think of Cindy Sherman or Tony Oursler—have generally employed a more outwardly consistent aesthetic.

THE SOCIAL NETWORK

While the photographic medium may have allowed Ethridge and others to nudge the master narrative ever closer to ultimate dissolution, the internet and its associated technologies have in some senses already facilitated a total transcendence of their drive toward the non-linear and the post-logical. After a shaky start with exhibitions like Lawrence Rinder's Bitstreams at the Whitney in 2001, and a tokenistic treatment in the following year's Biennial, art that not only uses the Web but which is derived from the species of structure it feeds off, and facilitates, has gradually become a vital component of the American scene. Initiatives such as the New Museum of Contemporary Art's ongoing Rhizome project and 2010 exhibition Free, and the continued success of curatorial-informational networks such as Anton Vidokle's *e-flux* newsletter and journal, have contributed to a climate in which emergent platforms are now generally seen as prompts not to aimless experiment

art-world context can seem almost incidental; the exhibitions, events, and publications it produces are as much pedagogic as they are 'expressive'.[9] As befits its remit, the Center operates from multiple locations, in Los Angeles, Troy, Wendover, Houston, and Albaquerque. It also maintains a research station in the Mojave Desert, thereby inserting itself into an American artistic tradition that runs from Nancy Holt's monumental *Sun Tunnels*, installed in Utah's Box Elder County in 1976, to Andrea Zittel's "High Desert Test Sites", an ongoing series of experimental arenas spread across a number of communities from Joshua Tree to Wonder Valley.

Among those individual artists who have begun to realise the potential of the social as framed and facilitated by new technologies are Ryan Trecartin and Cory Arcangel. Los Angeles-based Trecartin makes work across a range of mediums but generally enlists multiple co-workers to assist not only in its physical production, but also in its conception and development. His sculptures—grotesquely exaggerated or otherwise distorted figures that suggest the efforts of a cack-handed Charles Ray—exist alongside and within videos like *A Family Finds Entertainment*, 2004. In this rambling epic, Trecartin's helpers (among them several actual relatives) inhabit various roles in the story of a troubled teen named Skippy. The approach is absurdist high camp, the result a riot of clashing pop-cultural references and visual non-sequiturs that makes a virtue of discontinuity but feels entirely appropriate to a contemporary coming-out, equating, as it seems to, queerness with a species of ungovernable imagination.

Arcangel also makes videos, but his species of interaction is more often allied to the past and present of personal computing. Exploiting the increasing ubiquity of editorial hardware and software, Arcangel steers the hacker ethic into previously uncharted territory by 'collaborating' with the designers of such products without their knowledge or consent. In *Super Mario Movie*, 2008, a video made with the Paper Rad collective, he replaces the coding of the titular computer game with lines of his own, steering the extant graphics in an unexpectedly filmic direction. But while such projects require a degree of expertise, Arcangel has also adopted the role of unskilled everyman, treating the operating instructions of graphics programmes as readymade rules, deliberately following them to the letter—even when the results appear doomed to inadequacy. He thus not only engages in a classic form of creative deskilling, but also implies a very particular approach to the operation of the social derived from a lucid but complex relation to the means of production.

DEEP COVER

While these socially structured and technologically involved strategies draw, to a greater or lesser extent, on precedents established by, among many others, General Idea and Vito Acconci (who has latterly, along with Lawrence Weiner, achieved a kind of late-period ubiquity, branching out into ever more ambitious architectural and other public projects), artists concerned with more explicit critique have even more readily discernible roots in earlier American practice. This is perhaps unsurprising given the stridency of their respective aims and styles; artists like Barbara Kruger, Adrian Piper, and David Hammons have always provoked a variety of reactions, but indifference has rarely figured among them. Similarly, artists like Fred Wilson, Yes Men, and Critical Art Ensemble have sharpened various needles with which to probe and irritate the status quo, often working from embedded positions inside the institutions they aim to deconstruct.

Along with Andrea Fraser and Rirkrit Tiravanija, Wilson has come to exemplify the overlapping practices known (with a solemnity that might seem virtually

designed to repel the casual viewer) as Institutional Critique and (arguably the lesser of the two) Relational Aesthetics. Though the efficacy of the strategy he helped popularise is still regularly and rightly contested (the Guggenheim Museum's poorly received 2008 exhibition anyspacewhatever was a sobering example of how otherwise rigorous work might still, if presented without due regard to its conceptual *raison d'être*, fall short of engaging the not already sympathetic viewer), few would dispute its value as a problematic but occasionally necessary corrective to curatorial, art-historical, and critical bias. Mining the Museum, Wilson's 1992 exhibition at the Maryland Historical Society, remains a touchstone. 'Making' nothing new, the Bronx-born artist instead rearranged and recontextualised the Society's existing collection to focus on the history of slavery in America. More recent projects have employed similar techniques, also directing attention toward issues of racial and cultural identity. Wilson's installation for the American Pavilion at the 2003 Venice Biennale, for example, explored the history of Africans in the Italian city via—among various other elements—sculpture, video and graffiti derived from existing narrative accounts.

While Wilson launches his critique from platforms provided by the art world establishment and directs it in part back toward that point of origin, other artists have sought to position themselves within the broader but arguably tougher-to-penetrate arena of the mainstream media. Milwaukee-based duo the Yes Men, aka Andy Bichlbaum and Mike Bonanno, are primarily social activists, and exercise a canny awareness of the complex sphere in which they operate. Producers of feature films *The Yes Men*, 2003, and *The Yes Men Fix the World*, 2009, Bichlbaum and Bonanno engage in what they term "identity correction", a playful strategy of fakery and impersonation that has granted them illicit access to otherwise impenetrable forums and embarrassed some major corporate and governmental players. One of the duo's most visible and reported-on pranks involved a collaborator posing as a spokesman for Dow, appearing on BBC World television news in 2004 to seemingly accept the corporation's responsibility for the 1984 Bhopal industrial disaster on the occasion of its twentieth anniversary. Recounting the event on their website, the group writes, with understandable glee:

We expect the story to be retracted immediately, but Dow takes two hours to notice that alas and alack, it's

DAVID HAMMONS
Bliz-aard Ball Sale
1983, performance
Courtesy the artist

done the right thing. The full interview therefore runs twice, and for two hours the story is the top item on news.google.com. CNN reports a Dow stock loss of two billion dollars on the German exchange. After Dow notes emphatically that it is not in fact going to do right by those non-shareholders in Bhopal, the retraction remains the top Google story for the rest of the day.[10]

This kind of direct and purposeful engagement with the mechanisms of reportage, corporate communications, and PR carries an active subversive charge that Wilson's more necessarily bounded provocations, for all their evident sophistication, never could.

Another group, Critical Art Ensemble (CAE) partially bridges the gap between these two extremes. Formed in 1987 in Tallahassee, Florida, CAE is a group of five "tactical media practitioners" with specialisations in a range of disciplines including web design, film, video, and performance. Operating between theoretical research and art-for-exhibition and the more unequivocally real-world areas of technology and politics, CAE has also produced a substantial body of written work addressing genetic engineering, cybernetics, and various forms of "electronic civil disobedience". The group achieved notoriety in 2004 when founder member Steve Kurtz was arrested on suspicion of 'bioterrorism' following the discovery of organic samples in his home. The fact that these were related to a project on genetically modified agriculture commissioned by the Massachusetts Museum of Contemporary Art was initially lost on both local law enforcement and the FBI. Their charges—and others related to the mailing of the samples—were later dropped, but not before Kurtz had suffered various indignities including the seizure of books and materials and the removal of his just-deceased wife Hope's body for 'analysis'. If any single incident focused art world attention on the widespread misdirection of official concern following 9/11, this—the cruel irony of its accidental occurrence notwithstanding—was surely it.

POETIC OBJECTS
While the focus of such practices has not generally been on objects *per se*—or even on images in the conventionally understood sense of the word—a parallel tendency in American and Canadian art has cohered around idiosyncratic makers whose work is more indebted to Surrealism and Arte Povera than it is to more historically immediate antecedents such as Minimalism, Conceptual Art, and their various splinter groups and subgenres. These artists have substantially reinvested sculpture in particular with an ambiguity and elusiveness that more outwardly 'rational' approaches tended to sideline. In this they might even be thought of as rather un-American, pointing as they do toward a subtlety more often associated with a generalised (if frequently erroneous) notion of current European practice.

The work of some of these artists does at least evince an awareness of how one set of influences might be filtered through another. Among a number of emergent sculptors gathered in 2009s Unmonumental, the New Museum of Contemporary Art's inaugural show in their then-new premises on Manhattan's resurgent Lower East Side, was Gedi Sibony, whose assemblages invest low-rent materials with a peculiar atmosphere and authority that feels both of the art world and rooted in the quotidian realm of architectural construction and maintenance. Since his solo debut at nearby gallery Canada in 2004, Sibony has continued to use found materials like industrial carpeting, window blinds, and cardboard boxes, installing them in seemingly casual but contextually incongruous and ultimately alchemical arrangements. Profiling Sibony, Claire Gilman points to the essential theatricality of this approach, the way in which the work's components seem not only to be playing roles, but also doing so with an affecting lack of polish.[11]

Quotidian materials are also front-and-centre in the sprawling installations of Sarah Sze. Symptomatic of what Saltz dubbed "termite art"—a tendency to bury the viewer in mounds of 'stuff' that seemed ubiquitous during the artist's late 1990s rise to prominence—Sze is the maximalist to Sibony's minimalist.[12] A typical Sze consists of thousands of individual components arranged in runs and rows like dominos ready to be toppled, often making use of architectural peculiarities and suggesting the irresistible progress of a kind of object-virus. In

Uncountables, her 2010 exhibition at Tanya Bonakdar Gallery, Sze augmented another truckload of odds and ends with a system of support structures, introducing towers, beams, and platforms into the space that allow the work to extend higher and further than it otherwise might. With Q-tips, twigs, toothpicks, plastic bottles, milk cartons, pens, bars of soap, and a hundred other ephemeral objects, Sze creates intricate formal arrays that also narrate a drama of accumulation that recalls those of great American hoarders like the late Collyer brothers, eccentric recluses who stuffed their Harlem brownstone with some 130 tons of books, papers, furniture, musical instruments, and other items, most of value to no-one but themselves.

While Sibony and Sze root their work firmly in the everyday, Trisha Donnelly has often seemed to sidestep the quotidian in favour of a quasi-mystical realm, hinting at a private mythology that fascinates even as it consistently refuses to locate itself in a straightforward narrative of artistic 'development'. The quietly charismatic Donnelly punctuates her sculptural oeuvre with performances (the word feels inadequate—they might better be referred to as 'incidents' or even 'manifestations') that feel similarly external to the conventions of the genre. Famously, she turned up at the opening of her solo debut at New York's Casey Kaplan Gallery in 2002 atop a white horse, introducing herself as a Napoleonic envoy; at a follow-up three years later she led visitors on a walk in search of "the sound that stops time", eventually locating a mysterious

boom issuing from an unmarked Chelsea doorway. Such antics have, allied with an equally enigmatic body of sculpture and drawing, lent Donnelly's name an almost talismanic resonance.

INSIDER TRADING

Fleeting interventions like Donnelly's can, when finely judged, transcend their immediate circumstances to live on in collective memory, but it is showable, sellable, shippable, and storable artefacts that still, for the most part, hold sway in the American and Canadian scenes. As I write, Art Basel Miami Beach, an event often looked to as a barometer of the health of the Western market, has just wrapped up. Having hit a peak in 2007, then weathered two rather less successful years, the fair bounced back in 2010; attendance was up and sales stronger. The indication is of a resilience that, while it may appear surprising in its independence of prevailing economic conditions, in fact simply underlines a wearisomely familiar American paradigm: rich-get-richer-poor-get-poorer. Dealerships and auction houses rub their hands at continued 'commitment' on the part of collectors; artists, curators, and museum directors are more ambivalent; critics, academics, and educators achieve the peace of mind that comes from an acceptance that some things never change.

Over the past decade, private collectors have come to exercise an unprecedented—and acutely problematic—influence over American museums and public galleries. At best, their interventions have brought major new work into the public arena; at worst, they have threatened to compromise institutional integrity and accountability. Two recent examples: first, in 2008, philanthropist Eli Broad attracted criticism for announcing that he would not be donating his $1.9 billion collection to the Los Angeles County Museum of Art, but would instead use it to adorn his own new institution, the Broad Contemporary Art Museum. The decision was seen by some as a betrayal of Director Michael Govan, who had been convinced to move to Los Angeles from New York two years earlier by (among others) Broad, who was then Vice-Chair of the LACMA board. Second, in 2009, the New Museum caught substantial flak for inviting Jeff Koons to guest curate an exhibition, Skin Fruit, from the collection of his

close friend, Greek billionaire Dakis Joannou. The fact that Joannou was also a trustee of the museum elicited accusations of cronyism, with some concerned that the moneyed, insiderish pairing contradicted the ideal of support for emerging practices on which the venue was founded. Artist William Powhida's satirical drawing *How the New Museum Committed Suicide with Banality*, 2009, fanned the flames of controversy by mapping and mocking the connections involved.[13]

Whatever the ethics of such high-profile private-public intersections, they look set to continue, with, for example, former New York dealer Jeffrey Deitch presently settling in as Director of Los Angeles Museum of Contemporary Art. And as the 2010 release of *Wall Street: Money Never Sleeps* demonstrated, America retains its tendency not only to position cash near the centre of any given enterprise, but also to shamelessly dramatise the results—even at the most inappropriate juncture. For the outsider, this can make for entertaining spectator sport; for those directly implicated—that is, not only art-world players but also artists at all levels of visibility and the diverse audiences with which they interact—the situation is more complex, and invariably more fraught. A treatise on the allocation of governmental and charitable funds belongs elsewhere, but suffice to say the challenges of independent, grass-roots creative activity remain very much in place. The challenge for artists in both America and Canada remains that of resisting the temptation to slot neatly into a canon that, while unquestionably 'expanded'—in formal terms at least—still suffers from a knee-jerk tendency to reward personality above invention. Duchamp may cast a long shadow here, but Warhol looms still larger—and you know what he said about fame.

> I'm bored with that line. I never use it anymore. My new line is "In fifteen minutes, everybody will be famous."—Andy Warhol

1 Saltz, Jerry, "The New York Canon: Forty Years of New York Minutes", *New York Magazine*, 23 April, 2008, reprinted in Jerry Saltz, *Seeing Out Louder: Art Criticism 2003–2009*, Lenox, MA: Hard Press Editions, 2009, pp. 410–421.

2 "Conversations about Canadian Contemporary Art: Artistic Practice at Home and Abroad", symposium at the National Gallery of Canada, Ottawa, 19 November, 2010. Moderator: Josee Douin-Briseboid; panelists: Denise Markonish, Adam Budak, Ryan Rice, Ken Lum.

3 Los Angeles, CA: *Semiotext[e]*, 2009. Originally published as *L'insurrection qui vient* by Paris: Editions La Fabrique, 2007.

4 Jack Bankowsky explores this phenomenon in detail in his "Pop After Pop" special issue of *Artforum*, vol. XLIII, no. 2, October 2004, and in Pop Life: Art in a Material World, an exhibition he co-curated with Alison Gingeras for Tate Modern, London, in 2009.

5 Fried, Michael, *Why Photography Matters as Art as Never Before*, London and New Haven: Yale University Press, 2008.

6 As I write, American opponents of new airport full-body scanners are engaging in a day of non-compliance, concerned that the use of such equipment, which penetrates passengers' clothing, constitutes an unjustifiable invasion of privacy.

7 Bennett Simpson, "What does the jellyfish want? Bennett Simpson on the Art of Christopher Williams", *Artforum*, vol. XLIV, no. 8, April 2006, pp. 204–211.

8 Bishop, Claire, "The Social Turn: Collaboration and its Discontents", *Artforum*, vol. XLIV, no. 6, February 2006, pp. 178–183.

9 http://www.clui.org/

10 http://theyesmen.org/hijinks/bbcbhopal

11 Gilman, Claire, "Focus: Gedi Sibony", *Frieze*, issue 113, March 2008, pp. 160–161.

12 Saltz, Jerry, "California Earthquakes", in *Village Voice*, 23 June, 2004, reprinted as "Termite Theory" in *Seeing Out Louder*, pp. 181–183.

13 Powhida's drawing was commissioned by critical journal *Brooklyn Rail* for their November 2009 cover and later appeared in the form of an editioned print—one of which was purchased by Jannou.

ARTISTS

30 **ALLORA AND CALZADILLA**	76 **ROBERT GOBER**	134 **MARTHA ROSLER**
34 **MARTIN KERSELS**	80 **FRED WILSON**	138 **KARA WALKER**
38 **RYAN TRECARTIN**	82 **ARTURO HERRERA**	142 **CHRISTIAN MARCLAY**
40 **MATTHEW BARNEY**	84 **JIM SHAW**	146 **TONY OURSLER**
44 **PAUL MCCARTHY**	88 **JOHN CURRIN**	150 **RODNEY GRAHAM**
48 **ANDREA FRASER**	92 **KERRY JAMES MARSHALL**	154 **SUSAN HILLER**
50 **DEXTER SINISTER**	96 **GLENN LIGON**	158 **PAUL PFEIFFER**
52 **CENTER FOR LAND USE INTERPRETATION**	100 **CHRISTOPHER WOOL**	160 **JOSEPHINE MECKSEPER**
	104 **RAYMOND PETTIBON**	162 **ROE ETHRIDGE**
54 **MARK DION**	108 **JULIE MEHRETU**	164 **BERNADETTE CORPORATION**
58 **OSCAR TUAZON**	112 **MATT MULLICAN**	166 **CHRISTOPHER WILLIAMS**
60 **PAE WHITE**	114 **MARCEL DZAMA**	168 **MICHAEL SNOW**
64 **RIRKRIT TIRAVANIJA**	118 **FRANCES STARK**	172 **CINDY SHERMAN**
66 **SARAH SZE**	122 **ELLEN GALLAGHER**	176 **SHARON LOCKHART**
70 **JESSICA STOCKHOLDER**	126 **WADE GUYTON**	180 **JEFF WALL**
72 **RACHEL HARRISON**	128 **RICHARD PRINCE**	184 **RONI HORN**
74 **TOM FRIEDMAN**	132 **JONATHAN HOROWITZ**	186 **STAN DOUGLAS**

Under Discussion (right)
2005, colour video with sound, 6:14
Copyright Allora and Calzadilla, courtesy Gladstone Gallery,
New York and Lisson Gallery

Stop, Repair, Prepare: Variations on 'Ode to Joy' for a Prepared Piano (opposite)
2008, prepared Bechstein piano, pianist Amir Khosrowpour, 206 cm in length
Copyright Allora and Calzadilla, courtesy Gladstone Gallery, New York
photo: David Regen

ALLORA AND CALZADILLA

Working in collaboration since 1995, Allora and Calzadilla's interdisciplinary practice encompasses sculpture, performance, video and photography, to address often-poignant political, social and environmental issues. Their carefully planned and articulated pieces capitalise on the simplest of materials that aid the artists in their exploration of their surrounding landscape. For Allora and Calzadilla, these materials should not be viewed in their simplest form, but rather with the knowledge that they are marked with the history of where they derive from. It is this strong sense of meaning imbued throughout their work, and the social and historical heritage it carries, that makes their practice so unique—reflected in their being chosen as the United States' Venice Biennale 2011 entry—as it draws complex associations between materials and their meanings to reinforce the issues at the core of their practice.

A recurring trope throughout their work is that of animality and its relationship with humanity. In works such as *Hope Hippo*, 2005, and *How to Appear Invisible*, 2009, the artists use animals as the focus for their work. The German Shepherd in the latter piece roams the remains of the Palast der Republik, Berlin, wearing a cone collar fashioned from a KFC bucket that at once points to the effects of capitalism, along with ideas on iconoclasm, historicity and collective memory—ideas which feature throughout Allora and Calzadilla's work. This piece also reflects the artists' determined sense of site-specificity, evident throughout their work.

Another unifying aspect within Allora and Calzadilla's practice is their employment of sound and music, contributing to the performative aspect of their work and alluding to explored ideas of absence. For *Stop, Repair, Prepare: Variations on 'Ode to Joy' for a Prepared Piano*, 2008, they enlisted the help of six pianists to play a specially customised piano, parts of which had been rendered inactive—made obvious when played. This alternate fashioning of found objects appears throughout the duo's work, and is a process, which allows them to pursue ideas on meaning and resonance so central to their practice.

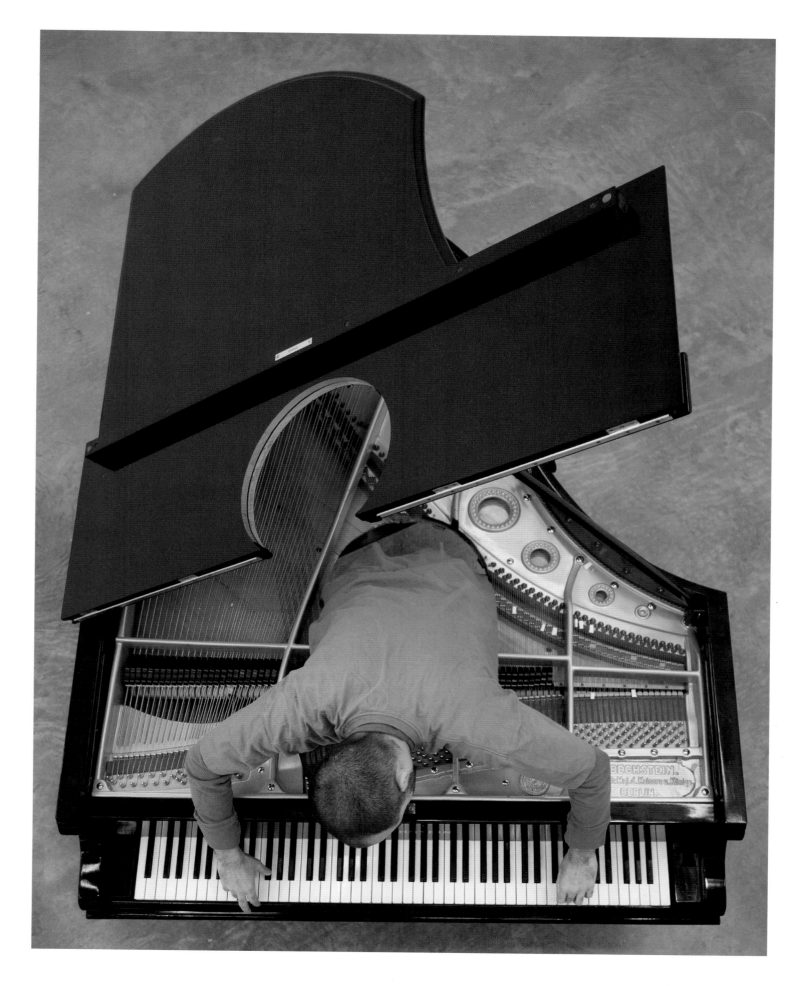

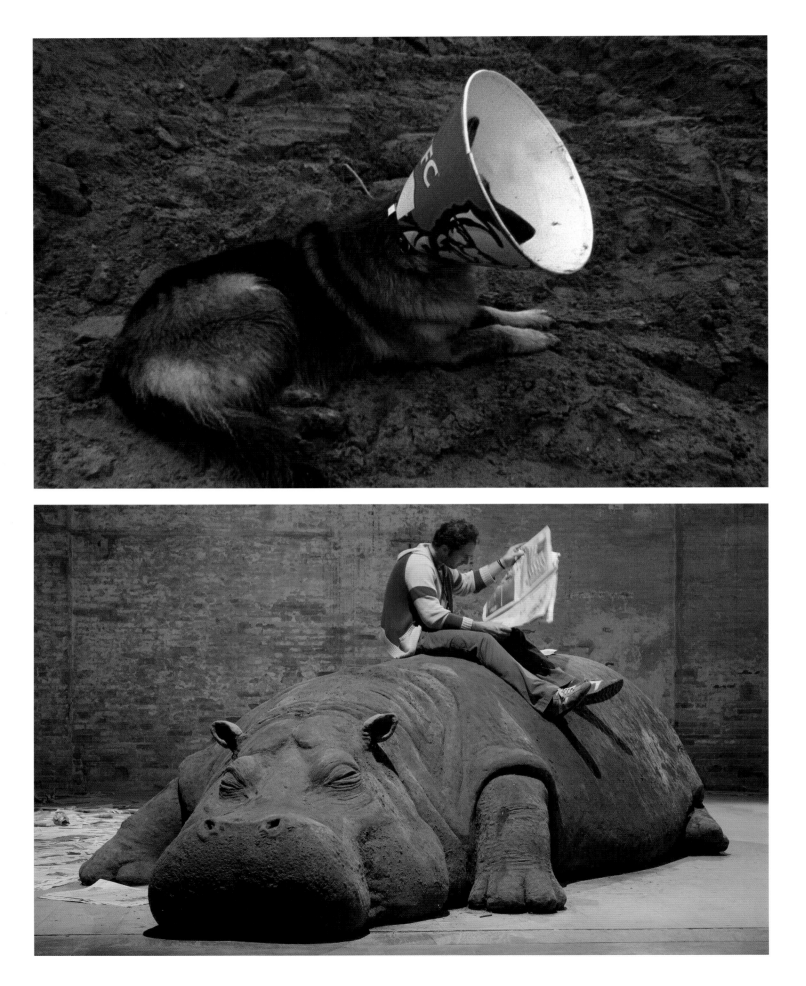

ALLORA AND CALZADILLA

How To Appear Invisible (opposite top)
2009, super 16mm film transferred on disc
Courtesy the artists and Lisson Gallery

Hope Hippo (opposite bottom)
2005, mud, whistle, daily newspaper, reader,
488 x 183 x 152 cm
Installation View 51st Venice Biennale
Copyright Allora and Calzadilla, courtesy Lisson Gallery,
London and Gladstone Gallery, New York,
photo: Giorgio Boata

Sediments Sentiments (Figures of Speech) (below)
2007, mixed media installation, live performance
and pre-recorded sound-track
Courtesy the artists and Lisson Gallery

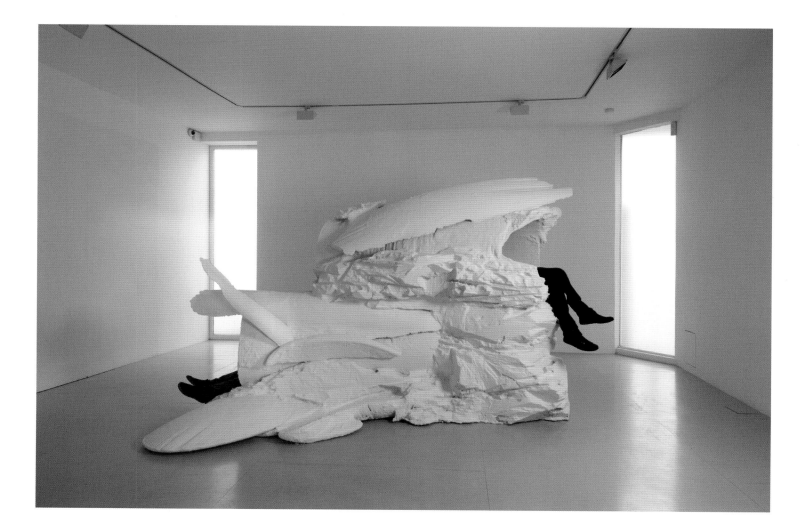

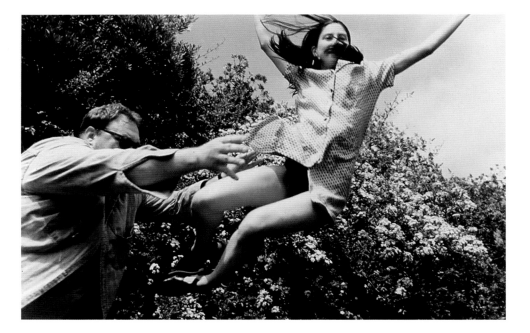

MARTIN KERSELS

Martin Kersels studied at the University of California, Los Angeles, for both his Bachelor of Fine Arts (BFA), graduating in 1984, and his Masters of Fine Arts (MFA), graduating in 1995; being taught by West coast art heavyweights Paul McCarthy and Chris Burden in the latter. Considered a product of his southern Californian background, Kersels' conceptually driven practice navigates both performance and sculpture, covering a range of themes, including suburban teen culture, natural disasters and the Hollywood entertainment industry; it also capitalises upon well-known pop culture subjects and celebrities, such as rock star Iggy Pop and comic actor Buster Keaton.

In *Tumble Room*, 2000, Kersels built a full-scale teenage girls' bedroom, which rotated steadily, suspended from above on a cylindrical steel armature. Kersels then filmed himself rotating within the room, until its contents were turned into a kind-of suburban pop culture mulch. The subsequent film, entitled *Pink Constellation* and the sculptural structure of the room, are thought to be a homage to the physics defying frolics of Fred Astaire in Stanley Donen's 1951 film *Royal Wedding*. Here, as in frequent other occasions throughout his work, Kersels physical stature—standing tall at six foot six, and over 300 pounds—has informed the piece and its final outcome.

Kersels' interest in the body and its relation to performance is explored frequently, with ideas on how humans negotiate their bodies in relation to each other—particularly in reference to their size—becoming central to his practice. This is apparent in the *Tossing a Friend* series, in which he is photographed physically throwing various friends up into the air, their size somewhat at odds to his own, as seen in *Tossing a Friend (Melinda)*, 1996. Kersels' sense of humour, which plays upon ideas of slapstick comedy and wit, has also played an important part in his work, helping him to negotiate the subject of pop culture personally, and with ease.

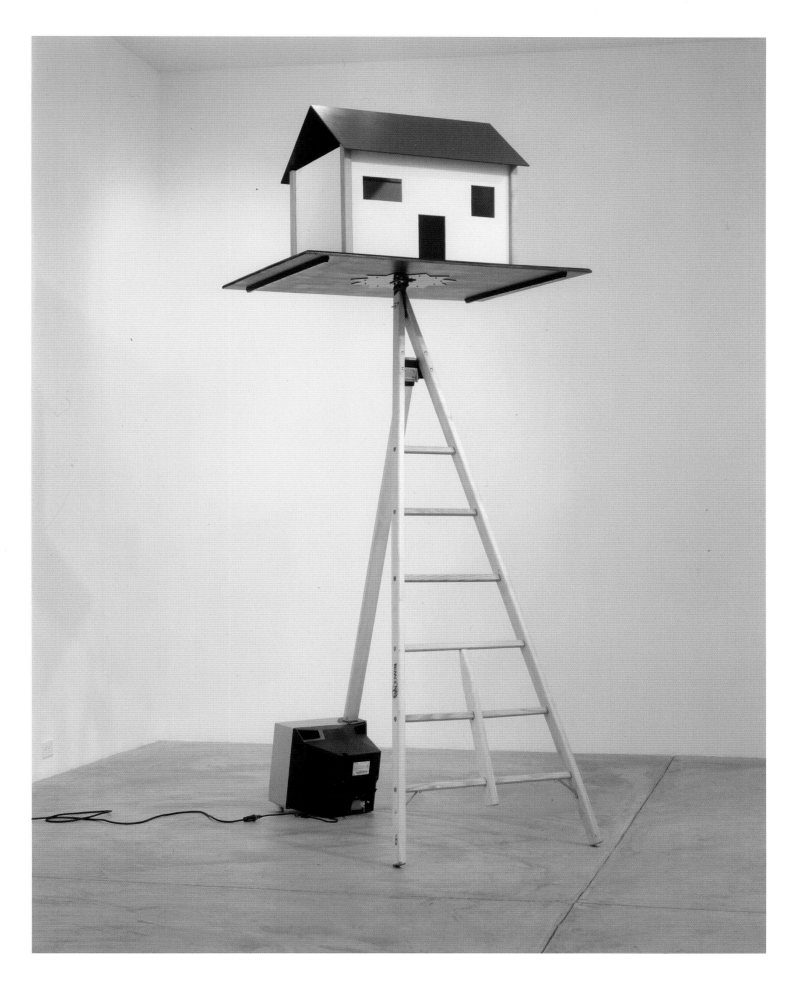

MARTIN KERSELS
Tumble Room
2000, installation, 315 x 160 x 122 cm
Courtesy the artist

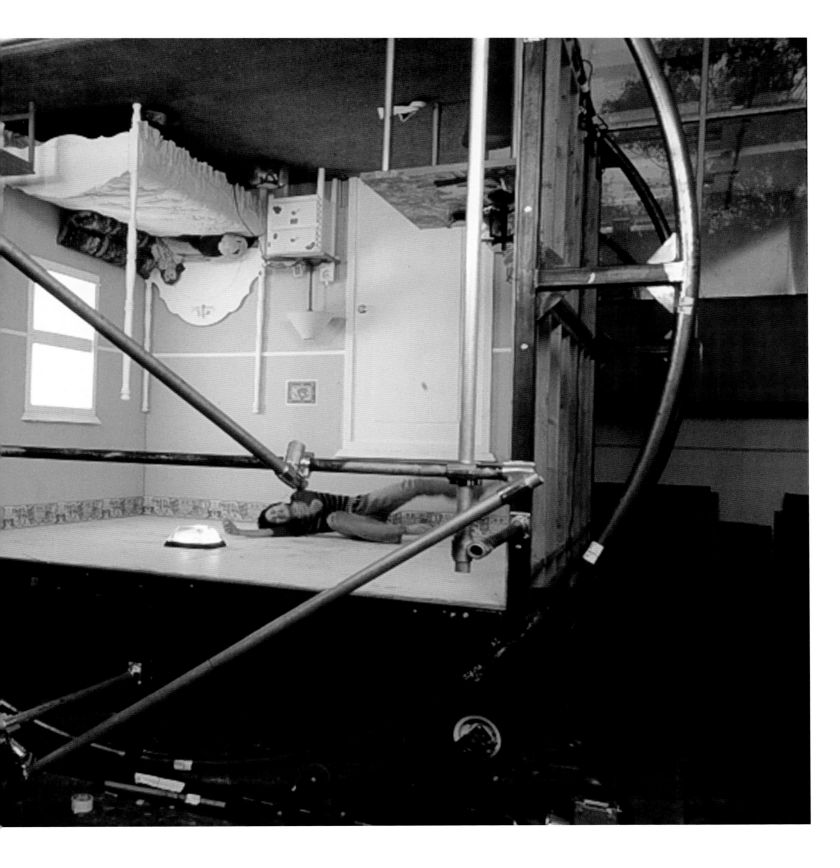

RYAN TRECARTIN
Untitled (Ready (Re'Search Wait'S))
2009–2010, sculptural theatre installation and HD
video, dimensions variable, 26:49
Installation view of Any Ever, MOCA Pacific Design
Center, 18 July–17 October, 2010
Photo: Brian Forrest

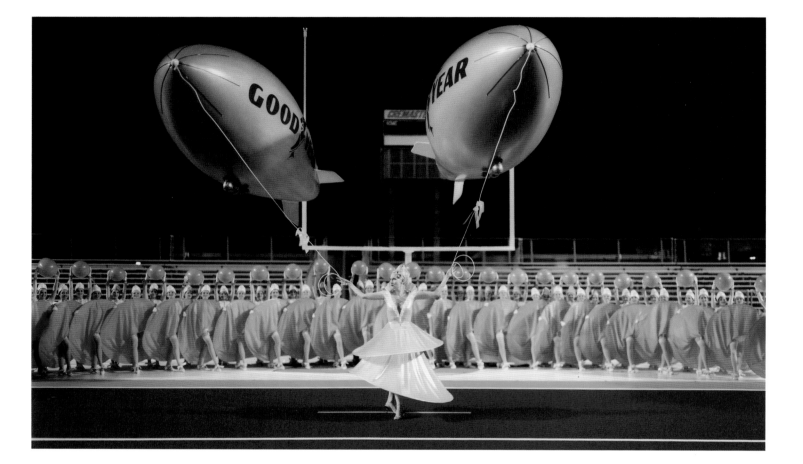

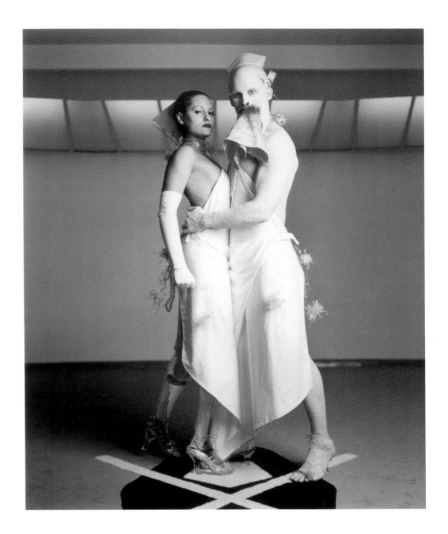

MATTHEW BARNEY

The cyclical, amorphous nature of Matthew Barney's artistic practice insists that we accept a certain fluidity when appreciating his work. The multimedia basis of many of his pieces means the viewer is forced into a free associative discourse with what quite literally surrounds them. Described as a "process sculptor", a term indicative of his focus on the act of artistic creation itself, Barney's work is often epitomised by the notion of being 'in process', changeable and unstable.

Drawing Restraint 2—Barney's 1989 performance piece documented with photography and film—sees the artist restrained by a harness, climbing ramps and pushing blocking sleds while attempting to draw. The piece intends to demonstrate that hypertrophy (muscle and tissue growth) and creation can only occur through restraint; as the artist stretches, his muscles strain, and it is with their healing that they become stronger, allowing him to continue his work.

It is this interplay of opposing forces, a sense of "coexisting equilibrium" that fuels much of the artist's work. *The Cremaster Cycle*, 1994–2002, five films with accompanying drawings, sculpture, photographs and artist's books, focuses on the idea of opposition and indeterminacy; the cremaster muscle raises and lowers the male genitalia in response to temperature or fear, while the films centre on the processes of creation, concentrating on the period leading up to sexual differentiation. In *Cremaster Four*, 1994, Barney himself plays a satyr—half man, half beast, again portraying a sense of conceptual liminality.

It has been said that Barney is "at his best when the work neither explains nor illustrates", a statement reflected in the absurdity of the messy, formless references to the human body and use of such slimy substances as Vaseline in most of the *Cremaster* films. The lack of chronology within the *Cycle* itself only augments this lack of conventional structure, highlighting once again the highly conceptual nature of the artist's oeuvre. While Barney's work inevitably succumbs to artistic interpretation, it is most powerful when its surreal quality is seen to issue straight from the artist's disordered consciousness, unaffected by structured analysis.

MATTHEW BARNEY
Drawing Restraint 2
1988, action and installation view
Copyright Matthew Barney,
courtesy Gladstone Gallery, New York
photo: Michael Rees

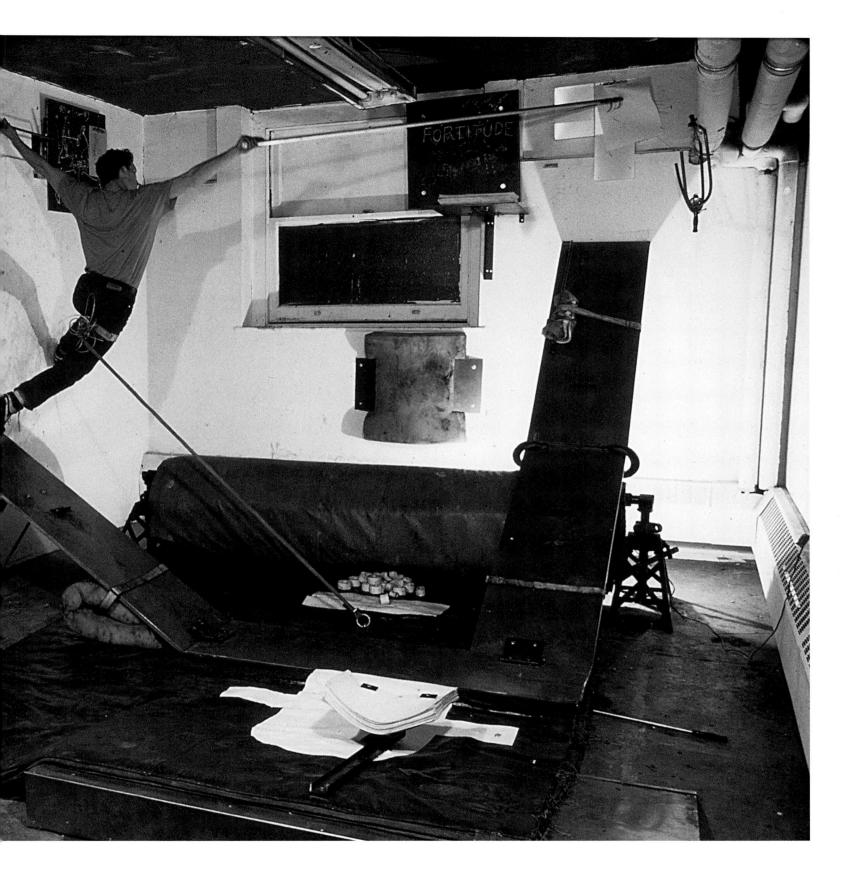

Santa Chocolate Shop (right)
1997, still from colour film
Courtesy the artist and Hauser and Wirth

Caribbean Pirates (opposite top and bottom)
2001–2005, multimedia installation
Courtesy the artist and Hauser and Wirth

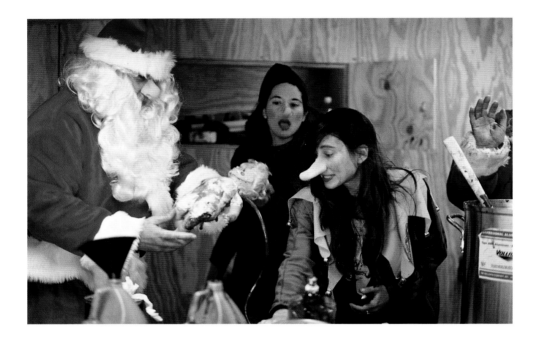

PAUL MCCARTHY

Provocative in nature, Paul McCarthy's practice—initially comprised of videotaped performances and film, and later developing into multimedia installations and sculptural figures—ridicules authority and consumerism, using a monstrous liberalisation of unconscious cultural fantasies and perverted sexual desires. Informed by the traditions of 1960s art, particularly that of the West Coast—including experimental film, Pop Art, Conceptualism and Minimalism—McCarthy combines features from each of these movements with experimental humour.

Bordering on the grotesque, McCarthy's work delves into popular culture in commenting upon contemporary American society. Caricatured figures, ranging from the political to cherished American icons, frequent his work, depicted in scenes of sexual gluttony,

or as mutated hybrid forms. From fantastical characters such as Santa Claus, to ex-President George Bush, his subjects are depicted in an assortment of compromising positions, often with mutilated limbs and dripping fluids. *Caribbean Pirates*, 2001–2005, an installation McCarthy made with his son Damon, can be read as a critique of the American film industry as it directly references the Hollywood blockbuster *Pirates of the Caribbean*. An imposing fibreglass pirate ship stands as the focal point to the installation, smeared with chocolate and fake blood, whilst videos of a carnivalesque 'pirate party' are projected onto the walls around the ship that simulate extreme acts of violence by the masked pirates. The installation has been described as a metaphor for the United States' invasion of foreign lands, with some critics considering it to be a direct reference to the Iraq War.

McCarthy's foray into inflatable sculpture combines his irreverent wit with fairground spectacle. Increasing the scale of his work, the caricatured forms that he has previously exaggerated within his work are pushed to new extremes; such as in *White Head Bush Head*, 2007, in which a giant inflatable reproduction of George Bush Junior's head is moored to the ground. The artist's inflatables have covered a range of subjects from abstract forms to consumer products such as Daddies ketchup, their size and form allowing him to comment upon subjects central to his practice such as consumerism: "Inflatables create attention. And they're often product-related. Big companies make brightly coloured inflatables for big events", whilst highlighting the 'larger-than-life' aspect of his practice.

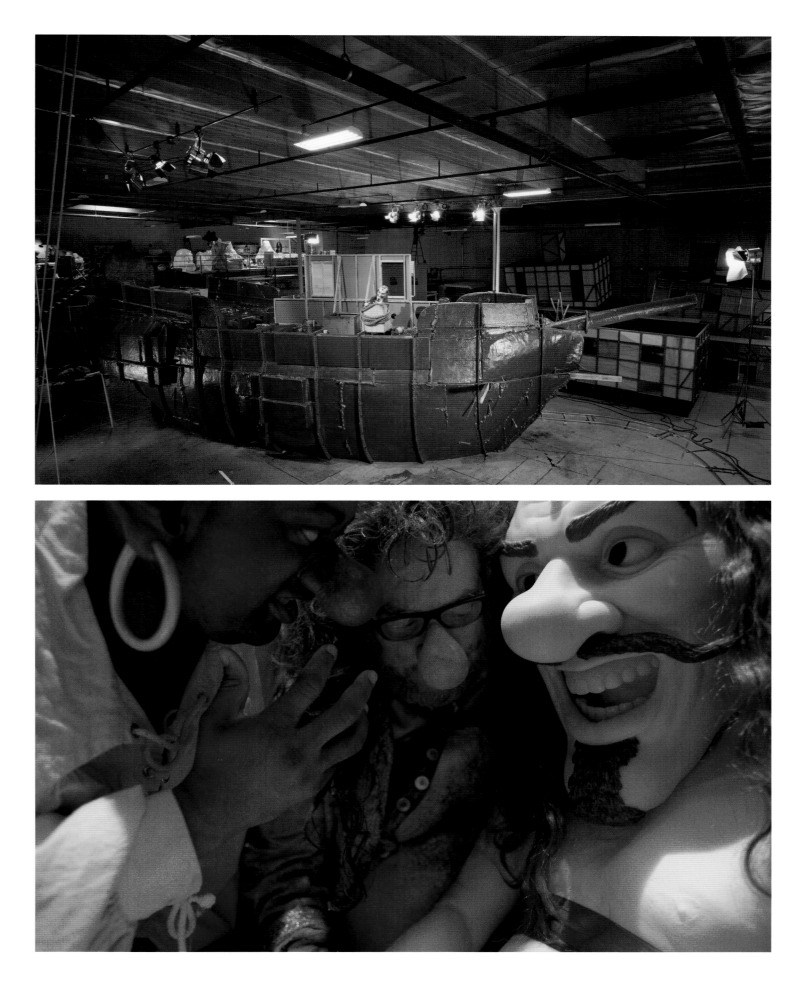

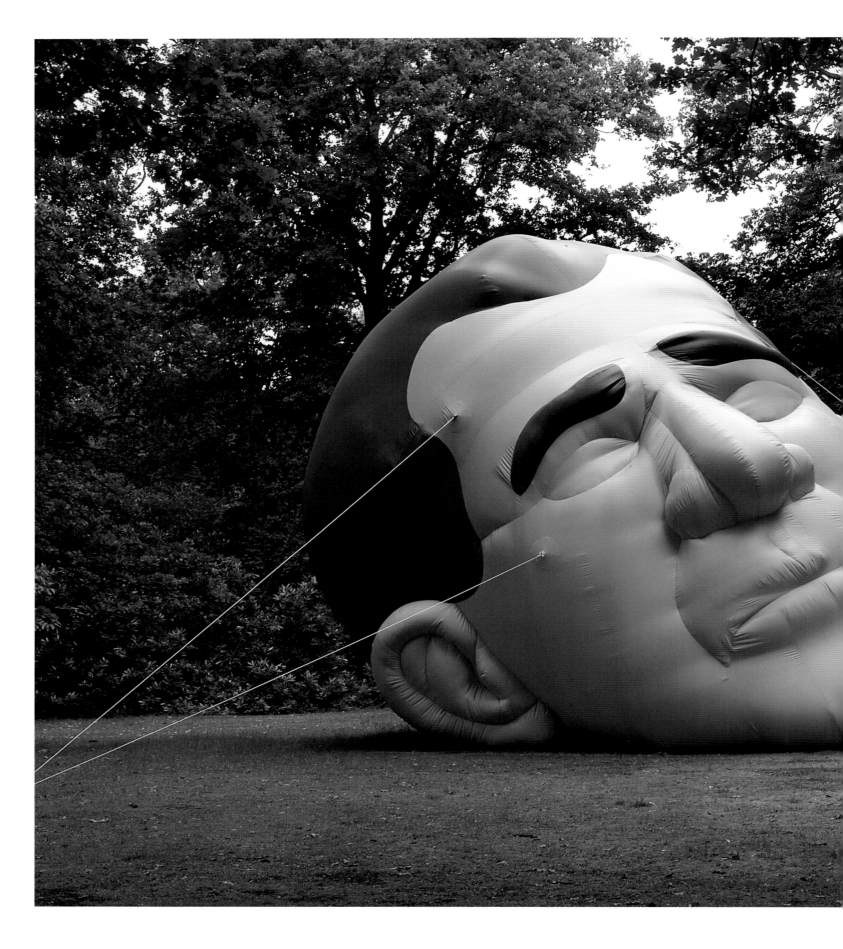

PAUL MCCARTHY
White Head Bush Head
2007, inflatable, installation view, Middelheim
Sculpture Museum, Antwerp, Belgium
Courtesy the artist
photo: Philippe de Gobert

Official Welcome (Hamburg version) (right)
2003, DVD, 30:00
Courtesy the artist and Friedrich Petzel Gallery, New York

Little Frank and His Carp (opposite top and bottom)
2001, DVD NTSC, 6:00
Courtesy the artist and Friedrich Petzel Gallery, New York

ANDREA FRASER

Art, criticism, feminism and psychoanalysis are interwoven into incisively scripted site-specific performances, film works and installations in Andrea Fraser's practice. She first became known in the 1980s for a filmed performance titled *Museum Highlights: A Gallery Talk*, 1989. Performing in various different museums, Fraser adopted the role of a fictional museum tour guide, appropriating the language of art discourse. Contesting the museum's educational and interpretative perspectives she led her audience through each institution using the same elevated language to describe the museum cafeteria and the staff room as for discussing canonical works of fine art. Maintaining the art world as her field of inquiry, deconstruction, mimicry and parody have ever since been prevalent tactics in her practice as she has continued to challenge the institutional art context through an interrogation of its biases, hierarchies and exclusions. Consequently, Fraser's name has become commonplace in discussions on art practice described as "institutional critique".

Little Frank and His Carp, 2001, ("Frank" in the title refers to Frank Gehry, the Guggenheim's architect; the carp references Gehry's practical inspiration from fish) is a filmed performance based on the Guggenheim Bilbao's introductory audiotour. This time performing the role of a museum visitor, Fraser moves through the museum led by the audioguide. Recognising its rhetoric as typical to neoliberal ideology and the market place, however, Fraser sets out to interrogate the neutrality and innocence the audioguide states.

To the surprise of the unsuspecting museum audience, Fraser lifts up her skirt and takes on the unusual invitation to touch and feel the museum surroundings, in what could be described as a semi-erotic encounter between the artist and the surrounding architecture. Her performance ultimately draws attention to the role of museums in determining how the public experiences art. Using parody, Fraser's work highlights how the material structure of the museum is inseparable from the political and economic structures that support the institution. This type of renegotiation and redefinition of art institutions and her own position within it is an on-going strategy for Fraser, who has time and again demonstrated her exceptional capacity to undo the distinctions between art, reflection and analysis.

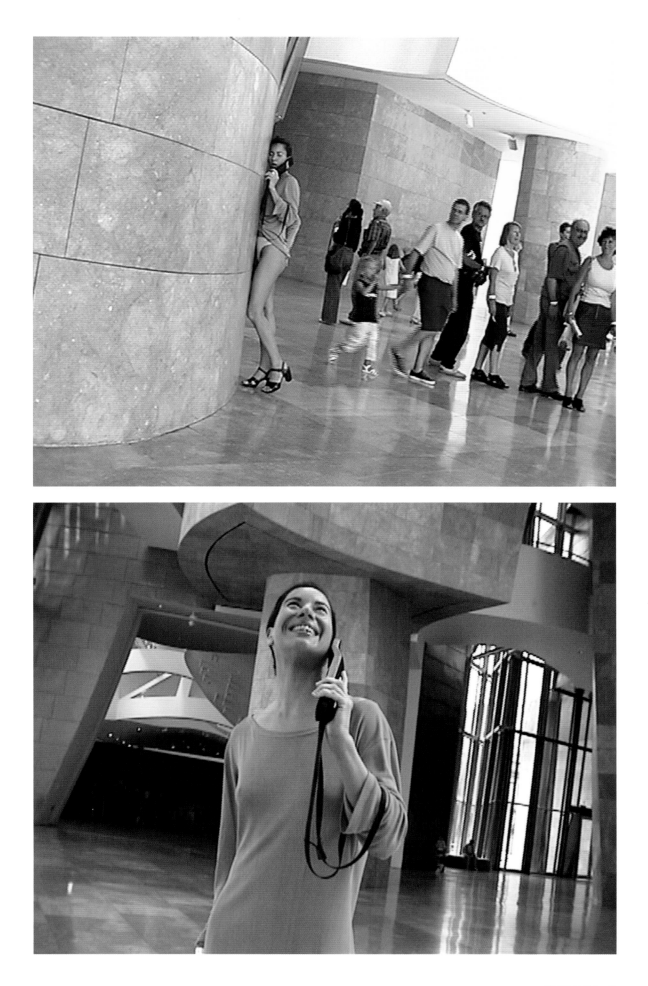

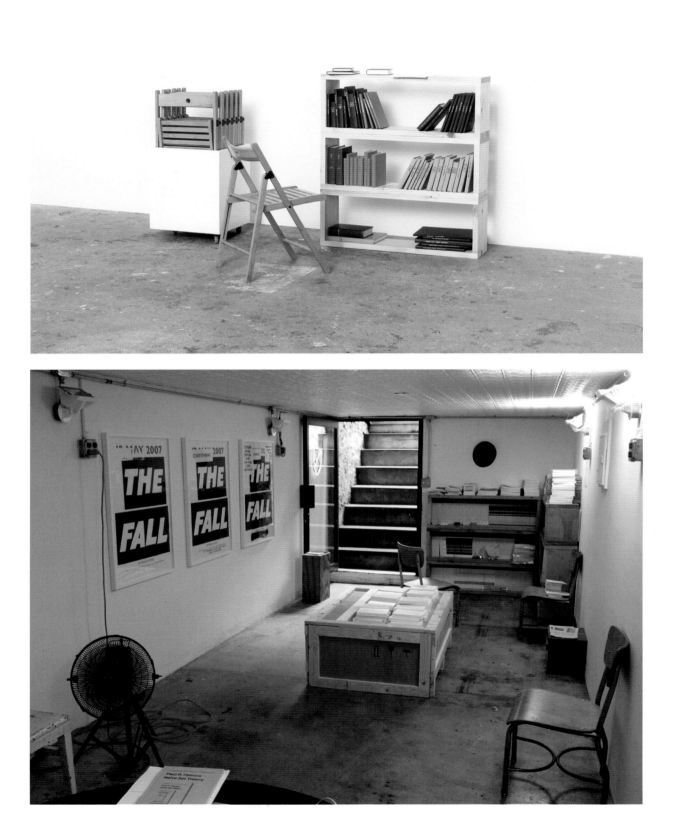

Nascent library collection installed for the exhibition/
workshop **Re-Applied Art** (opposite top)
2010, LiveInYourHead, Geneva
Courtesy the artists

Interior of Dexter Sinister, with "occasional bookstore"
and a temporary hang of prints (opposite bottom)
2008
Courtesy the artists

David Reinfurt presenting a talk on "Naive Set Theory"
at Somerset House, London, later transcribed in
Dot Dot Dot 17 (right)
2008
Courtesy the artists

DEXTER SINISTER

Collaborating under the name Dexter Sinister since 2006, New York-based artists Stuart Bailey and David Reinfurt explore the relationship between designing, editing and distributing, utilizing diverse forms from printed matter to performance. Their eccentric publishing programme operates from a 'Just-In-Time Workshop and Occasional Bookstore', located in a basement at 38 Ludlow Street on New York's Lower East Side.

Dexter Sinister was originally conceived as a print workshop for the Manifesta Six biennial, set up according to the Toyota Corporation's 'Just-in-Time' model—as opposed to the Fordist production line. When the biennial was cancelled amid controversy, Bailey and Reinfurt shifted the idea to New York, and have since produced and distributed a wide variety of titles, including the *Uncertain States of America Reader*, 2007, for the Serpentine Gallery, London—a compendium of essays on contemporary art in the United States; *Studio and Cube*, 2008, by Brian O'Doherty—the follow up to his seminal 1976 text *Inside the White Cube*; and collaborations with the artists Cory Arcangel and Shannon Ebner. The duo have consistently explored alternative methods of publishing, including web-based print-on-demand, and their own online 'distributing library' at www.dextersinister.org. They also published the now-defunct *Dot Dot Dot*, a wide-ranging arts journal 'concerned with the design of language' over ten years and 20 issues.

At the time of writing, Dexter Sinister are in the process of setting up a non-profit institution called The Serving Library, which aims to extend these ideas in a more deliberate, public, and coherent manner. They will inaugurate this project in spring 2011 with *Dot Dot Dot*'s successor, *Bulletins of The Serving Library*, published both online, from www.servinglibrary.org, and in print.

THE CENTER FOR LAND USE INTERPRETATION
View of the CLUI Program "A Tour of the Monuments of the Great American Void" (below)
CLUI Archive Photo

ExxonMobil Baytown Refinery, Baytown, Texas (opposite top)
2008, from the CLUI Exhibit Texas Oil: Landscape of an Industry
CLUI Archive Photo

CLUI Exhibit Unit at the Geographical Center of the Contiguous United States (opposite bottom)
2010, Part of the Exhibit "Centers of the USA", produced by CLUI and the Institute for Marking and Measuring
CLUI Archive Photo

Rescue Archaeology (installation view) (right)
2004, steel cabinet filled with found objects collected during the Rescue Archaeology project at The Museum of Modern Art, New York
Courtesy Tanya Bonakdar Gallery, New York

Alexander Wilson-Studio (opposite)
1999, wooden structure, mixed media, 244 x 366 x 274 cm
Courtesy Tanya Bonakdar Gallery, New York

MARK DION

American artist Mark Dion looks to archaeology, ecology and taxonomy to inform his practice, citing the nineteenth century naturalist Charles Darwin as a major influence. Through his work he brings to light the way that public institutions shape our understanding of history, and questions their authority by displaying found objects using scientific methods.

Dion's concept-driven work is the result of a meticulous process involving the planning, recovery, conservation, classification and installation of found objects, both ancient and modern. Well-known for his "curiosity cabinets" that take inspiration from the *Wunderkabinetts* of the sixteenth century,

Dion displays the items he has excavated from sites internationally, using various different methods. From the banks of the River Thames, London, where Dion, commissioned by Tate Britain, carefully collected pottery, bits of bone, glass and other items from the foreshore of the river; to Perugia, Italy, where he excavated part of an eroded hillside, uncovering stoneware shards, glass bottles and plastic bric-a-brac.

In *Rescue Archaeology*, 2000–2004, The Museum of Modern Art, New York, invited Dion to excavate The Abby Aldrich Rockefeller Sculpture Garden, beneath, which lay the foundations of John D Rockefeller, Sr's, former townhouse at 4 West 54 Street and John D Rockefeller,

Jr's, at 10 West 54 Street, onto which the museum's foundations were built. The artefacts discovered by Dion were then displayed in a traditional manner within the museum.

The Library for the Birds of Antwerp, 1993, was an indoor sculpture that Dion created for the Museum van Hedendaagse Kunst, Antwerp, for 18 African finches to nest upon. Amongst the branches of the tree Dion placed ceramic tiles, birdcages, an axe, photographs, nets, wax fruit and other assorted objects. Dion's interest in the classification and display of objects is highlighted here, with the tree taking centre stage; its branches severed and precariously reattached to one another.

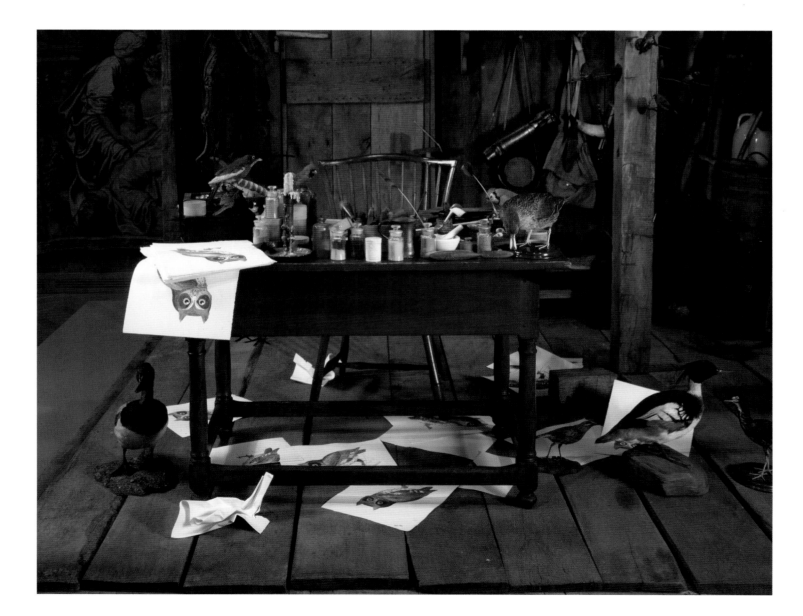

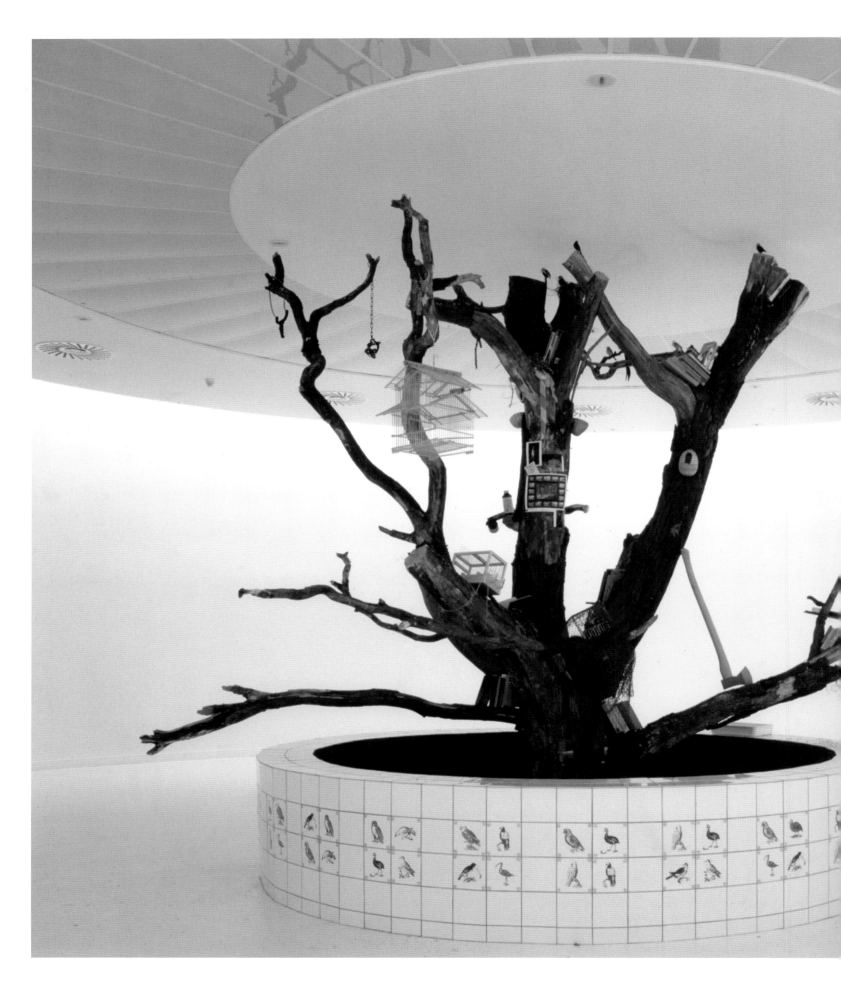

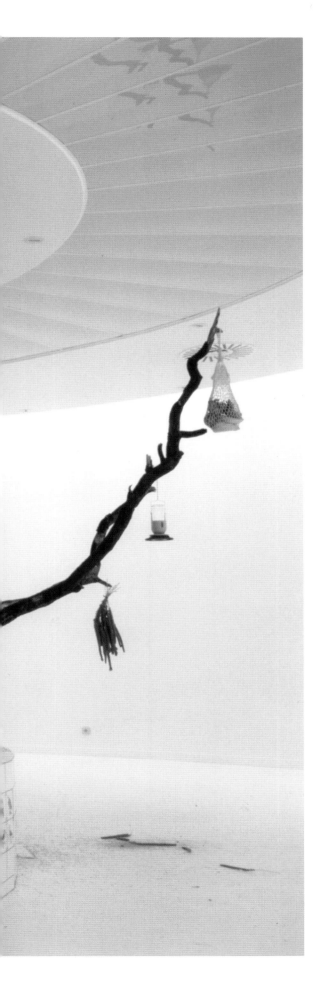

MARK DION
The Library for the Birds of Antwerp
1993, 18 African finches, tree, ceramic tiles, books, photographs, birdcages, bird traps, chemical containers, rat and snake liquid, shot gun shells, axe, nets, Audubon prints, bird nests, assorted objects. Installation, Museum van Hedendaagse Kunst, Antwerp.
Courtesy the artist and Tanya Bonakdar Gallery, New York

My Flesh to your Bare Bones (installation view) (right)
2010
Courtesy the artist

Untitled (installation view) (opposite)
2010
Courtesy the artist

OSCAR TUAZON

Oscar Tuazon's installations evince a strong interest in architecture and how a space is determined by its architecture. Often working in response to a specific site, Tuazon assembles large-scale structures made from industrial and natural materials such as wood, concrete and steel.

Tuazon's art education—having attended the Independent Study Program at New York's Whitney Museum, followed by assisting one of the United States' best-known artists, Vito Acconci—has left its mark upon his own, often-extreme, practice. Whilst most of Tuazon's ideas evolve from his interest in structure, his work still manages to evoke a sense of precariousness. Traversing galleries with vast lengths of wooden beams, as seen in his solo show at the Kunsthalle Bern in 2010, the vulnerability of his work is highlighted as his structures purposefully appear to be consumed by the permanent architecture of the gallery space: "one structure laid over another, one structure growing inside another, a plan for a renovation laid over an existing building, a redevelopment, two structures fucking one another".

Vito Acconci's lasting impression upon Tuazon's work is seen in his solo exhibition My Flesh to Your Bare Bones at the Maccarone Gallery, New York, in 2010; a personal response to Acconci's reading "Antarctica of the Mind"—a proposal for the Halley Two Research Station—in which a rattled response is heard from Tuazon, positioning himself in competition with Acconci. The piece ultimately reflects both a personal and national art history into which the artist is delving. The minimalist sculptural forms found throughout the gallery are Tuazon's interpretations of Acconci's proposals throughout his recording. These simple structures, again made from simple yet robust materials, evince the same vulnerability with which Tuazon's work is often attributed.

Alongside art, Tuazon also writes and curates and in 2007 he moved to Paris where he co-founded the artist run collective and gallery, castillo/co.

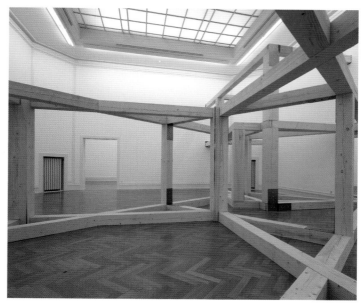

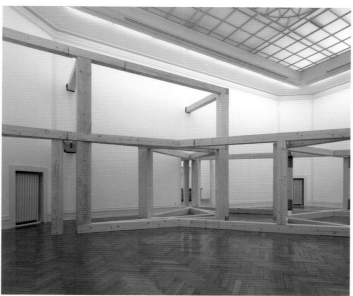

PAE WHITE
Landscape Theater (below)
2009, mixed media, dimensions variable
Courtesy greengrassi, London

Weaving, Unsung (opposite top)
2009, mixed media, dimensions variable
Courtesy Galleria Francesca Kaufmann, Milan, greengrassi,
London and Neugerriemschneider, Berlin

Self Roaming (opposite bottom)
2009, mixed media, dimensions variable
Courtesy greengrassi, London

PAE WHITE
MetaFoil
2008, cotton and polyester, 1097 x 2895 cm
Courtesy Neugerriemschneider, Berlin
photo: Eric Berg

RIRKRIT TIRAVANIJA
Untitled (Free) (below)
1992, 303 Gallery, NY
Courtesy the artist

Untitled 2002 (He promised) (opposite top and bottom)
2002, chrome stain and stainless steel, 120 x 60 x 30 cm
Courtesy the artist

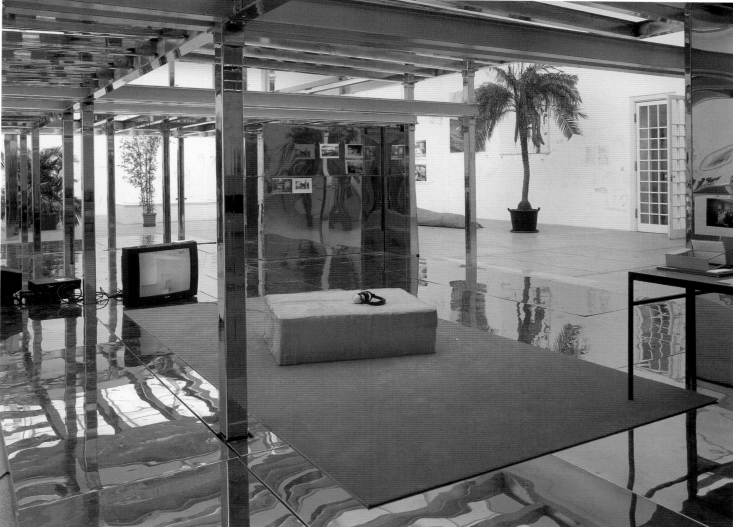

SARAH SZE
Corner Plot (top and bottom)
2006, mixed media, 480 x 513 x 391 cm
Courtesy of the artist and Tanya Bonakdar Gallery, New York

360 (Portable Planetarium) (opposite)
2010, mixed media, wood, paper, string, jeans, rocks,
411 x 345 x 470 cm
Courtesy the artist and Tanya Bonakdar Gallery, New York
photo: Tom Powel Imaging

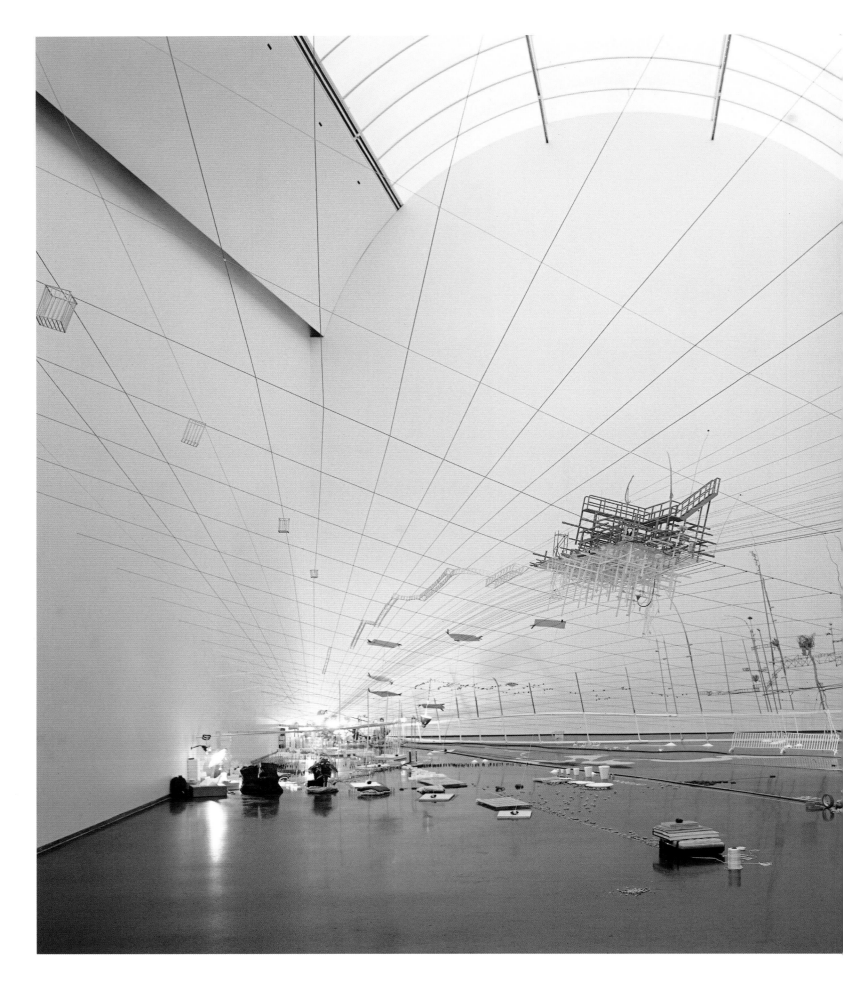

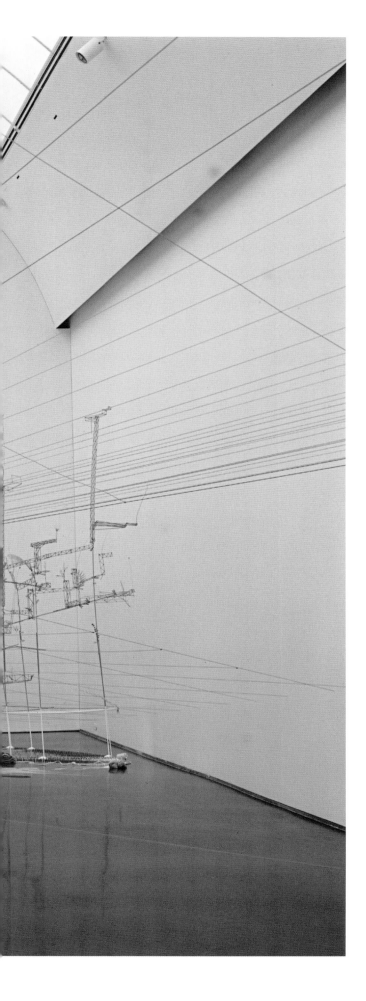

SARAH SZE
Proportioned to the Groove
2005, mixed media, dimensions variable
Courtesy the artist and Tanya Bonakdar Gallery, New York
photo: David Allison. Collection of Museum of Contemporary
Art, Chicago

Air Padded Table Haunches (right)
2005, hanging lamps, fluorescent lights, park bench, carpet, linoleum tiles, fake fur, two rectangular tables, five coffee tables, six floor lamps with shades, acrylic paint and plasti-dip, dimensions variable
Courtesy the artist

Untitled (opposite)
2009, wooden surf board, metal flashing, wire cable, metal weight, rooster lamp, metal table stand, metal pot, cake pedestal, plastic parts, light bulb, power bar, electric cord, oil paint, enamel paint, hardware, plastic shower curtain fragment with grommet, carpet, fabric tape, blue foam, metal pole, 229 x 137 x 42 cm
Courtesy the artist

JESSICA STOCKHOLDER

Seattle-born Jessica Stockholder's expansive multimedia installations and amalgamations of found objects—described as "paintings in space"—belie a structured control of colour and dimension in their seemingly chaotic, idiosyncratic aesthetic. Stockholder utilises mass-produced household objects which would normally be seen as disposable and generic—from cheap lamps, fans, upholstery and furniture through to more basic construction materials—to render her distinctions between the realist and the abstract, the building blocks of the modern consumer's life and the hidden expressionistic potential therein. The artist's multi-surface pieces also appropriate

the architectural structures they inhabit, spanning walls, floors and ceilings, and demanding the viewer to let themselves be enveloped by the work to feel their full effect.

1995's *Your Skin in this Weather Bourne Eye— Threads and Swollen Perfume* is comprised of blocks of vivid colour, interspersed with the aforementioned household objects, electrical wires, and a hanging sack of shirt-stuffed pillows. By viewing the piece at first from a distance—initially experiencing it as a kind of two-dimensional painting—and then moving through it, the viewer effectively deconstructs their own experience of the installation, confusing and blurring the

piece's conceptions of interactive space and dimension; as states Mark Van de Welle, "Herself adrift, Stockholder creates an environment for drifting."

Similarly, *Air Padded Table Haunches*, 2005, is made of myriad lamps, brightly coloured sheets of linoleum, fake fur, a park bench and multiple coffee tables. Though less immersive than *Your Skin in this Weather Bourne Eye...*, the installation is similarly disorientating in its composition; the layout is almost that of a generic sitting-room, but the random colouring and skewed placement of objects create a Surreal, almost rubbish dump-like atmosphere of islands and walk-ways.

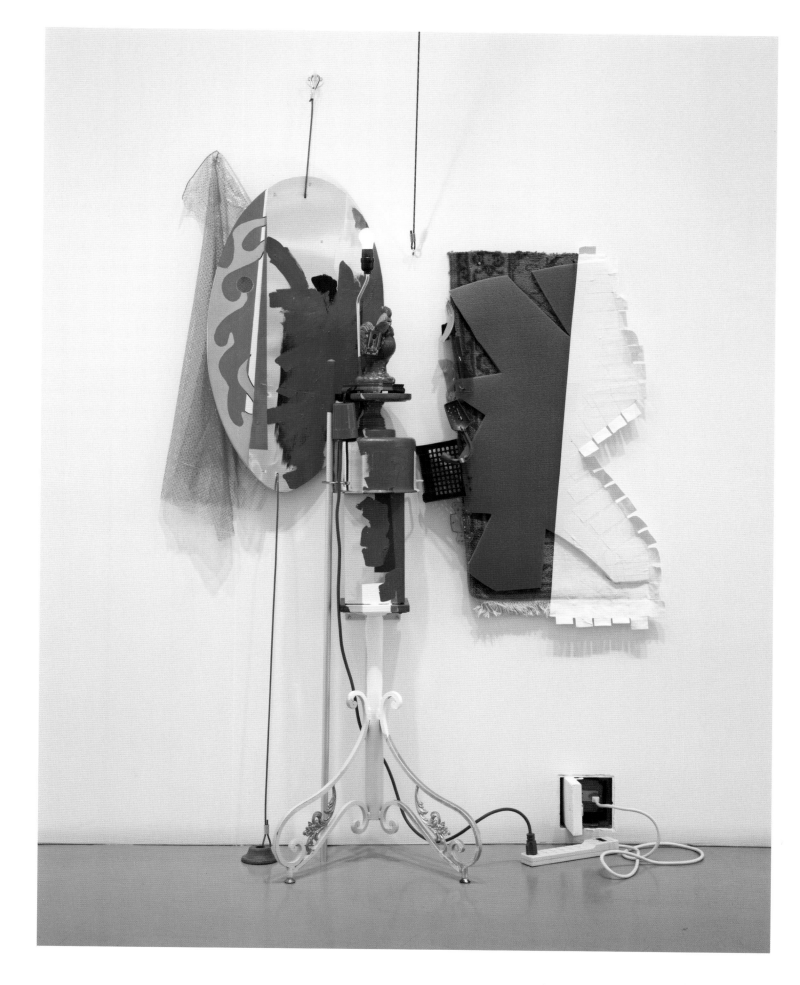

RACHEL HARRISON

Al Gore (opposite)
2007, wood, chicken wire, polystyrene, cement, Parex,
acrylic, and Honeywell T87 thermostat, 216 x 86 x 43 cm
Courtesy the artist and Greene Naftali, New York

Trees for the Forest (right)
2007, pedestals, acrylic latex, anonymous paintings,
moving blanket, CD-R discs, canned pineapple, plastic
wrap, bubble wrap, pink tissue paper, Pearl River
candy, bag, portable radio, poster, and magazines,
dimensions variable
Courtesy the artist and Greene Naftali, New York
photo: A Burger

Perth Amboy (below)
2001/2009, cardboard, coloured straws, five sculptures,
and 21 chromogenic prints, 457 x 1262 x 1809 cm
Courtesy the artist and Greene Naftali, New York
photo: Jason Mandella

TOM FRIEDMAN
Untitled (Cosmic Bust man) (below)
2009, mixed media, 91 x 107 x 56 cm
Copyright Tom Friedman, courtesy the artist and Stephen
Friedman Gallery, London

Being (opposite)
2009, styrofoam balls and paint, 220 x 56 x 58 cm
Copyright Tom Friedman, courtesy the artist and Stephen
Friedman Gallery, London

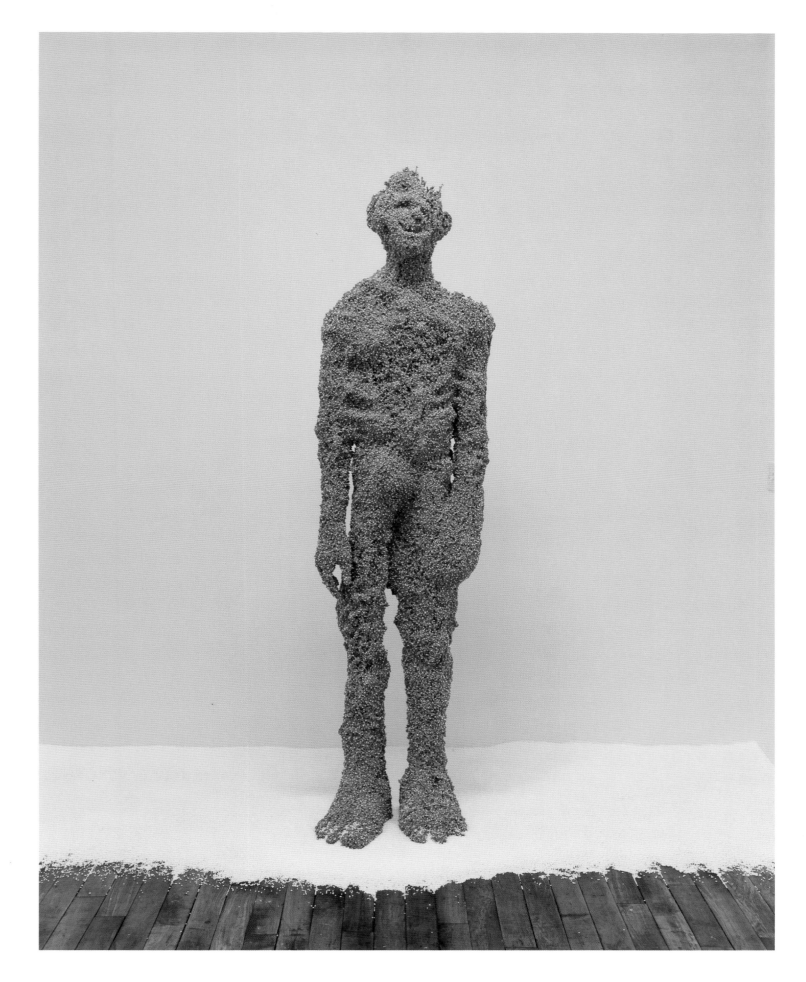

ROBERT GOBER

Untitled (left)
1992, dimensions variable
Installation view, Dia Center for the Arts,
New York, 1992
Copyright Robert Gober,
courtesy Matthew Marks Gallery, New York

Distorted Playpen (right)
1986, painted wood, 66 x 168 x 109 cm
Copyright Robert Gober,
courtesy Matthew Marks Gallery, New York

Untitled (overleaf left)
2009–2010, forged iron and steel, beeswax,
cotton, leather, aluminum pull tabs,
human hair, 53 x 43 x 45 cm
Copyright Robert Gober,
courtesy Matthew Marks Gallery, New York

Melted Rifle (overleaf right)
2006, plaster, paint, cast plastic, beeswax,
walnut and lead, 69 x 58 x 40 cm
Copyright Robert Gober,
courtesy Matthew Marks Gallery, New York

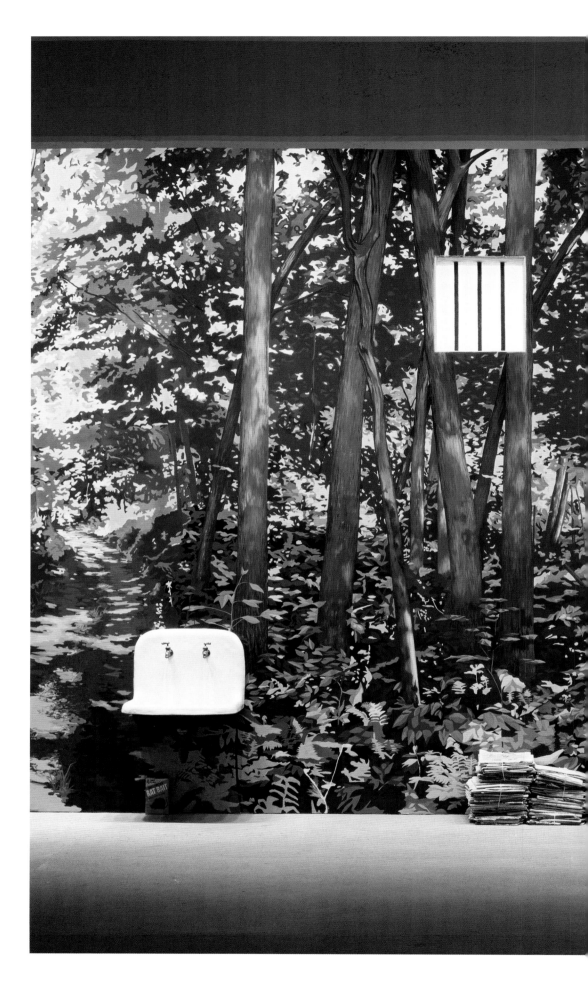

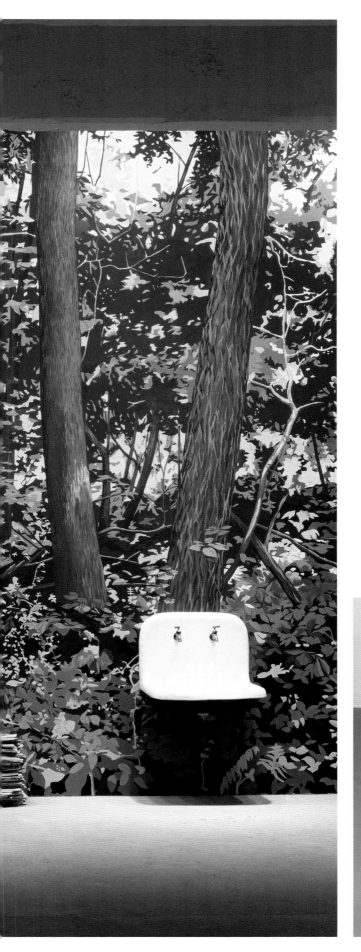

FRED WILSON

Metal Work, 1793–1880 (below)
1992–1993, from Mining the Museum: An Installation
by Fred Wilson, The Contemporary Museum and
Maryland Historical Society, Baltimore
Copyright Fred Wilson, courtesy The Pace Gallery

Speak of Me as I Am: Chandelier Mori (opposite)
2003, murano glass with 20 light bulbs, 178 x 170 x 170 cm
Copyright Fred Wilson, courtesy the artist and The Pace Gallery
photo: Ellen Labenski

Come (below)
2008, collage, mixed media on paper,
three parts: 208 x 144 cm
Courtesy the artist

Felt #16 / Black (opposite)
2008, wool felt, 503 x 160 cm
Courtesy the artist

ARTURO HERRERA

The basis of a lot of Arturo Herrera's work is juxtaposition. He uses familiar imagery—objects imbued with socio-cultural significance—and combines them with abstracted forms, resulting in what could be seen as a tension between the known and the unknown. It has been said that, like a graffiti artist, "he literally inserts his expressive mark into an artistic landscape that already exists", sometimes using cartoon and comic book characters within his oeuvre.

Even though there are recognisable aspects to Herrera's work, the artist prefers not to force a personal interpretation upon the viewer, but rather encourages a level of freedom to ponder the work's significance—leading to what the artist hopes are entirely subjective interpretations.

For instance, the painting *Come*, 2008, at first glance appears as a colourful collage, busily decorative but lacking in formal meaning. Slowly, however, we begin to recognise shapes and forms—perhaps a cartoon-like line drawing. We start to realise that it is often within the gaps, within the omissions of colour and abstract shape that one discovers another level of artistic meaning; if we look beyond the initial premise of the image, whether it is abstract or contains familiar elements, we can add a certain depth to our understanding.

Felt #16/Black features cut up pieces of wool felt hanging from a wall, continuing this idea. The absent fragments within the material recall a past 'whole' in the same way that the recognisable images within

an abstraction such as *Come* recall a preconceived meaning from the past. The artwork becomes a hybrid of the formal and the abstract, past and present, fragment and whole—a hybrid that Herrera admits "recalls, and at the same time, undercuts its origin". We are forced to take into account our recognition of the familiar aspects of the work, or the semblance of a 'whole' that once was.

All of this leaves the viewer with a premise but no definitive answer as to how to interpret Herrera's artistic practice. He has said that he has "a very set structure. But it doesn't have a specific result." At best, what his work provides, then, is a glimpse at potential meaning with its mass cultural snippets and remaining silhouettes, a kind of bridge to subjective understanding.

JIM SHAW

Dream Object (At a LACE meeting with Liz Taylor in some warehouse I realized I could make (as Dream Objects) stuff I'd not dreamt of like the giant ear lounge chair) (below)
2007, foam, upholstery and wood, 74 x 243 x 117 cm
Courtesy the artist and Metro Pictures

Untitled (Self Portrait) (opposite)
2010, oil on plywood, 27 x 23 x 2 cm
Courtesy the artist and Metro Pictures

JIM SHAW
Dream Object (Painting in style of Robert Williams)
2007, acrylic on canvas, 61 x 76 cm
Courtesy the artist and Metro Pictures

JOHN CURRIN
Constance Towers (below)
2009, oil on canvas, 102 x 69 cm
Copyright John Currin, courtesy Gagosian Gallery

Kissers (opposite)
2006, Oil on canvas, 58 x 64 cm
Copyright John Currin, courtesy Gagosian Gallery

The Veil (overleaf left)
1999, oil on canvas, 71 x 56 cm
Copyright John Currin, courtesy Gagosian Gallery

Thanksgiving (overleaf right)
2003, oil on canvas, 173 x 132 cm
Copyright John Currin, courtesy Gagosian Gallery

KERRY JAMES MARSHALL
Untitled (right)
2009, acrylic on paper, 152 x 211 cm
Courtesy the artist

Bride of Frankenstein (overleaf left)
2009, acrylic on pvc, 216 x 155 cm
Courtesy the artist

Frankenstein (overleaf right)
2009, acrylic on pvc, 216 x 155 cm
Courtesy the artist

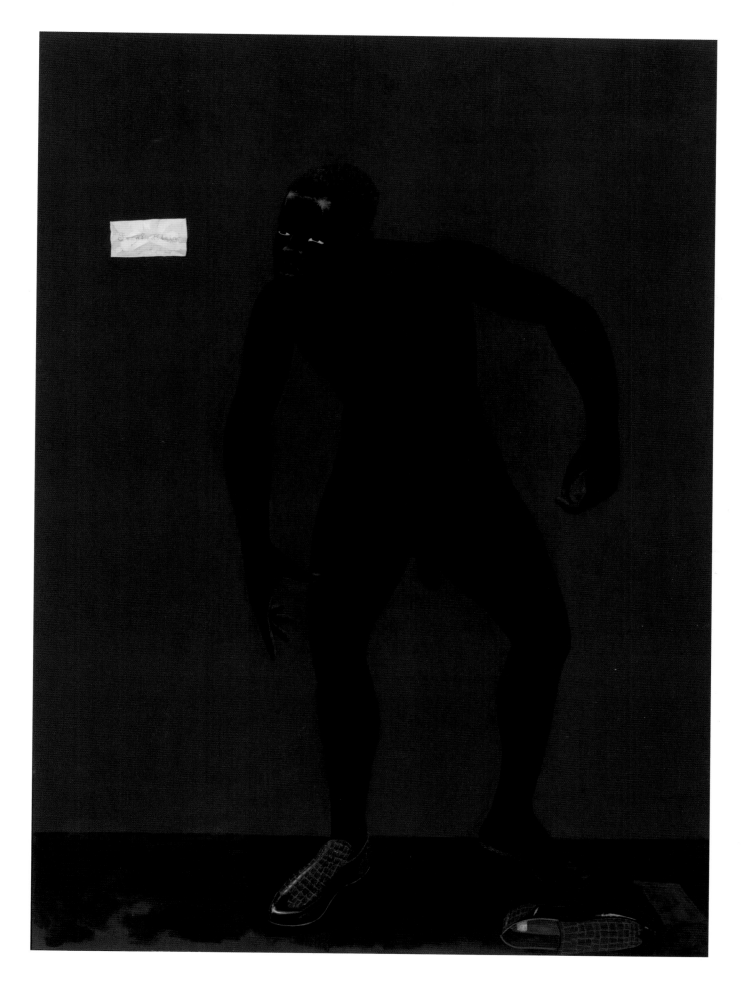

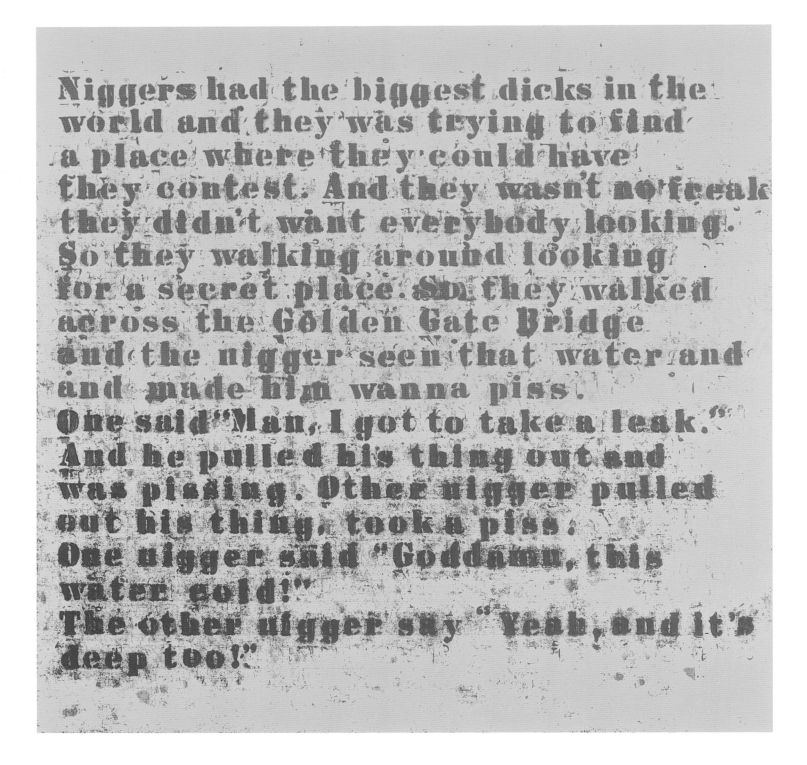

Mudbone (Liar) #3 (opposite)

2004, oilstick and acrylic on canvas, 81 x 81 cm

Copyright Glenn Ligon, courtesy Regen Projects, Los Angeles

Hands (below)

1996, silkscreen on unstretched canvas, 208 x 366 cm

Copyright Glenn Ligon, courtesy Regen Projects, Los Angeles

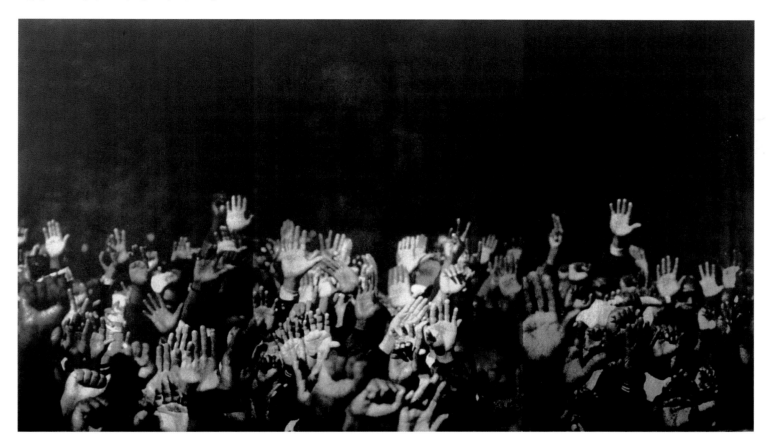

GLENN LIGON

Glenn Ligon's multimedia conceptual practice explores contemporary ideas on issues concerning race and sexual identity—informed by his experiences as an African American homosexual male living in the United States— through a variety of mediums, including photography, painting, neon and print, and in more recent years, film. Text features prominently within Ligon's work, whether subtly in his more abstract paintings, or explicitly in neon, as seen in *Excerpt*, 2009, where strips of neon lighting have been painted black, highlighting ideas on colour and illumination.

Appropriating quotes by individuals such as Zora Neale Hurston, James Baldwin and the stand-up comedian Richard Pryor within his work, Ligon engages with a major heritage of African American writers, reflecting his "deep interest in literature". In the piece *Mudbone (Liar) #3*, 2004, Ligon appropriates one of Richard Pryor's jokes concerned with the sexual stereotype of the black man. However, when presented written down in this brightly coloured oil and acrylic painting, comic effect is removed, as spoken delivery is left redundant. Here, as in other works, Ligon forces the viewer to reflect upon racial stereotypes such as these.

Works such as *Masquerade #3*, 2006, reflect Ligon's invested interest in Abstraction, influenced by artists before him, such as Willem de Kooning and Jackson Pollock. These text-based paintings, created through a repeated process of stencilling, "still function as Abstraction for me (Ligon). If I repeat a sentence down a canvas, the text starts to smudge and disappear. It essentially becomes an Abstract piece. The meaning of the text is still there...."

Ligon's influence as an African American artist was consolidated in 2009 when President Barack Obama added Ligon's *Black Like Me* #2 to the White House collection of art.

GLENN LIGON
Excerpt (below)
2009, neon and black paint, 7 x 141 cm, edition of 5
Copyright Glenn Ligon, courtesy Regen Projects, Los Angeles

Masquerade #3 (opposite)
2006, silkscreen and coal dust on canvas, 198 x 132 cm
Copyright Glenn Ligon, courtesy Regen Projects, Los Angeles

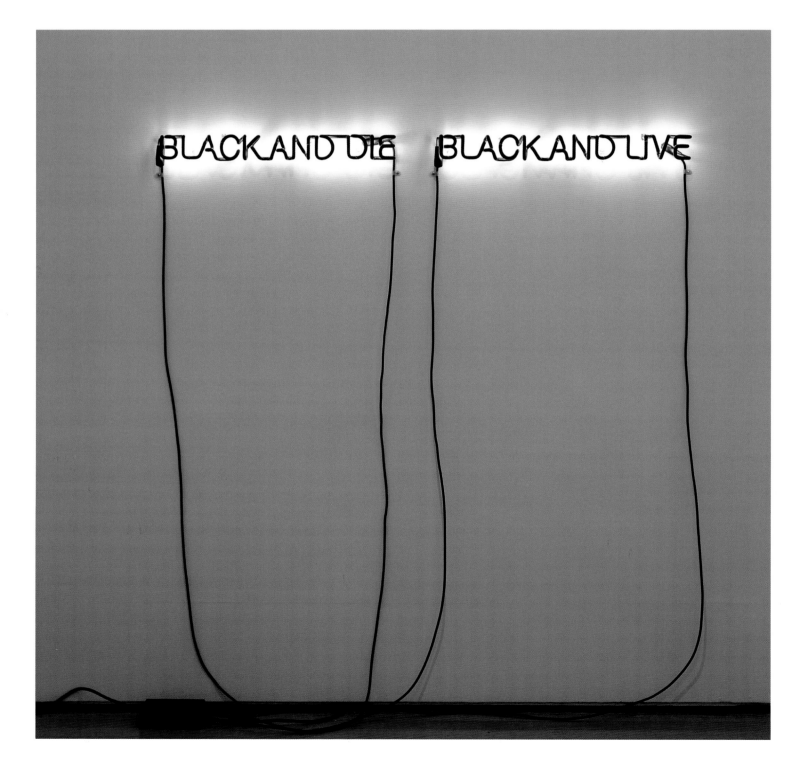

Trouble (opposite)
1990, enamel on aluminium, 274 x 183 cm
Courtesy the artist and Luhring Augustine Gallery

Minor Mishap (overleaf left)
2001, silkscreen ink on linen, 274 x 183 cm
Courtesy the artist and Luhring Augustine Gallery

Untitled (overleaf right)
2000, enamel on aluminium, 274 x 183 cm
Courtesy the artist and Luhring Augustine Gallery

CHRISTOPHER WOOL

Christopher Wool came to fame during the 1980s, largely for his paintings of large stencilled words or phrases on white canvas. Playing with these words, Wool would often omit letters, alternate the order of a phrase or repeat words to emphasise or draw attention to their meaning. An example of this would be *Trouble*, 1990. He would also focus upon phrases within popular culture, such as Muhammad Ali's "float like a butterfly, sting like a bee". The alternate meaning these words would take on from their modified composition was, for the artist, more important than their initial meaning, best represented by his piece *Untitled*, 2000.

Taking inspiration from Abstract Expressionism and Pop Art before him, Wool's work calls to mind elements of Jasper Johns, Willem De Kooning and Jackson Pollock, the latter of who's influence upon the artist is clearly alluded to in his "drip" paintings from 1985–1986. His work with text however, participates in a tradition associated with the work of artists such as Bruce Nauman and Vito Acconci, and more recently Glenn Ligon and Richard Prince; the latter of whose work Wool appropriated, using the 'jokes' "I didn't have a penny to my name so I changed my name" and "I went to see a psychiatrist. He said tell me everything. I did, and now he's doing my act" within his work. Wool's interest in

representation and re-representation is alluded to here, with the words gaining new meaning by being depicted as such.

Alongside his work with text, Wool's oeuvre covers earlier figurative work, alongside abstract paintings that focus the attention upon technique and form. He also continually looks for different methods of representation that open up new possibilities for form, such as the layering of letters. Amongst other methods Wool uses silkscreen, spray cans and paint rollers to achieve different effects within his work, whilst keeping to a fairly rigid use of subject matter, colour, range of motifs and form.

RAYMOND PETTIBON

No Title (Faster Faster Please) (below)
2010, pen, ink, gouache, acrylic and collage on
paper, 79 x 57 cm
Copyright Raymond Pettibon, courtesy Regen Projects, Los Angeles

No Title (One Christmas eve) (opposite)
2010, pen, ink and gouache on paper,
173 x 193 cm
Copyright Raymond Pettibon, courtesy Regen Projects, Los Angeles

No Title (Free Liberace My) (overleaf left)
2010, pen, ink, gouache and collage on paper,
127 x 97 cm
Copyright Raymond Pettibon, courtesy Regen Projects, Los Angeles

No Title (K I Didn't) (overleaf right)
2010, pen, ink, gouache and acrylic on paper,
135 x 92 cm
Copyright Raymond Pettibon, courtesy Regen Projects, Los Angeles

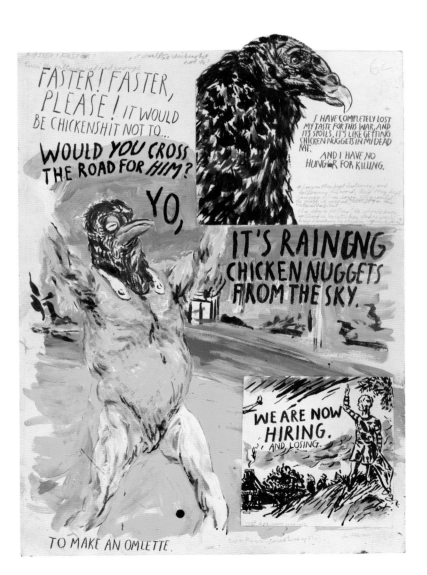

eve, just turned 16, I was getting
when I heard a knock on my bedroom door.
thing was up. I finished buttoning my jeans.

open!"

with the key in the ignition.

worthy, they drop from the sky,
aded and factory sealed.

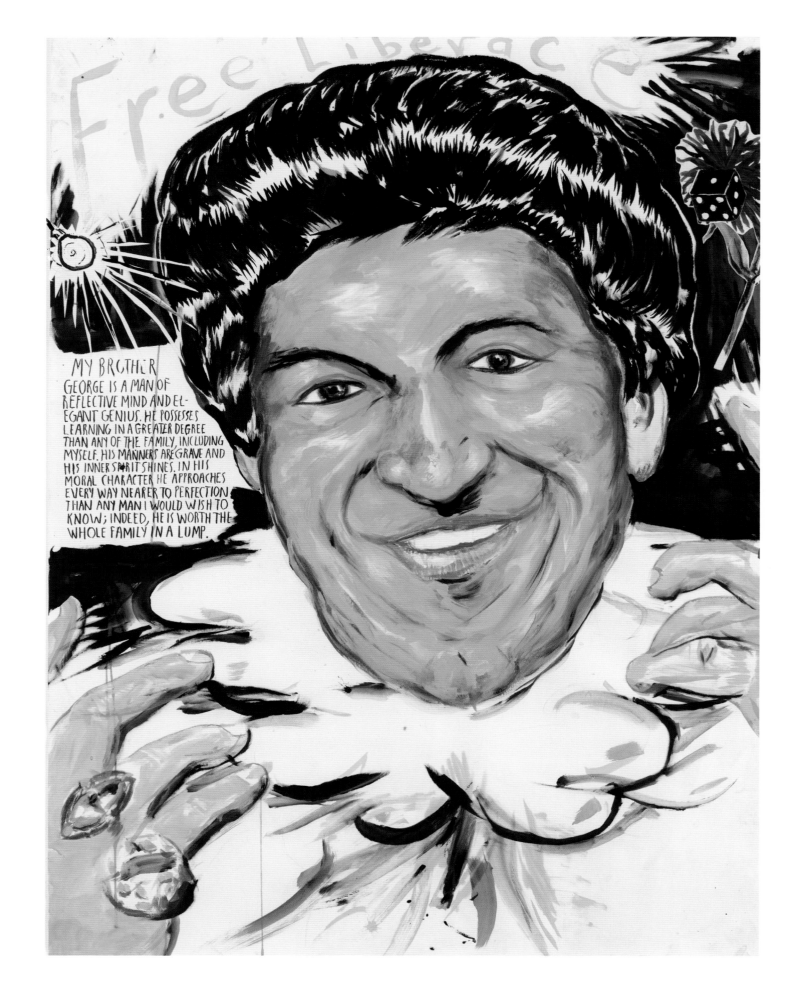

MY BROTHER
GEORGE IS A MAN OF
REFLECTIVE MIND AND EL-
EGANT GENIUS. HE POSSESSES
LEARNING IN A GREATER DEGREE
THAN ANY OF THE FAMILY, INCLUDING
MYSELF. HIS MANNERS ARE GRAVE AND
HIS INNER SPIRIT SHINES. IN HIS
MORAL CHARACTER HE APPROACHES
EVERY WAY NEARER TO PERFECTION
THAN ANY MAN I WOULD WISH TO
KNOW; INDEED, HE IS WORTH THE
WHOLE FAMILY IN A LUMP.

K

I DIDN'T HIT MY PITCH, BECAUSE I DIDN'T GET IT TO HIT, SO I SWUNG AWAY, WITH A LENT BAT, AFTER TAKING TWO I HAD COMING. . . .

I DIDN'T SO MUCH AS SWING AND MISS AS MUCH AS I SWUNG RIGHT THROUGH IT. AT A PITCH IN THE DIRT. HIT THAT? NOT MY TYPE.

SKIP CALLS IT SELF-CONTROL, BUT THEIR PITCHER'S THE ONE WITH CONTROL PROBLEMS.

IT IS NOT IN MY POWER TO WILL A HIT; IF IT WERE, I'D HIT WITH POWER--EVERY TIME.

WHAT IF SOME OBJECT'S AT FAULT? ONCE IT WAS A PIN-OAK TREE IN THE PARK WHICH I HAD CLIMBED ALL THE WAY UP AND COULDN'T CLIMB DOWN. SO I SCREAMED ALOUD AND HIT IT WITH MY HEAD, THE ONLY PART I COULD SPARE, WHILE MY FAMILY SAW MY FULL TANTRUM FROM BELOW AND MADE FUN OF THEIR BOY, SAYING THAT NOBODY COULD BRING ME DOWN BUT ME.

SOMETIMES IT'S THE BALL THAT WAS AT FAULT, OR OFTEN, THE SUN...I'VE EXPERIENCED BOTH.

TOP of 9th INNING:
NO RUNS SCORED
NO ERRORS
ONE WALK
TWO HITS

THREE RUNNERS LEFT ON BASE

O

AND FUCK THE FANS, TOO!

Black Ground (deep light) (right)
2006, ink and acrylic on canvas, 183 x 244 cm
Private collection

Stadia I (opposite)
2004, ink and acrylic on canvas, 274 x 366 cm
Collection San Francisco MoMA

The Seven Acts of Mercy (overleaf)
2004, ink and acrylic on canvas, 285 x 640 cm
Private collection

JULIE MEHRETU

Born in 1970 in Addis Ababa, Julie Mehretu was bought up in Michigan, educated in Senegal and Rhode Island, and now lives and works in New York. Her large-scale works convey themes relating to the social sphere, history, urban architectural forms, semiotics, and time and place. These aspects converge in plain, aesthetically ambiguous spaces, creating complex—almost cathartic—storms of abstracted narrative, socio-cultural and personal detail.

The works *Black Ground (deep light)*, 2006, *Stadia I*, 2004, and *The Seven Acts of Mercy*, 2004, exemplify Mehretu's artistic dedication to

the blurring of the abstract and the figurative. The paintings initially appear impenetrably dense and chaotic—though, Mehretu states, each separate mark represents a single figure in the paintings' abstract world, characters in "story maps of no location"—but with close observation the viewer can pick out clearly recognisable images and symbols: flags, bunting, blueprints, fading roads, smoke, aircraft, perhaps even illegible text, make up these imagined, almost kinetic cityscapes. Mehretu's practical technique of building up layers of acrylic paint and ink before embellishing this with pencil, pen and other paints creates a sense of both of the tangibly real

and of barely realised thoughts, a soft technicality residing behind an inescapable, often disorientating, geometric 'reality'.

The Seven Acts of Mercy—which appropriates the title of a Caravaggio work from 1607—depicts, through its many hundreds of ink marks, miniature explosions of 'cultural-resistance' within standardised cultural orders; according to the curator Heidi Zuckerman Jacobson, Mehretu's piece can be read as "a reaction against the bureaucratic systems of inaction while simultaneously posing questions of cause and effect, fate and destiny, chance and divine intervention".

Performance Under Hypnosis (top)
2007, Tate Modern, London
Courtesy the artist

Untitled (bottom)
1985, gouache on paper
Courtesy the artist

Details from Fictional Reality (opposite)
1973, collage of cut out comics on paper
Courtesy the artist

MATT MULLICAN

For over three decades, New York and now Berlin-based artist Matt Mullican has created a complex body of work concerned with systems of knowledge, meaning, language, and signification. Mullican has always been concerned with the relationship between perception and reality, and the ability to see something and represent it. Mullican's oeuvre, which takes form as drawing, collage, video, sculpture, performance, and installation, confronts the nature of subjective understanding, rationality, and cognition—in essence proposing a 'picture' of the world.

Since the 1970s Mullican has often performed and created work whilst under hypnotherapy. Drawing upon large sheets of paper using black ink, the artist seeks to reveal something of his inner psyche—as seen in *Performance Under Hypnosis*, at the Tate Modern, London, in 2007. Interested in sign systems and semiotics, Mullican's work portrays a definite graphic component that also brings to mind elements of surrealism. Often working in grid formations, Mullican is able to arrange and make sense of the images he creates. *Untitled*, 1985 shows the artist's interest in electronic media, as digitally created images are arranged into colour coded rows. *Details from Fictional Reality*, 1973, on the other hand, denotes a fictive cosmology that arranges usually abstract images with their corresponding names into what appears to be some kind of sign system.

An investigative purpose pervades through Mullican's practice, concerned with the creative self, representation and visceral experience. Considering different forms of information and how it is categorised and represented, Mullican tries to make sense of the ways in which information can be organised and classified so as to structure our perception of the world around us.

SKIN WATER SHADOWS GRAVITY

STARS ICE ASSORTED FOODS A MIRROR

HAIR DIRECTED LIGHT TIME RAIN

SAND SKY GRASS NO LIGHT

The Underground (opposite)

2008, diorama: wood, glazed ceramic sculptures, fiberglass, resin, sand, metal, fabric, 132 x 74 x 211 cm

Courtesy David Zwirner, New York

Untitled (right)

2007, mixed media on paper, 28 x 22 cm

Courtesya David Zwirner, New York

MARCEL DZAMA

The stylised pen and ink drawings of Canadian artist Marcel Dzama capture an innocence evocative of children's fairy tales, with his use of muted colours and ambiguous characters reflecting this tradition. On closer inspection, these delicately rendered works reveal something much more sinister, however. The artist depicts a savage, anachronistic world, filled with extreme scenes of sexual and physical violence that draw upon popular culture for inspiration. In *What Dogs Are These*, 2010, masked and costumed characters are depicted in an ominous scene of violence and hedonism. Dzama is also known for his dioramas, miniature sculptures that evoke a similar eerie charm as his drawings, such as *The Underground*, 2008, in which a

nude woman crouches and urinates into a long plastic tube that leads underground to a man's mouth. With ambiguously sexual overtones, it is unclear whether the man in the hole is being punished or nourished by the act.

Highly informed by his upbringing in Winnipeg, Canada, Dzama's work depicts archetypal Canadian images, such as that of the bear. Also, anthropomorphised and hybrid animals, reminiscent of native Canadian art, for which the artist had an early interest, feature throughout. His use of space has also been credited to his Canadian background, with Dzama himself stating that "The isolation of the place (Canada) really influenced

the background of the drawings and paintings, in that there's this empty vastness that's behind them, like the white snow."

Dzama is one of the founding members of the collective The Royal Art Lodge, created in 1996 along with Michael Dumontier, Neil Farber, Drue Langlois, Jonathan Pylypchuk, and Adrian Williams. Meeting once a week as a way to cope with Winnipeg's extreme temperatures during the winter months (yet working year-round) the group made small-scale collaborative drawings and paintings. Often simple and naïve in style—not too dissimilar from Dzama's own work—their work captures a fantastical world populated with characters from each artist's imagination.

MARCEL DZAMA
Shelley Brings Me Everything and More or The
Extravagant Demonstration (below)
2010, wood, glass, cardboard, paper collage,
watercolour, and ink, 34 x 46 x 15 cm
Courtesy David Zwirner, New York

What Dogs Are These (opposite)
2010, ink, watercoalour, and graphite on paper, 36 x 56 cm
Courtesy David Zwirner, New York

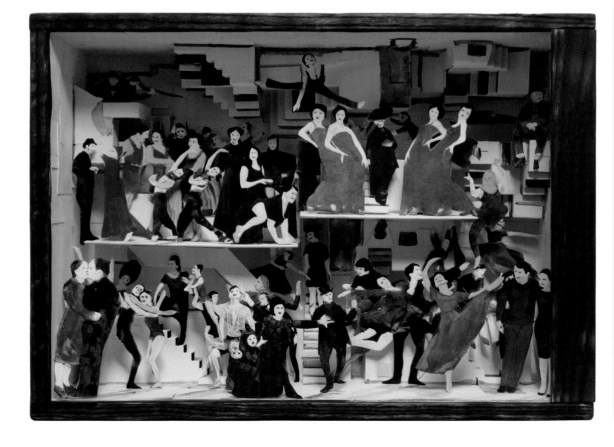

Subtraction (right)
2007, ink on paper inlaid with found printed matter,
233 x 203 cm
Courtesy Galerie Daniel Buchholz, Cologne/Berlin

Push (opposite)
2006, latex, printed matter, linen tape, stickers on
panel, 203 x 226 cm
Courtesy of the Whitney Museum of American Art, New York

If conceited girls want to show they have a seat...
(standing) (overleaf left)
2008, vinyl, paint, rice paper and fabric on canvas,
186 x 97 cm
Courtesy the collection of Thea Westreich and Ethan Wagner,
New York

I must explain, specify, rationalize, classify, etc.
(overleaf right)
2007, vinyl paint and inlaid laser print on paper,
201 x 152 cm
Courtesy of greengrassi, London; Collection of Thea Westreich
and Ethan Wagner, New York

FRANCES STARK

Lauded as one of Los Angeles' most interesting exports of the last two decades, the Californian artist Frances Stark engages with themes of literature, self-conception and the practise of making art to deliver poignant insights into conditions both creative and human, laced with insouciance, ennui and wry humour. Stark's multimedia practice utilises painting, writing, drawing, collage, video and PowerPoint presentations. She creates skewed self-portraits, encompassing domestic, intellectual and professional details and emphasising the banalities of modern life whilst foregrounding the practical trials of being an artist; specifically, the journey of a piece of 'work' from the artist's mind to the public sphere. Stark's work takes inspiration from myriad sources, including classic literature and contemporary popular music. The literary elements of her work are often influenced by and presented through the words of others, acting as both a commentary on the convergence of the written word and art, and a knowing interior monologue.

Stark's intertextual approach is apparent in the piece *I must explain, specify, rationalize, classify, etc.*, 2007, within which she appropriates text from Polish novelist Witold Gombrowicz's *Ferdydurke* from 1937. The painting sees a figure standing on an office chair and straightening a partly obscured text that states the artist's need to make clear the underlying themes of her work through the eponymous actions. The unstable act of standing on a chair on casters reveals a self-conscious pessimism towards Stark's ability to do this; but the figure's use of a spirit level shows a dedication to expression perhaps unappreciated by the casual viewer.

If conceited girls want to show they have a seat...(standing), 2008, is directly inspired by Goya's late eighteenth century etching *They've already got a seat*, from his *Caprichos* series of drawings. Stark directly utilises the Spaniard's vague accompanying text to create an image which juxtaposes Goya's monologue, expounding of the artist's inner anxieties.

Another preface.... without a preface I cannot possibly go on. I must explain, specify, rationalize, classify, bring out the root idea underlying all other ideas in the book, demonstrate and make plain the essential griefs and hierarchy of ideas which are here isolated and exposed... thus enabling the reader to find the work's head, legs nose, fingers and to prevent him from coming and telling me that I don't know what I'm driving and that instead of marching forward straight erect like the great writers of all ages, I ly revolving ridiculously on my own then shall the fundamental overall ang here art thou great-grandmother of all The deeper I dig, the more I explore and e, the more clearly do I see that in re rimary, the fundamental grief is pure mply, in my opinion, the agony of bad form, defective appearance, th phraseology, grimaces, faces... yes, this igin, the source, the fount from whi flow harmoniously all the other ts, follies, and afflictions without any exce whatever. Or perhaps it would be as well asize that the primary and fundamenta g s that born of the constraint of man by from the fact that we suffocate and s e narrow and rigid idea of ourselves rs have of us.

Monster (Murmur) (below)
2003–2004, 16mm film stills
Copyright Ellen Gallagher and Edgar Cleijne
courtesy the artist and Hauser and Wirth

Wiglette (Deluxe) (opposite)
**2004/2005, photogravure, engraving, aquatint,
spit-bite, silkscreen, offset lithography and
collage, 33 x 27 cm**
Copyright Ellen Gallagher, courtesy the artist
and Hauser and Wirth
photo: Stefan Altenburger Photography, Zürich

ELLEN GALLAGHER

From the outset of her career, Gallagher has brought together non-representational formal concerns—seriality, process and charged figuration in paintings, drawings, collages, and films that reveal themselves slowly, first as intricate abstractions, then later as unnerving stories. The tension sustained between Minimalist Abstraction and image-based narratives deriving from her use of found materials gives rise to a dynamic that posits the historical constructions of the "New Negro"—a central development of the Harlem Renaissance—with concurrent developments in Modernist abstraction. In doing so, she points to the artificiality of the perceived schism between figuration and abstraction in art.

Selecting from a wealth of popular ephemera—lined penmanship paper, magazine pages, journals, and advertising —as support for her paintings and drawings, Gallagher subjects the original elements and motifs to intense and laborious processes of transformation including accumulation, erasure, interruption and interference. Like forensic evidence, only traces of their original state remain, veiled by inky saturation, smudges, staining, perforations, punctures, spills, abrasions, printed lettering and marking; all potent evocations and emanations of time and its materiality. This attained state of

"unknowing" fascinates Gallagher and is one of the primary themes in her work.

Her new work, which she has described as "charts or maps of a world not yet visible", requires an exploratory approach, as if navigating unfamiliar territory or ruins. It is a liminal realm that oscillates between legibility and blankness and which appears at different velocities, both sudden and perpetual. Corporeal features emerge out of overlapping, abstract fields; protagonists recur in various guises; incompatible narratives meet in fragmentation, cutting, and collage; fact and fiction merge in graphic eddies; as meaning is generated by the elasticity between myriad associations.

ELLEN GALLAGHER

Bird in Hand (below)

**2006, oil, ink, cut paper, polymer medium,
salt and gold leaf on canvas, 238 x 307 cm**

Copyright Ellen Gallagher, courtesy the artist
and Hauser and Wirth, Tate Collection
photo: Mike Bruce

Untitled (opposite)

2006, oil, ink and paper on linen, 61 x 61 cm

Copyright Ellen Gallagher, courtesy the artist
and Hauser and Wirth, Private Collection
photo: Mike Bruce

69

WADE GUYTON
Untitled (below)
2010, Epson DURABrite inkjet on book page, 21 x 29 cm
Courtesy the artist

Untitled (57 69) (opposite)
2008, Epson DURABrite inkjet on book page, 21 x 15 cm
Courtesy the artist

Surf Safari Nurse (right)
2007–2008, ink jet and acrylic on canvas, 229 x 137 cm
Courtesy the artist

Untitled (opposite)
2003, Ektacolor photograph, 199 x 155 cm
Courtesy the artist

I Never Had a Penny to My Name (overleaf)
2009, collage and acrylic on canvas, 129 x 230 cm
Courtesy the artist

RICHARD PRINCE

Coming to prominence in the 1980s, American artist Richard Prince buys into the idea of an 'American myth' within his work, that spans the mediums of photography, painting and sculpture and features numerous references to popular culture, and, more specifically, consumerism.

His highly celebrated career is perhaps best represented by the archetypal American image of a cowboy galloping across an open plain in *Untitled (Cowboy)*, 1989. Through a process of 're-photographing', the image, taken from a Marlboro Lights advertisement, was doctored so that both the cigarette pack and any copy was removed; it was then enlarged. The final result portrayed something far

different than the original image found in a magazine to promote sales of cigarettes. Prince ultimately highlights the beauty of the image, something that was overlooked in its initial incarnation, opening discussion upon how an image is received depending on its context and questioning the idea of a cultural myth—in this instance the idea of the cowboy being seen as the epitome of American masculinity. An ongoing series of *Cowboy* works have followed the original, each using the same technique of re-photography.

Prince's series of nurse paintings take their inspiration from pulp fiction romance novels sold at newspaper stands. Using a digitalised method of re-photography, Prince used a scanner and inkjet printer to

transfer the images from the covers of these books to canvas; using acrylic paint Prince then personalised each, as seen in *Surf Safari Nurse*, 2007–2008.

Prince's sense of humour is apparent throughout his practice and is something, which is reinforced by his adoption of popular culture themes. *I Never Had a Penny to My Name*, 2009, is an example of a work from one of Prince's "joke" series that combines both image and text—a style made popular during the 1980s by artists including Barbara Kruger. The jokes, usually satirical one-liners, were often combined with images that had no relation to the words, a technique that could be considered as Prince's way of pushing the joke even further.

Pillow Talk Bed (opposite)
2002, mattress, white sheets, pillows, varying silkscreened cases, wood pedestal, 71 x 173 x 226 cm
Courtesy Sadie Coles HQ, London

Lindsay (right)
2006, inkjet photo mural, 274 x 184 cm
Courtesy Sadie Coles HQ, London

JONATHAN HOROWITZ

Jonathan Horowitz's practice critically examines contemporary culture, with ideas on politics, celebrity, war and consumerism taking centre stage. Intuitively, these ideas have found form in various different media from video to sculpture; yet at the root of his practice, and perhaps the reason why his art is so successful, is his ability to find connections between completely unrelated, arbitrary elements, in turn making insightful comments on Western society today.

At face value, Horowitz's work is imbued with a raw wit that resonates with the spectator; nowhere more so than in *Lindsay*, 2006, showing two comparative photographs of Lindsay Lohan, emblazoned with her name. Horowitz's humour appears to mask a much deeper

message here, as with his other works; a message concerned with celebrity culture and our consumption of it through the media. Images such as those in *Lindsay*, commonplace in tabloid newspapers and magazines, are, once taken out of context and placed within the setting of the art gallery, given somewhat different meanings that force us to reflect on their impact.

Horowitz also looks to video and sound footage spanning the past few decades to help articulate particular arguments, often incorporating several different eras of material. Central to Horowitz's practice is his use of popular culture, celebrated by critics and writers, who often discuss his work in relation to a Warholian tradition; in so much as he finds influence in the 1970s, 1980s and

1990s, as Warhol did from the decades before him. The zeitgeist issues discussed through Horowitz's work are mirrored within the popularised images he chooses. The politics of sexuality are addressed in *Pillow Talk Bed*, 2002, a white bed with two pillows, each embroidered with different names, which are then periodically changed by the gallery staff to reveal the names of alternate couples. From "Portia" and "Ellen", to "Gertrude" and "Alice", this piece is subtly referring to sexual politics in America; and the point is underscored in this installation view, which shows the American flag hung above the bed, depicted, hazily, in the colours of the gay flag. It is this subtlety in conviction where Horowitz succeeds in working with these topics, allowing him to convey an objective yet informed opinion.

Hothouse, or Harem (top)
1966–1972, photomontage, 51 x 123 cm
Courtesy the artist

Nature Girls (Jumping Janes) (bottom)
1966–1972, photomontage, 69 x 102 cm
Courtesy the artist

MARTHA ROSLER

One of the most influential artists of her generation—renowned as much for her art, as for her work as a cultural critic and writer—Martha Rosler has made politically and socially engaged work since the late 1960s. Her multi-dimensional practice—working in video, collage, sculpture, installation and performance—defies straight forward categorisation as it blurs the boundaries between the here and there, private and public, art and everyday life.

Rosler's work is perhaps best characterised by its political commitment to investigating power, domination and culture under capitalism. Her subject matters have varied from gendered social roles, housing and homelessness, and the highly problematic

relationship between the media and war. One of Rosler's most iconic works is her first engagement with war imagery: a collage series created at the height of the Vietnam War entitled *Bringing the War Home: House Beautiful*. In these collages, press images depicting the atrocities of the Vietnam War, originally published in *Life* magazine, became re-assembled with domestic spaces cut out from *House Beautiful* magazine. The striking juxtaposition of disturbing war imagery with the comfort and safety of an idyllic Western domestic interior compels the viewer to think about connections between 'our' comforts and 'their' pain and misery. Taking an activist approach typical to her work, Rosler chose to disseminate the collages in underground

publications and at anti-war protests instead of the confined institutional gallery spaces.

Out of a renewed urgency to protest brought by the recent military engagements in Iraq and Afghanistan, Rosler revived her original anti-war project in 2004 to create another thought-provoking and politically striking response to war. Like the original series, the new collages were assembled from advertising images of suburban American living rooms and combat scenes from overseas. In these collages the troops have again invaded the idyllic American home to uncover the material connection between going to war and Western consumer lifestyles often ignored by war reportage in the mass media.

MARTHA ROSLER
Cleaning the Drapes (below)
1967–1972, photomontage, 51 x 61 cm
Courtesy the artist

Point and Shoot (opposite)
2008, photomontage, 76 x 102 cm
Courtesy the artist

Untitled (right)

2009, cut paper and collage on paper, 98 x 79 cm

Courtesy of Sikkema Jenkins & Co

Mistress Demanded a Swift and Dramatic Empathetic Reaction, Which We Obliged Her (opposite)

1999, cut paper and projection on wall, 366 x 518 cm

Courtesy of Sikkema Jenkins & Co

KARA WALKER

A narrative driven by history, race, gender and sexuality pervades within Kara Walker's work, acted out by a cast of delicately crafted paper figurines that recall the Victorian art of silhouette. Scenes depicting life in the antebellum south are played out using theatrical devices such as the Cyclorama—a concave wall or curtain found at the back of a stage to create the illusion of depth—onto which Walker successfully merges various styles, influences, time periods and subject matter.

She engages with African American history through both form and content, juxtaposing an outwardly decorative appearance with an often-shocking subject matter—as in *Gone, An Historical Romance of a Civil War as it Occurred between the Dusky Thighs of One Young Negress and Her Heart*, 1994—that in turn questions issues of race and gender central to Walker's practice: "The silhouette says a lot with very little information, but that's also what the stereotype does. So I saw the silhouette and the stereotype as linked." These silhouetted scenes, for which she has become so well known, conjure up ideas of blackface minstrelsy, their caricatured forms clearly alluding to a preconceived racial stereotype that was once, to some extent, ingrained into the American psyche.

More recently, Walker has begun to work with coloured projections, in a bid to "engage the space a little bit more directly than the pieces that are just cut paper on the wall". Viewing the projectors as a kind of "shadow tool" Walker purposefully involves the spectator within these works, their shadow appearing alongside a now projected cast of characters, their looming forms not too dissimilar to those of the earlier silhouettes, as Walker plays once more with the illusion of depth.

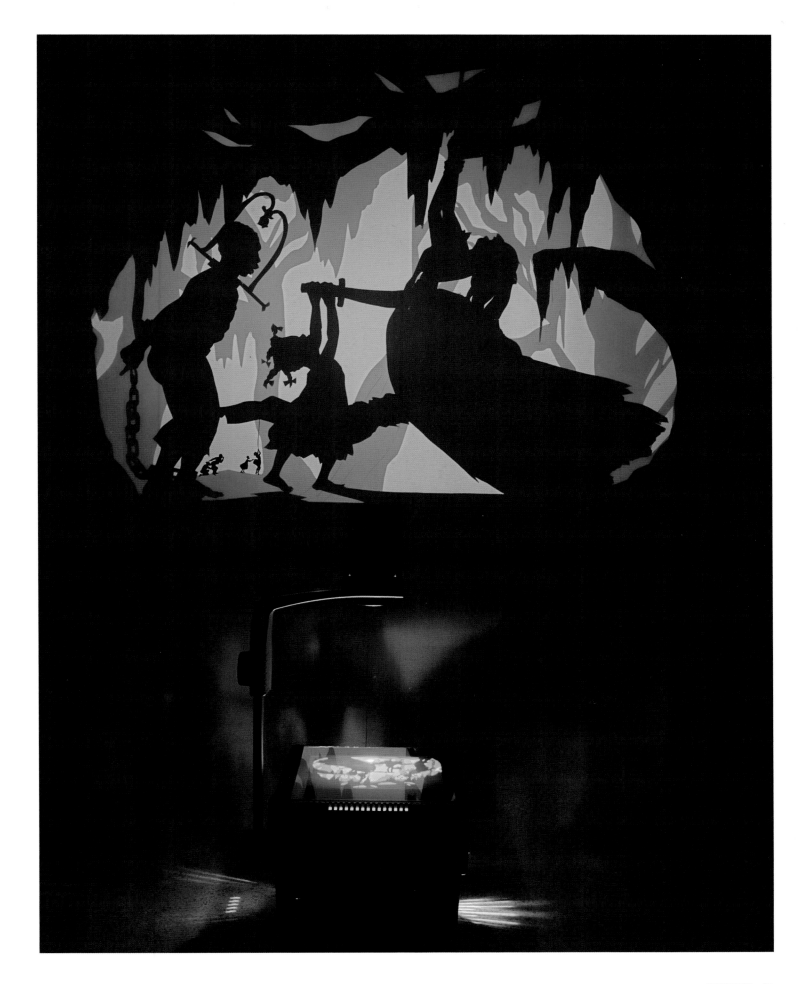

KARA WALKER
Darkytown Rebellion
2001, cut paper and projection on wall,
457 x 1006 cm. Installation view: *Kara Walker: My
Complement, My Enemy, My Oppressor, My Love*
Walker Art Center, Minneapolis, 2007
Courtesy of Sikkema Jenkins & Co
photo: Dave Sweeny

CHRISTIAN MARCLAY

Foot Stompin (from the series Body Mix) (below)
1991, record covers and cotton thread, 44 x 91 cm
Copyright Christian Marclay, courtesy Paula Cooper Gallery, New York

Footsteps (opposite)
1989, single-sided, 12 inch vinyl records,
dimensions variable
Copyright Christian Marclay, courtesy Paula Cooper Gallery, New York

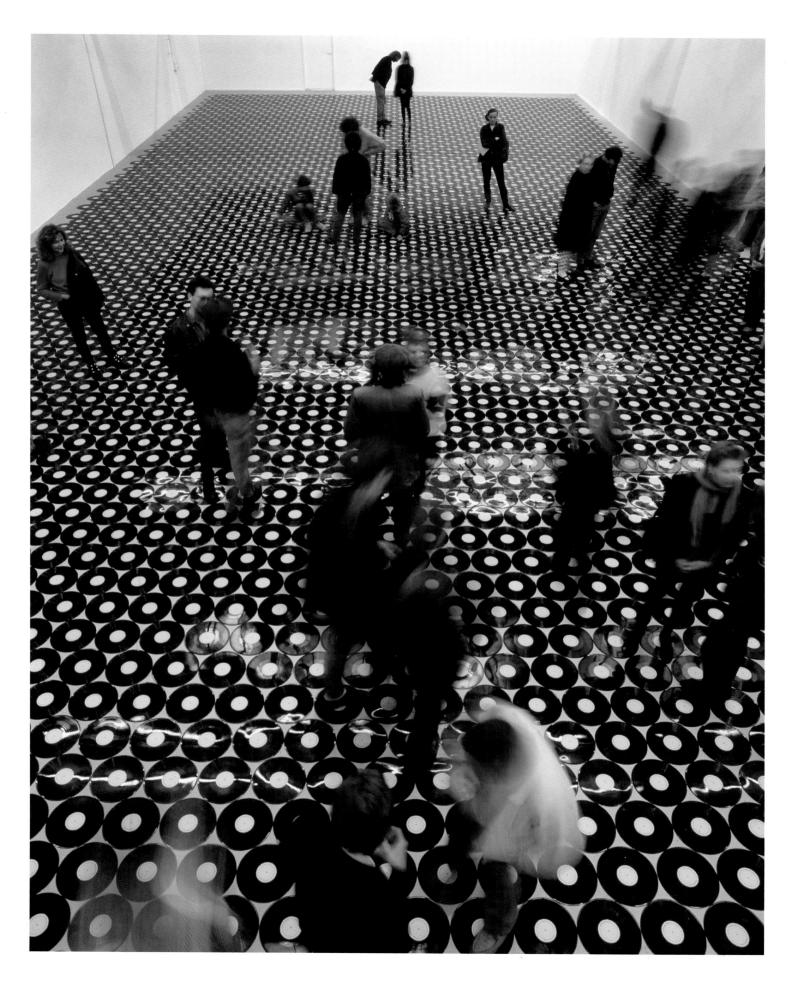

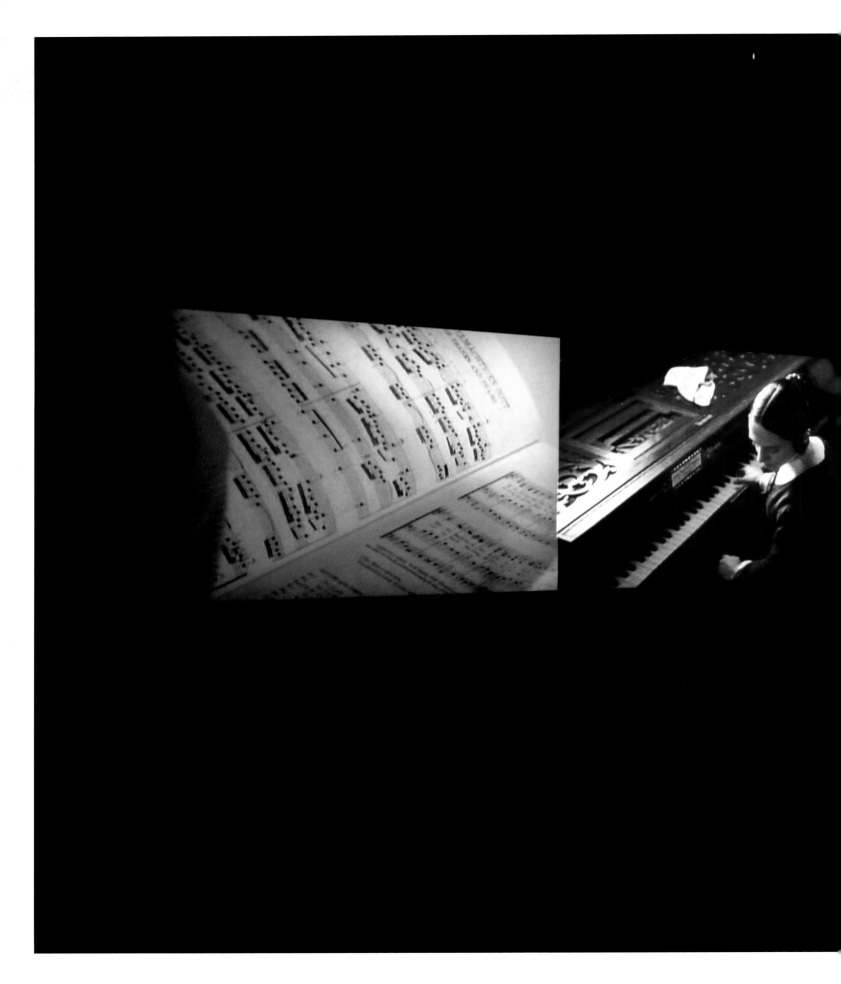

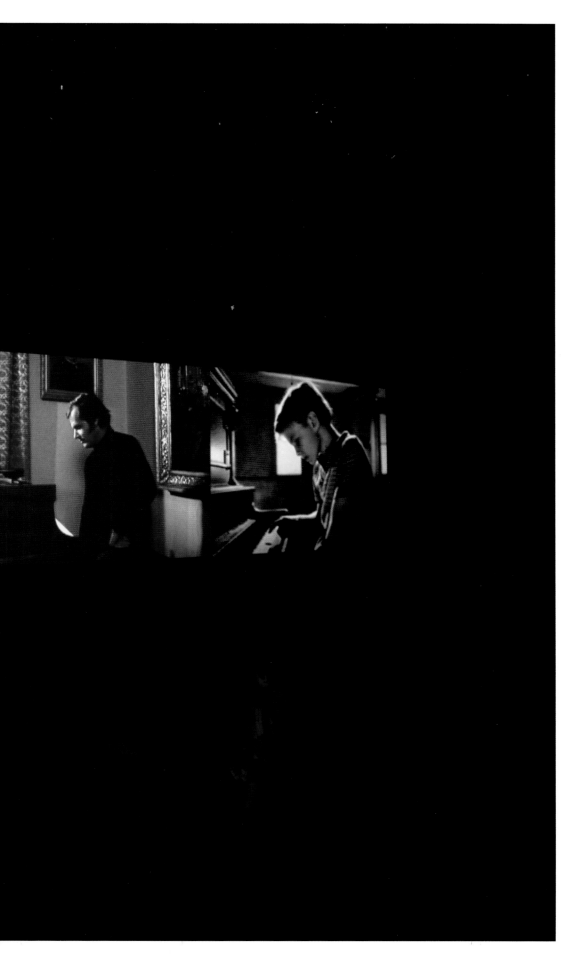

Liquid (right)
2008, video projection
Courtesy the artist and Lisson Gallery

C-word (opposite)
2008, video projection, sound, resin, mirror, wallpaper
Courtesy the artist and Lisson Gallery

TONY OURSLER

Tony Oursler is a distinguished multimedia artist and a pioneer in his field. His career, spanning over three decades, has included exhibitions at MoMA, the Whitney Museum of American Art and the Centre Georges Pompidou. Working mainly in video, sculpture, performance and painting, Oursler innovatively combines these mediums into highly immersive installations; his works often occupy entire rooms absorbing the viewer inside the psychological landscapes they create. A consistent central theme in Oursler's work is the relationship between the individual and mass media systems, investigated with humour and imagination. Oursler's discovery of liquid crystal display projectors

enabled him to project televisual images on different spaces and materials, thus creating his own distinctive sculptural aesthetic. Through this combination of moving image, sculptural objects and spoken text, Oursler's installations become effective, uncanny psychological spaces, which often seem to interact directly with the viewer.

C-word, 2008, follows the artist's signature style of fusing sculptural forms with video. Simple in form, the arrangement of different elements in the installation invests it with a new aesthetic meaning. As in much of Oursler's work, the human body is a prominent feature in this installation. In the literal sense, it is employed through the projection and sculptural elements.

On another level, *C-word* functions as an encounter between the body of the viewer, with the work itself. *Liquid*, 2008 —a pictorial film work depicting a woman drinking from a constant flow of what appears to be red wine, however, with the flow of the liquid reversed—is a departure from Oursler's usual techniques of fusing sculpture and video. As with some of the more recent work by Oursler, *Liquid* probes into a realm where real and fantastic, rational and irrational, desires and needs become entangled. Oursler's works can be as disturbing, and as complex, as they are immensely fascinating embodiments of psychological tensions, in particular humans' evolving, interdependent relationship with technology.

TONY OURSLER
AWGTHTGTWTA (Are We Going to Have to Go Through with This Again?)
2008, projection onto translucent screen
Courtesy the artist and Lisson Gallery

RODNEY GRAHAM

Rodney Graham's work has had a huge influence upon his peers, and younger generations of artists practising today. Emerging from the highly conceptual Canadian school of Vancouver artists of the 1970s, Graham's work has consistently succeeded in pushing the boundaries of film, photography, video, sculpture and painting within his practice. His work is also frequently discussed in relation to the generation of Photoconceptualists who emerged from Vancouver at the time, including Jeff Wall.

Drawing from a range of influences, Graham's work seeks to explore ideas as varied as perception, time, human limitations and frustrated desires. The range of sources from which he draws influence include literature, poetry, film, philosophy, and art history. Graham explicitly divulges his interest in the latter within a number of works that recreate art historical scenes; such as *Allegory of Folly: Study for an Equestrian Monument in the Form of a Wind Vane*, 2005, in which Graham appears dressed in costume as the philosopher Erasmus, as painted by Hans Holbein the Younger. He is, however, sat backwards upon the horse, reading a copy of the Vancouver phonebook—a nod towards the artists' deadpan sense of humour. Graham's interest in appearing within his own works developed during the 1990s, as he pursued a study of circular time through looped film footage. One of his best-known pieces, *Vexation Island*, is a film that he created for the Canadian pavilion at the Venice Biennale in 1997, which gained him instant notoriety. Here, Graham, in scenes reminiscent of Daniel Defoe's *Robinson Crusoe*, appears as a shipwrecked pirate, who, whilst shaking a palm tree, gets knocked out by a falling coconut, only to reawaken and do the same again. The looped film depicts this cycle, with Graham's preoccupation with time and repetition being focused upon, both in terms of form and content, particularly in relation to the psychological wellbeing of the pirate.

In *The Gifted Amateur, Nov.10th, 1962*, 2007, a three-part lightbox reveals Graham as a fictional character who has just discovered art, creating a large painting in the style of Abstract Expressionism. Set in a West Coast Modernist living room, the photograph depicts several art-historical and cultural references, with Graham surrounded by stacks of artist monographs, pots of paint and scattered newspapers.

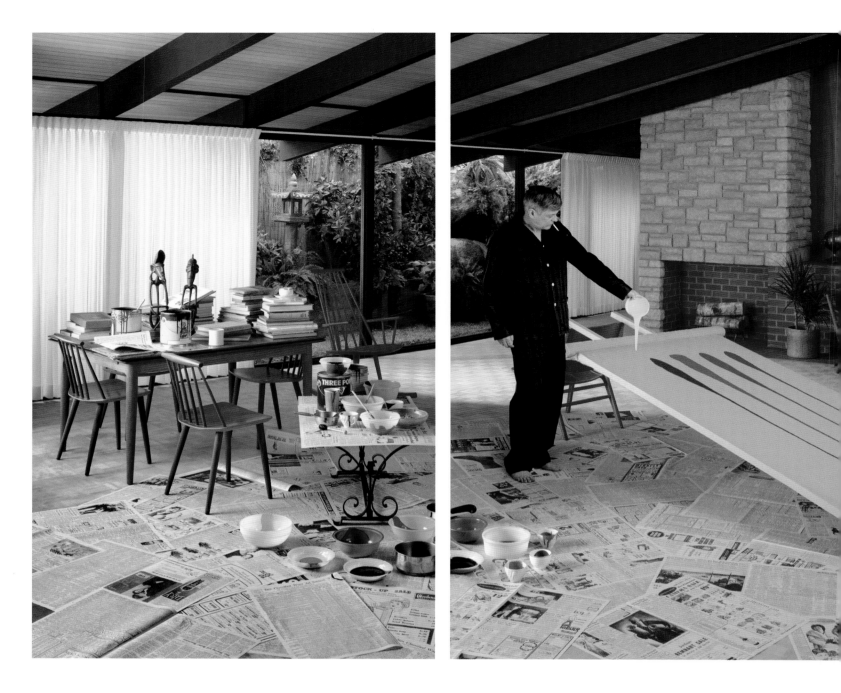

RODNEY GRAHAM
The Gifted Amateur, Nov. 10th, 1962
2007, transmounted chromogenic transparencies in
three painted aluminium light boxes
Courtesy the artist and Lisson Gallery

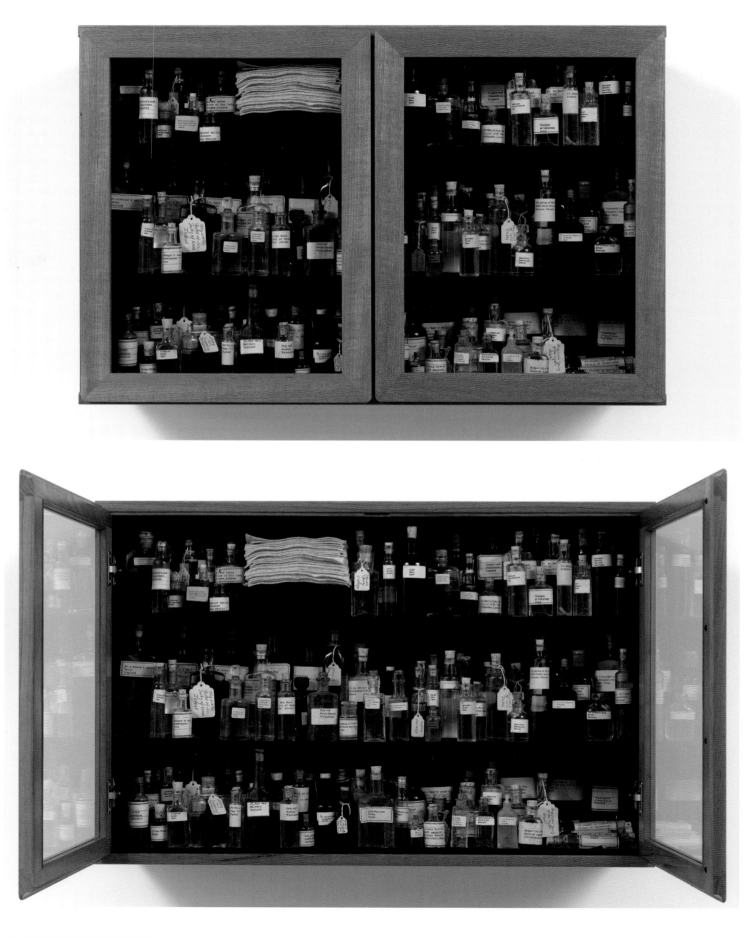

SUSAN HILLER

The Tao of Water: Homage to Joseph Beuys

(opposite top and bottom)

1969–2010, mixed media: felt lined cabinet, felt
squares, bottles of holy water, 56 x 84 x 29 cm

Copyright Susan Hiller, courtesy Timothy Taylor Gallery, London

An Entertainment (below)

1990, four channel video installation with sound, 25:59,
each projected image 260 x 480 cm

Copyright Susan Hiller, courtesy Timothy Taylor Gallery, London

Homage to Marcel Duchamp: Aura (Blue Boy)

(overleaf left)

2011, digital C-type archival colour print on dibond,
127 x 188 cm, ed 1/2+1 ap

Copyright Susan Hiller, courtesy Timothy Taylor Gallery, London

Homage to Yves Klein: Levitation (Child) (overleaf right)

2011, archival C-type black and white print on dibond,
234 x 169 cm, ed 1/2+1 ap

Copyright Susan Hiller, courtesy Timothy Taylor Gallery, London

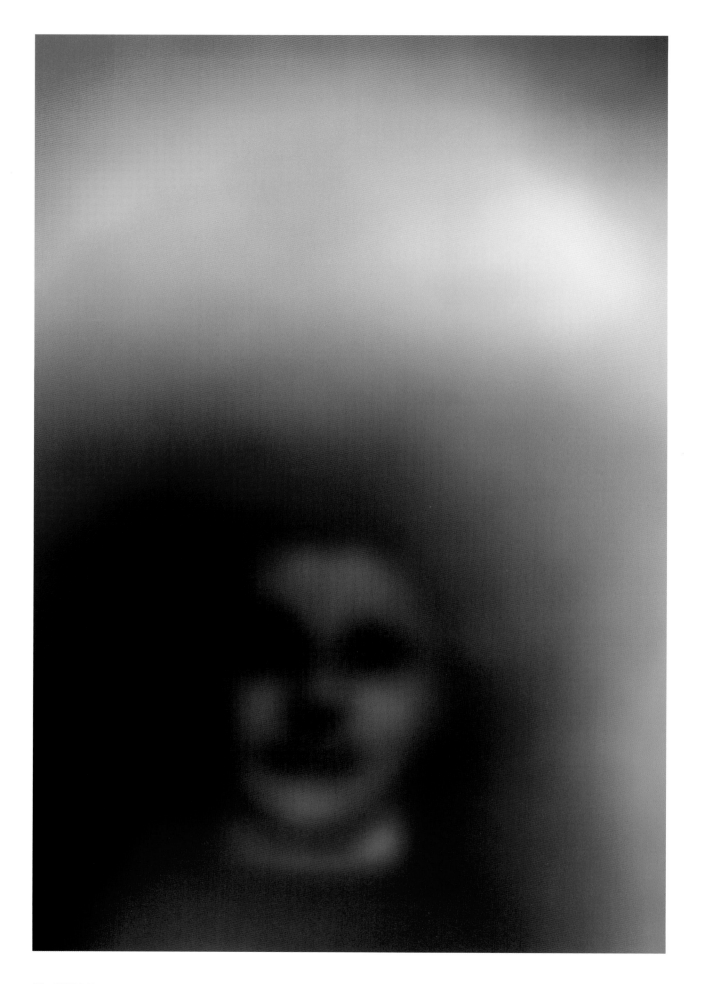

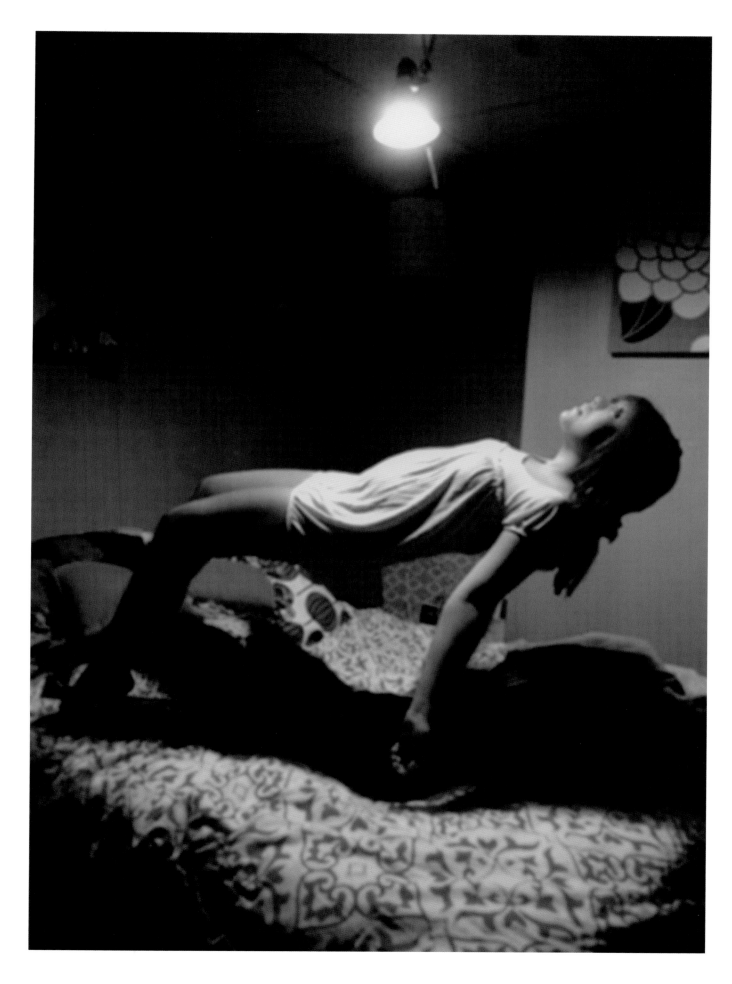

Four Horsemen of the Apocalypse (26) (right)
2006, Fugiflex digital C-print, 122 x 174 cm
Copyright Paul Pfeiffer, courtesy Paula Cooper Gallery, New York,
Thomas Dane Gallery, London, and Carlier | Gebauer, Berlin

Vitruvian Figure (exterior) (opposite top)
2009, birch plywood, one-way mirrored glass, polished
stainless steel, 586 x 472 x 240 cm
Copyright Paul Pfeiffer, courtesy Paula Cooper Gallery, New York,
Thomas Dane Gallery, London, and Carlier | Gebauer, Berlin

Vitruvian Figure (interior) (opposite bottom)
2009, birch plywood, one-way mirrored glass, polished
stainless steel, 586 x 472 x 240 cm
Copyright Paul Pfeiffer, courtesy Paula Cooper Gallery, New York,
Thomas Dane Gallery, London, and Carlier | Gebauer, Berlin

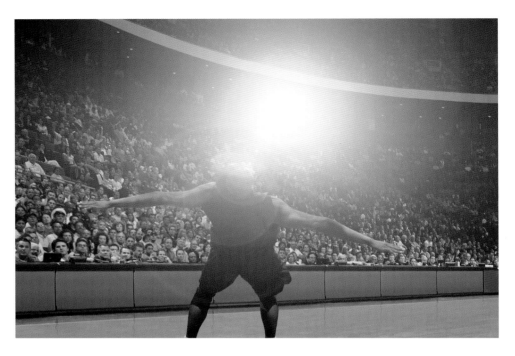

PAUL PFEIFFER

Born in Honolulu, Hawaii, Paul Pfeiffer spent his childhood in the Philippines, eventually relocating to New York City in 1990. Specialising in video and photography, Pfeiffer's work explores ideas of image-making within the entertainment industry, using found footage from film and television. Often focusing upon sporting events, Pfeiffer poses the 'stars' of the footage as saint-like figures, questioning the idea of celebrity within contemporary society.

In the ongoing series *Four Horsemen of the Apocalypse*, Pfeiffer manipulates photographs so that they appear differently to the original. Initially using publicity stills of Marilyn Monroe, Pfeiffer digitally removed Monroe from the images, replacing where she stood with duplicated images of the background, changing the focus of the photograph entirely. Following the images of Monroe, Pfeiffer continued the series using images taken from the online archive of the National Basketball Association (NBA) dating back to 1950. Within these images, the artist has chosen to remove much of the contextual detail, be it basketball players or the basketball itself, leaving a lone figure; however as stated by Pfeiffer "what remains is not an absent figure but an intensified figure by virtue of the fact that you are lacking some aspects of a context to place it in."

Pfeiffer's work in sculpture capitalises upon the same subject matter, concerned with the effects of mass media. In *Vitruvian Figure*, 2009, Pfeiffer's focus shifts from his previous works, onto that of the space, rather than the individual. Meticulously crafted from wood, glass and polished steel, the sculpture is positioned at an angle so that viewers gaze down over the stadium from a viewing platform above. His work with sculpture also extends to recreations of film props and miniature dioramas.

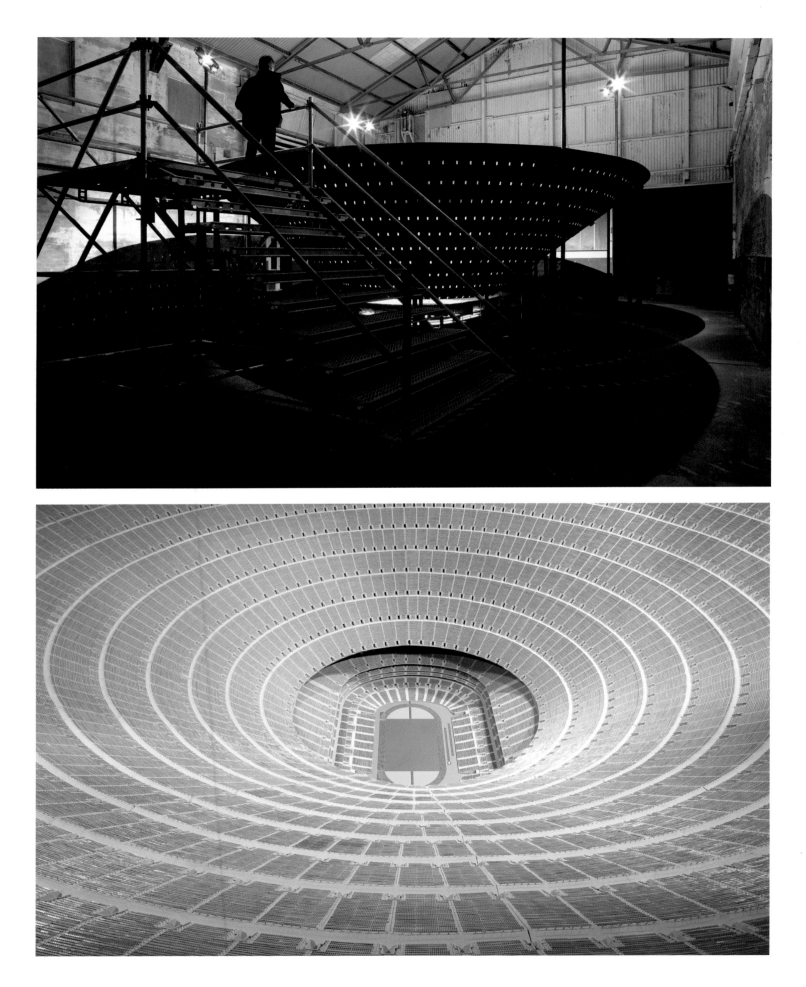

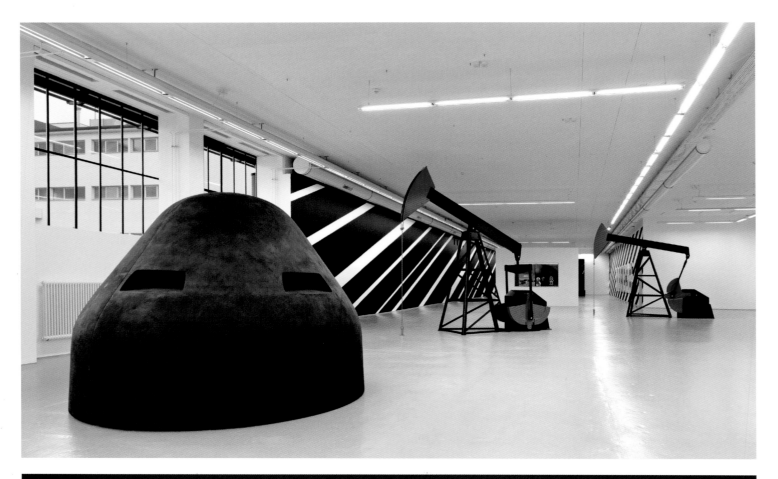

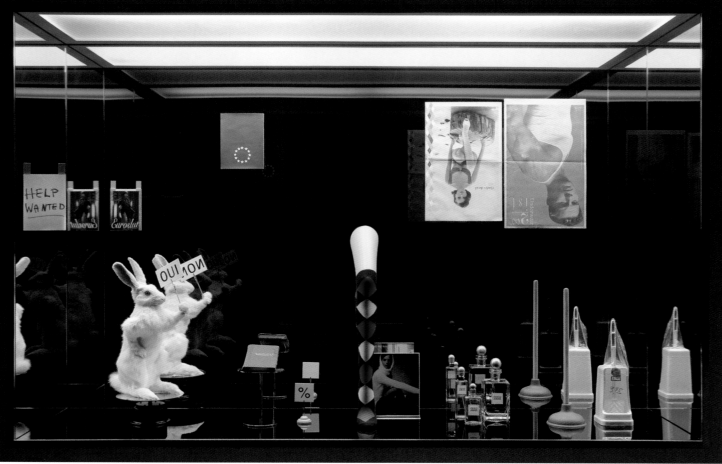

Installation View, Migros Museum (opposite top)
2009
Copyright Josephine Meckseper and VG Bild-Kunst, Bonn
courtesy the artist and Elizabeth Dee, New York

The Complete History of Postcontemporary Art
(opposite bottom)
2005, mixed media in display window, 160 x 250 x 60 cm
Copyright Josephine Meckseper and VG Bild-Kunst, Bonn
courtesy the artist and Elizabeth Dee, New York

Scale (right)
2010, metal chains, papier mache and broken mirror, jewellery, fur tail on chrome stand 152 x 100 x 30 cm
Copyright Josephine Meckseper and VG Bild-Kunst, Bonn
courtesy the artist and Elizabeth Dee, New York

JOSEPHINE MECKSEPER

Born in Germany, Josephine Meckseper relocated to the United States to study at the California Institute of the Arts. Her work, spanning photography, sculpture, installation and film, explores ideas about politics, feminism, consumerism and globalism. Images of cars, oil rigs, and warfare are paired with fashion accessories, household products and car parts, often utilising the architecture and fixtures of commercial showrooms—vitrines, slatwalls, mannequins, and advertisements. These juxtapositions highlight Meckseper's deep-rooted interest in the connections between capitalism, politics and life.

Consumerism is frequently invoked in Meckseper's work, particularly in her use of readymades. Her eclectic displays feature disparate objects, such as the "Help Wanted" sign, plunger and stuffed rabbit of her mirrored vitrine *The Complete History of Postcontemporary Art*, 2005. These carefully arranged sculptures and installations, often crammed with objects, purport that, despite excess, society has succumbed to a materialistic emptiness. Pulling source material from the media, Meckseper exposes these relationships between politics and capitalism. In two

recent films, Meckseper ties consumerism directly to the Iraq War, merging images of fighter jets with fast cars, in *0% Down*, 2008, and scenes of a military recruitment videos with a shopping mall, in *Mall of America*, 2009. These ideas are explored further in two large-scale photocopies of the Ford Mustang—*Mustang (White)* and *Mustang (Black)*, 2010. Meckseper focuses upon the connection between Western oil dependency and consumer culture, tracking these ties from the drilling of oil to its final consumption in the Mustang, a glorified national symbol of real America.

ROE ETHRIDGE

New York Whiskey and Cigarettes (below)
2009, C-print, edition of five, + 2 AP, 107 x 84 cm
Courtesy the artist, Andrew Kreps Gallery, New York/
greengrassi, London/Mai 36 Gallerie, Zurich

Studio with Red Bag (opposite)
2009, C-print, edition of five, + 2 AP, 130 x 102 cm
Courtesy the artist, Andrew Kreps Gallery, New York/
greengrassi, London/Mai 36 Gallerie, Zurich

BERNADETTE CORPORATION

From *Ars Nova* (opposite)
2009; digital inkjet print, 56 x 43
Courtesy the artists

From A Haven for the Soul (below)
2010, chrome bathroom fitting
Courtesy the artists

CHRISTOPHER WILLIAMS

Pacific Sea Nettle, Chrysaora Melanaster, Long Beach
Aquarium of the Pacific, 100 Aquarium Way, Long
Beach, California, September 5, 2007 (below)
2008, gelatin silver print, 61 x 51 cm, ed 10
Courtesy David Zwirner, New York

Linhof Technika V fabricated in Munich, Germany. Salon
Studio Stand fabricated in Florence, Italy. Dual cable
release. Prontor shutter. Symar-s lens 150mm/f 5.6
Schneider kreuznach. Sinar fresnel lens placed with
black tape on the ground glass. (Yellow) Dirk Schaper
Studio, Berlin, June 19, 2007 (opposite)
2008, C-Print, 86 x 74 cm, ed 10 + 4 ap
Courtesy David Zwirner, New York

MICHAEL SNOW

Flash! (below)

2001, laminated colour photo on aluminium, 122 x 183 cm

Courtesy the artist and Jack Shainman Gallery, New York

Handed to Eyes (opposite)

1983, oil on photograph, 124 x 102 cm

Courtesy the artist and Jack Shainman Gallery, New York

MICHAEL SNOW
Condensation. A Cove Story (below)
2009, blu-ray DVD projection, 10:28 loop
Courtesy the artist and Jack Shainman Gallery, New York

Parked (opposite)
1992, light box, 61 x 81 x 15 cm
Courtesy the artist and Jack Shainman Gallery, New York

CINDY SHERMAN
Untitled Film Still
1978, black and white photograph, 20 x 25 cm
Courtesy of the artist and Metro Pictures

CINDY SHERMAN
Untitled (below)
1987, colour photograph, 119 x 180 cm
Courtesy of the artist and Metro Pictures

Untitled (opposite)
2008, colour photograph, 176 x 132 cm
Courtesy of the artist and Metro Pictures

Dirty Don's Delicious Dogs (opposite top)
2008, C-print, 102 x 127 cm
Copyright Sharon Lockhart, courtesy Gladstone Gallery, New York

Outside AB Tool Crib: Matt, Mike, Carey, Steven, John,
Mel and Karl (opposite bottom)
2008, C-print, 122 x 172 cm
Copyright Sharon Lockhart, courtesy Gladstone Gallery, New York

SHARON LOCKHART

Based in Los Angeles, Sharon Lockhart makes photography and film that focuses upon the observational. Humanistic in approach, Lockhart's work is concerned with everyday experience as it is lived, whilst also incorporating an air of the imaginary and exploring the relationship that lies between. Essentially belonging to Conceptualism, Lockhart's work, is cleverly understated, seducing the viewer with a cinematic composition. At the same time, her films are often made using a static camera that recalls a number of photographic techniques.

Untitled, 1996, is one of a series of large-scale colour photographs that Lockhart made depicting people within interior spaces. In *Untitled*, 1996, a man is shown within a hotel room, standing in front of floor-to-ceiling windows as daylight is gradually fading. Several of the photographic techniques that Lockhart has adopted here demonstrate the conceptual approach to her work; with the reflections in the windows of the room forcing the viewer to consider space within the photograph, as well as what is real and what is in fact a duplication.

The photographic and film works from Lockhart's Lunch Break exhibition portray the working life of contractors at the Bath Iron Works, Maine. In opposition to the vast majority of her work, Lockhart has chosen to focus upon objects and places rather than people here, with one series from the exhibition—there are three in total—focusing upon the worker-run vending stations, such as that in *Dirty Don's Delicious Dogs*, 2008. These pieces offer an alternative view of Lockhart's usual humanistic approach to her work, however; giving an intimate view into the lives of the Iron Works employees, complete with their handmade signs and personal belongings. Another series from Lunch Break portrays the workers themselves, relaxing on their break, in a typical portrayal of Lockhart's style that has evolved from subjective experience.

SHARON LOCKHART
Untitled
1996, C-print, 185 x 277 cm
Copyright Sharon Lockhart, courtesy Gladstone Gallery, New York,
Blum & Poe, Los Angeles, and Neugerriemschneider, Berlin

JEFF WALL
Milk (below)
1984, transparency in lightbox, 187 x 229 cm
Courtesy the artist

Staining bench, furniture manufacturer's,
Vancouver (opposite)
2003, transparency in lightbox, 78 x 96 cm
Courtesy the artist

JEFF WALL
Morning Cleaning, Mies van der Rohe Foundation,
Barcelona
1999, transparency in lightbox,187 x 351 cm
Courtesy the artist

RONI HORN

American artist Roni Horn investigates ideas on mutability within art, explored through sculpture, drawing and photography. Influenced by Minimalism, Horn has developed her practice focusing upon ideas concerned with site-specificity, time and place, humankind and nature. The intimacy of Horn's practice is reflected in the importance she places upon the relationship between the viewer and her work and is reflected in the poetic beauty, which it conveys. Even its eventual organisation within a gallery space is of utmost importance to the artist, as she emphasises the significance of personal experience, both in terms of the viewer and the relevance of the work.

Horn's interest in people and place, and object and viewer is central to her work. She describes drawing as the main element of her practice, viewing its fundamental purpose as being concerned with the formation of relationships. Interested in the idea of pairing and doubling, her drawings will often feature paired clusters of cut-up lines; this is further extended into Horn's photography work, in which she will often split images into pairs so that two halves of one image sit next to each other as separate works, evoking a sense of *déjà vu* within the viewer—as seen in *Untitled, No. 15*, 1998–2007.

Place, geography and nature feature throughout Horn's work, themes which have led her to engage with the landscape of Iceland continually within her work over the past 30 years. First visiting as a young arts graduate from the United States, the country's singular identity and physical landscape—which Horn views as in a constant cycle of formation—became of great importance to the artist. This huge body of work, largely photographic, depict the people, landscape and animals, that together, build an intimate complexion of the relationship between the Icelandic people and their landscape. Her dedication to Iceland within her work is reflected in the permanent installation—*Vatnasafn*, or *Library of Water*—a sculptural piece, consisting of transparent glass columns holding glacial water taken from various regions of Iceland, located in the small town of Stykkisholmur, three hours from Reykjavik.

STAN DOUGLAS
Abbott & Cordova, 7 August 1971
2008, digital C-print mounted on aluminium,
187 x 230 x 6 cm
Courtesy the artist and David Zwirner, New York

APPENDIX

190 **THE NEW YORK CANON**
JERRY SALTZ

198 **CANADIAN CULTURAL POLICY: A METAPHYSICAL PROBLEM**
KEN LUM

206 **BOUNDARY ISSUES: THE ART WORLD UNDER THE SIGN OF GLOBALISM**
PAMELA M LEE

210 **ART IN THE FIELD OF ENGAGEMENT**
MARTHA ROSLER

212 **LESSONS OF THE CLASS OF 90: SITING RECENT ART IN LOS ANGELES**
JAN TUMLIR

219 **WHEN THOUGHT BECOMES CRIME**
CRITICAL ART ENSEMBLE

221 **CONTRIBUTORS**
222 **ARTIST BIOGRAPHIES**
231 **SELECTED BIBLIOGRAPHY**
233 **INDEX**
239 **ACKNOWLEDGEMENTS**

THE NEW YORK CANON
JERRY SALTZ

First published in *New York Magazine*, April, 2008
Copyright Jerry Saltz

A canon is antithetical to everything the New York art world has been about for the past 40 years, during which time we went from being the center of the art world to being one of many centres. But *New York Magazine* is celebrating its 40 year anniversary and asked me to think about what events make up a New York canon of art. It's possible to look at the artists and events I chose and not see a direct line of growth (if there has ever been such a thing), but rather an expanding and contracting cloud that has broken free of linear progress, something that grows in all directions at once. The fact that there was no one New York Ur-Artist, no single style that dominated all the others in this period is a form of progress in itself. Even though the magazine wanted a New York-oriented list I did not just pick art about New York by New Yorkers. I choose work that seemed to change the way that art looked in New York. That's why there are artists from Europe, Asia and elsewhere in America here.

Those who now say that New York is finished because the market is ruining everything need to get a grip. Several times in the past 40 years, New York artists faced oblivion. More bad art may be being made and sold now than ever before but each artist has to deal with what the market means to him or her in the privacy of their own studio. Enough artists are doing that, and are still making great art. They'll still be doing so 40 years from now.

1968

At 4:15 pm on Monday, 3 June, Valerie Solanas, a disgruntled Factory hanger-on and founder of S.C.U.M. (Society for Cutting Up Men), enters Warhol's studio at 33 Union Square and shoots him with a .32 automatic as he screams, "No! No! Valerie! Don't do it!" As Warhol lies on the floor critically wounded, longtime minion, Billy Name, cradles Warhol's head and begins to cry. Mistaking it for laughter, Warhol says, "Oh, please don't make me laugh, Billy. Please it hurts too much." Then he passes out. Warhol is taken by ambulance to Columbus Hospital, wheeled into an emergency room at 4:45 pm. Six minutes later, at 4:51 pm, he is pronounced "clinically dead." Still, Dr. Giuseppe Rossi continues to try, then succeeds in reviving him. Warhol recuperates in the hospital for several weeks. Afterwards he says, "Before I was shot, I always suspected I was watching TV instead of living life. Right when I was being shot I knew I was watching television. Since I was shot everything is such a dream to me. I don't know whether or not I'm really alive—whether I died. It's sad." Many say the shooting marks a downturn in Warhol's work. Later, at a party that year, a drunken Willem de Kooning refuses to shake Warhol's hand saying, "You're a killer of art."

Bruce Nauman's solo debut at Leo Castelli initiates the career of one of the most important American post-war artists. Nauman made art about making art and being in the studio. He tried to levitate there, walked in funny patterns, made mazes for rats then had people beat punching bags with bats to drive the rats nuts. He filmed clowns on the toilet and made dazzling neon text pieces that said "Run from Fear" then "Fun from Rear". Somewhere I remember Nauman saying that he was interested in "the not-knowing part" of art. That "not-knowing" has never seemed so bottomless.

The art world begins to codify into a new group of artists who are neither Pop nor Minimal. Two major gallery openings signal the rise of these new artists. The pioneering Bykert Gallery, run by writer-critic Klaus Kertess, debuts and exhibits a new generation including Chuck Close, Brice Marden, Dorthea Rockburne, Barry LeVa, Peter Campus and Joe Zucker—artists who will open Minimalism up and take it to wilder and more complicated shores. That same year Paula Cooper launches the first gallery in SoHo with an exhibition to benefit the Student Mobilization Committee to End the War in Vietnam, including works by Carl Andre, Robert Mangold, Robert Ryman, as well as Sol Le Witt's first wall drawing. Cooper goes on to champion the work of a generation of notables including Jonathan Borofsky, Jennifer Bartlett, Elizabeth Murray, Joel Shapiro and Alan Shields.

1969

Vito Acconci merges Conceptual Art, performance, psychology, paranoia and sexuality in *Following Piece*. Acconci followed selected strangers around

VITO ACCONCI
Following Piece (opposite)
1969, photograph
Courtesy the artist
photo: Betsy Jackson

CHRIS BURDEN
Shoot (below)
1971, "At 7:45 p.m. I was shot in the left arm by a friend. The bullet was a copper jacket .22 long rifle. My friend was standing about fifteen feet from me."
Courtesy the artist

the street until they went into a private place. *Pieces* lasted from a few minutes to several hours. The following year, when Leo Catelli, Ileana Sonnabend, John Weber and others opened galleries in an industrial building in SoHo at 420 West Broadway—thus heralding the arrival of the SoHo gallery scene—at Sonnabend, Acconci created *Seedbed*, in which he lay hidden under the ramped floor of the gallery masturbating for two weeks while recounting sexual fantasies via speakers to viewers above him. Later, when asked by Richard Prince if he thought that his gravely voice helped him with women, Acconci replied that his voice was one that "lulls you through a dark disturbed night... promising intimacy, sincerity, integrity, maybe some deep, dark secret." Acconci is the art world's Johnny Cash / Keith Richards / Quasimodo.

1970

Famed Abstract Expressionist Philip Guston abandons his former Abstract-Impressionist style and mounts a show at Marlborough Gallery of paintings of oafish figurative paintings, Ku Klux Klansmen, one-eyed brutes and paint brushes. Artists see that Guston is pointing towards new ideas for figuration at a time when strict Abstraction ruled the roost. The show is universally panned by critics, including grouchy conservative Hilton Kramer, who in the *New York Times* famously dismissed Guston as "a mandarin pretending to be a stumblebum".

With little money at stake, no sales prospects and few galleries committed to showing the work of emerging artists, 112 Greene Street gallery is founded. This initiates the rise of artist-run spaces. Artist-founder Jeffrey Lew remarks, "None of the doors in 112 were ever locked. It was the most open, if not the only socialist art system in New York at the time." Before it closed in 1978, the gallery exhibited the work of Alice Aycock, Laurie Anderson, Chris Burden, Mary Beth Edelson, Jackie Winsor and many other luminaries.

Avalanche Magazine—the main disseminator of Conceptual Art—is founded by Liza Bear and Willoughby Sharp. The modest black-and-white magazine features articles on artists like Yvonne Rainer, Keith Sonnier, Robert Smithson, Lawrence

Weiner, William Wegman, Bruce Nauman, Hans Haacke, Alice Aycock and others, and also looks towards new art in Europe, a relative rarity in the US-centric art scene in New York.

The Guggenheim Museum steps in it twice in one year.

It canceled its Hans Haacke exhibition six weeks before it is set to open because Haacke intended to exhibit a multi-part work delineating the real estate transactions of several of New York's most notorious slumlords. The director of the Guggenheim, Tom Messer, claimed museums should not exhibit work that has "active engagement toward social and political ends". Next, the museum removed Daniel Buren's 66 x 32 foot stripped banner-painting from the main rotunda after artists (including Dan Flavin and Donald Judd) vehemently protested that Buren's work interfered with theirs. Buren's heart was broken but his name was made.

At the corner of Wooster and Prince Streets in SoHo, the restaurant Food was opened by artists Gordon Matta-Clark, Tina Girouard and others. The place became the school cafeteria of SoHo and an

artistic nerve center as the neighbourhood slowly turned into a kibbutz and a clubhouse for artists.

1972

With the rise of the feminist art movement, A.I.R. Gallery opened its doors in SoHo. It was the first cooperative gallery for women artists in the United States. The gallery exhibited the work of Dotty Attie, Nancy Spero, Barbara Zucker, Agnes Denis, Harmony Hammond, Howardena Pindell and many others.

1973

Artist, writer, magician-of-the-earth Robert Smithson, 35, was killed in a plane crash inspecting a work in Amarillo, Texas. Smithson, a progenitor of Earth Works, demonstrated that art could be removed from galleries and also that galleries could embody some of the spirit and mood of outdoor works of art.

1974

Feeling "underrepresented in the male-run artistic community," artist Lynda Benglis took out a double page ad in the November issue of *Artforum*, featuring a photo of herself (taken by artist Robert Morris) wearing nothing but a pair of sunglasses, holding a giant dildo to her crotch. Carter Radcliff notes, "The following month, the other associate editors—Lawrence Alloway, Max Kozloff, Rosalind Krauss, Joseph Masheck, Annette Michelson—published a letter to the editor-in-chief, John Coplans, to let the art world know how deeply they had been offended by the 'extreme vulgarity' of Benglis's picture." Quick to see the hypocrisy of these reactions, the ever-anti-authoritarian critic Robert Rosenblum wrote a letter saying, "Let's give three dildos and a Pandora's Box to Ms Benglis, who finally brought out of the closet the Sons and Daughters of the Founding Fathers of the *Artforum* Committee of Public Decency and Ladies Etiquette." Krauss and other *Artforum* editors left the magazine to form the arcane theory journal, *October*.

1975

Gordon Matta-Clark cut large slices and holes out of Pier 52 on Gansevoort Street, creating an

LAWRENCE WIENER
& Given & Replaced
2009
Courtesy the artist and Lisson Gallery

enormous civic earthwork and an act of creative destruction. The work was a sort of Declaration of Artistic Independence that signalled to artists that art should be made in the world and not just shown in galleries. He was arrested for his efforts. Matta-Clark died of cancer three years later at the age of 35.

1976

Jennifer Bartlett exhibits her enormous multi-paneled painting *Rhapsody* at the Paula Cooper Gallery. Comprised of over 900 12-inch enamel-painted steel plates hung frieze-style, *Rhapsody* is immediately recognized as a breakthrough of systems art, process art, Post-Minimalism, feminism and a way back into the then-forbidden territory of painting.

1977

Marianne Goodman Gallery opens on 57th Street. She is known for showing top-tier non-Americans such as Marcel Broodthaers, Anselm Kiefer, Gerhard Richter, Jeff Wall, Maurizio Cattelan, Tony Craig, Richard Deacon, Rineke Dykstra, William Kentridge, Gabriel Orozco and Thomas Struth. Without

Goodman, it's arguable that America's wake-up call in the early 1980s might have come too late or not at all. She deserves some sort of Artistic Legion of Honor.

As does Marcia Tucker, who quit her job as curator at the Whitney Museum of American Art and founded the New Museum. Within its first five years, the New Museum presented the first retrospectives of artists like Alfred Jensen, Barry Le Va, Ree Morton and John Baldessari. Tucker retired her position in 1999 and died in 2006, at the age of 66.

The Pictures exhibition at Artist Space, curated by Douglas Crimp, with artists Troy Brauntuch, Jack Goldstein, Sherrie Levine, Robert Longo and Philip Smith, signalled a change in artistic atmosphere to a more theoretical, cerebral, critical approach. This cool, collected, theory-based work is antithetical to nascent Neo-Expressionist and Graffiti art of the same moment.

1978

Artist Alan Sonfist creates *Time Landscape*, a 40 x 200 foot plot of pre-colonial forest on the corner

of La Guardia and Houston using a palette of native trees, shrubs, wild grasses, flowers, plants, rocks and earth. I've always imagined Sonfist would be commissioned by the US government to create a one-mile-wide swath of pre-colonial growth stretching from New York to Los Angeles.

Two life-altering events in one day. First I was floored by Rothko's paintings in his Guggenheim retrospective, which were like glowing Buddhist TVs.

Immediately afterwards, I witnessed the effects of fame when I saw John Lennon and Yoko Ono on Madison Avenue. Dazzled by the sight, I couldn't stop looking, and fell into step behind them. I ended up following in their wake for about 20 blocks, watching the waves of recognition spread down Madison Avenue, the marvelous shock, the astonishment, the joy. It was like an emotional landslide. People staggered or seemed to buckle as the couple passed. Space distorted, time fell into a trance. The light of forever appeared to glow around them. At that exact moment in that exact place they seemed the sum of all sums. I still feel the reverberations on that particular stretch of upper Madison Avenue. That was old-fashioned fame: God-like, classic, aristocratic, transcendental, almost religious, a strange, strange love. The bigger the crowd of idolaters, the more unique you felt in your idolatry. Fame is not like that anymore. Fame is feral, or simply celebrity squared. Debased or replaced by its more ordinary manifestations (the well-known, the groovy, or the merely recognisable), fame now attaches itself to nobodies. Celebrity is an everyday thing, our biggest export. We're a nation of Kennedys. You're famous, maybe, or someone you know is: the chef at the restaurant you go to, your hairdresser, your doctor, architect, interior designer, or florist. You know somebody who knew John Jr, or, as one woman told News Channel 4, "I didn't know him, but my dog knew his dog."

1979

Five years after his barely-noticed 1974 New York debut in which he lived in the Rene Block Gallery for three days with a live coyote, the Guggenheim Museum retrospective of German artist Joseph Beuys ends America's isolationist hegemony. Major

critics denounce Beuys while artists see that he represents new ways of thinking about materials, myth, history, narrative and object-making. The following two years see the American debuts of German giants like Gerhard Richter, Sigmar Polke and Anselm Kiefer. It should have been too late for American artists to recover from their provincial pluralism. But because Americans didn't really know how far behind they were, they fought on and managed to take the stage.

Nan Goldin presents her great slideshow/ soap opera/book of the dead/manifesto of the beautiful and the damned, *The Ballad of Sexual Dependency*, at the Mudd Club. This work records the lives, loves, costume changes, addictions, distractions and binges of a small group of creative souls sometimes known as "The Family of Nan". Goldin opened the doors to legions of snap-shooters who also wanted to create their own Photography of Modern Life.

Julian Schnabel shows plate paintings at Mary Boone Gallery, makes everyone crazy with his ambition, self-centered pronouncements, high prices, sell-out shows, waiting lists and magazine coverage. The first time oil paint is smelled in New York galleries in years.

1980

Young artists, critics, and curators begin their takeover of the New York art world with the Times Square Show, curated by artists, and held in a two-floor former bus depot and massage parlour off Times Square. It included work by unknowns Jenny Holzer, David Hammons, Jean-Michel Basquiat, Keith Haring, Kiki Smith, Walter Robinson and many others who were making a loose street-wise non-academic, Non-Post-Minimal Art. The show is a call to artists everywhere to do what they want as often and as energetically as possible. Next, ABC No Rio incubates The Real Estate Show, a similarly all-over-the-place exhibition held in a vacant tenement Lower East Side tenement featuring many new downtown artists. The following year sees New Wave New York at PS1, curated by Diego Cortez. The show includes Sarah Charlesworth, Larry Clark, Fab 5 Freddy, Robert Mapplethorpe,

Keith Haring, Nan Goldin, Kenny Scharf, Kiki Smith, Robin Winters and others. Do-it-yourself becomes the new credo.

MoMA opened its gigantic, building-filling Pablo Picasso retrospective, then closes its gigantic building for the first of several large scale rebuilding projects, each time seemingly making its space more uptight.

Jasper Johns' *Three Flags* sells for over $1,000,000, the first time such an astronomic price is commanded by a living artist. The feeling that money is sniffing around art cannot be denied. Art and money are about to have a fling.

Signaling the arrival of more so-called "Pictures Artists", Metro Pictures Gallery opens in SoHo with a group show including the work of Brauntuch, Longo, Levine, Goldstein, Richard Prince, Cindy Sherman, Laurie Simmons and James Welling. I remember being scared to go in because the work seemed so hip and smart.

Walter De Maria's indoor earthwork, *New York Earth Room*, is installed at 141 Wooster Street. The piece is still there and consists of 250 cubic yards of earth, weighs 280,000 pounds, is 22 inches deep, and covers 3,600 square feet. The work can still take your breath away with its simplicity, grandeur, quietness and wonderful smell.

1981

The flowering of the scrappy do-it-yourself East Village scene begins when Gracie Mansion opens a gallery in her East Village bathroom. Galleries include Fun, International With Monument, Pat Hearn, Jay Gorney Modern Art, Vox Populi, Nature Morte, Piezo Electric, Postmasters, 303, B-Side, Civilian Warfare, New Math, Cash Newhouse and many others. By 1987 the East Village scene is over, a victim of its own success, absorbed by SoHo, and ravaged by AIDS.

O Superman, a catchy new wave chant / song by performance artist Laurie Anderson sells over 500,000 records in the US and suggests to artists everywhere that art can breakthrough to the wider public.

1982

Maya Linn's *Vietnam Veterans Memorial* is unveiled in Washington, DC After being widely criticised (by billionaire Ross Perot, among others), the black marble wall filled with names of the dead is embraced by a country that until this point hated nothing more than Abstract, Minimalist sculpture.

Keith Haring's first solo show opens at the SoHo gallery of Tony Shafrazi (the nitwit who in 1974 scrawled the words "Kill Lies All" in spray paint on Picasso's *Guernica*). Haring's exuberant example of painting in the subways and on the streets inspired thousands of young artists to do the same. I was barely out of my 20s and yet for the first time in the art world I felt old. Prices of the sold-out works ranged between $8,000 and $15,000. Haring dies of AIDS in 1990 at the age of 31.

Cindy Sherman's show of centrefold photographs, self-portraits based on images from magazines, makes good on the promise of her black-and-white *Film Stills*. One thing never written about Sherman is that her work revolves around a woman who loves to shop, try on clothes, pose in front of mirrors, do her make-up and take pictures. Sherman works so close to some psychological core that the core turns invisible. She's taken thousands of pictures of herself yet we still have no idea of who that self really is. Sherman's is the face that launched a thousand theories.

New York magazine features gallerist Mary Boone on its cover proclaiming her "The New Queen of the Art Scene."

1983

David Hammons sells snowballs alongside other venders on Astor Place. Titled *Bliz-aard-Ball Sale*, the piece reveals the complicated social ways Hammons would bring the usually cloistered Duchampian gesture into the art world and onto the streets. He reportedly earned $20 from his efforts. Throughout his career Hammons has remained off to the side of the art-world action. Early on he said, "I can't stand art actually. I've never, ever liked art, ever."

ADRIAN PIPER
My Calling (Card) # 1 (below)
1986, brown business cards with printed text, 5 x 9 cm
Copyright APRA Foundation Berlin
collection of the Adrian Piper Research Archive

ANDRES SERRANO
Klansmen Grand Dragon (opposite)
1990, 127 x 152 cm
Courtesy the artist

1984

Two 1984 massive MoMA missteps in one year trigger scene-altering phenomena.

Primitivism in 20th Century Art: Affinities of the Tribal and the Modern, curated by William Rubin and Kirk Varnedoe, displaying modern and so-called "primitive" works side-by-side, sets off charges of "colonisation" and "exploitation." A public exchange of letters between critic Thomas McEvilley and the curators takes place in the pages of *Artforum*. Perhaps the beginning of Multiculturalist Theory in the art world.

Next, MoMA mounts its enormous An International Survey of Recent Painting and Sculpture. The exhibition has 169 artists but only 19 women. All the artists are white and from Europe or the US. McShine also reportedly claims that any artist who isn't in the show should rethink "his" career. As a result, the Guerrilla Girls are founded by a group of almost 100 feminists who donned gorilla masks in public. They plastered New York with humorous but pointed posters decrying acts of sexism and discrimination in the art world. As they put it on their website: "We're feminist masked avengers in the tradition of anonymous do-gooders like Robin Hood, Wonder Woman and Batman.... We expose sexism, racism and corruption in politics, art, film and pop culture."

1986

In her 1986 work, *My Calling (Card) #1*, Adrian Piper handed out cards printed with the words, "Dear Friend, I am black. I am sure you did not realise this when you made/laughed at/agreed with that racist remark." Adrian was the first so-called "post-black" or "post-race" artist; she put race at the center of her work in order to question race as the determining lens through which people see the world. Today Piper's ideas are being played out on the world stage in the race for the presidency.

With the four-person exhibition at Sonnabend Gallery "Neo-Geo" arrives on the scene. The show includes Jeff Koons, Peter Halley, Ashley Bickerton and the now-almost-forgotten Meyer Vaisman. The marriage of art and money is consummated

Dear Friend,
 I am black.
 I am sure you did not realize this when you made/laughed at/agreed with that racist remark. In the past, I have attempted to alert white people to my racial identity in advance. Unfortunately, this invariably causes them to react to me as pushy, manipulative, or socially inappropriate. Therefore, my policy is to assume that white people do not make these remarks, even when they believe there are no black people present, and to distribute this card when they do.
 I regret any discomfort my presence is causing you, just as I am sure you regret the discomfort your racism is causing me.
 Sincerely yours,
 Adrian Margaret Smith Piper

in public. The year before this, Cable Gallery opened, operated by Nicole Klagsbrun and Clarissa Dalrymple, highlighting the transition from early 1980s Neo-Expressionism, Graffiti and Pictures Art to artists such as Bickerton, Haim Steinbach, Christopher Wool, Steve Di Benedetto and Collier Schorr.

At the Kitchen, Karen Finley's *Yams Up My Granny's Ass* opens. As part of a demented performance piece, she smears canned yams onto and into her ass—a move that becomes notorious. The Culture Wars of the late 1980s are about to begin.

1987

After a routine gallbladder operation a private nurse, Min Chou, reportedly fails to adequately monitor his condition and overloads him with fluids, and Andy Warhol dies at 6:31 am, 22 February. Warhol had been so terrified of hospitals that he would never use the word. He called it "the place". An almost instant positive reassessment of his then-disparaged late work began and continues still.

Barbara Kruger, who created one of the most readily identifiable graphic styles since Roy Lichtenstein, becomes the first female artist to join Mary Boone Gallery. She is soon joined by Sherrie Levine.

1988

Showman/strongman/gremlin Thomas Krens becomes Director of the Guggenheim Museum. Krens sees that culture is going to be big business and he begins to turn the sleepy, disorganised Guggenheim into a world brand. In the process he sells off parts of the museum's collection, soils some of the Guggenheim's good name, mounts attention-getting shows (some good), sets off on real-estate boondoggles, changes the role of museums, raises the stakes across the board and builds or tries to build buildings all over the world.

Jean-Michel Basquiat, who skyrocketed to fame in the early 1980s with his prodigious, intensely painted images of words, animals, black American heroes and ne'er-do-wells, as well as his collaborations with Andy Warhol and Francesco Clemente, dies at the age of 27. Basquiat represented the gritty faster-than-life side of Haring's ebullient esthetic. In death he became a Rimbaud-like anti-hero.

1989

After a nine year long court case, testimony by scores of art-world witnesses, repeated claims by the artist that he would forever leave the United States if his work were altered in any way, Richard Serra's *Tilted Arc* was removed from Federal Plaza.

It was the end of one phase of Serra's work but the beginning of his museum and public-art apotheosis. He never relocated to another country.

The Culture Wars arrive as Andrea Serrano's *Piss Christ* is attacked in the US Senate and the Corcoran Gallery, wary of losing grant money from the NEA, cancels its Robert Mapplethorpe exhibition. In retrospect, it is arguable that the curtailing of government-funded programs for the arts led directly to collectors, trustees and patrons gaining more power in institutions and slowly destroying them, making them more dependent on their wishes and whims. Thank you, politicians.

One of the most influential artists of the last 20 years, Cady Noland debuts at Colin De Land's American Fine Arts in SoHo. Her work consists of metal baskets, Budweiser beer cans, American flags and fence poles distributed willy-nilly around the gallery. It was the first time that I looked at art and didn't know what I was looking at. Noland opened the door to the esthetics of the 1990s. She is the missing link of the period. Inexplicably she doesn't show much and now exists mainly as a legend.

1990
One year after Noland's debut, Felix Gonzalez-Torres debuts at Andrea Rosen. His work, often dealing with the fleetingness of life, consisted of stacks of paper that viewers were allowed to take, piles of candy that visitors were able to sample or bead curtains or lightbulbs in empty rooms. Gonzalez-Torres combined eccentric materials, formalism, love, loss and Conceptualism in ways that helped create what would eventually be called "Relational Aesthetics". He died of AIDS, at the age of 36, in 1996.

1991
The stars aligned for Matthew Barney, 24. His solo debut at Barbara Gladstone in SoHo came after his work appeared on the cover of *Artforum*. The exhibition, which was continually packed with visitors, consisted of videos of Barney in drag dancing with a blocking sled, him dressed as a football player and crawling across Gladstone's ceiling, naked, suspended from ice screws. In the downstairs gallery we saw videos of Barney inserting an ice screw into his anus in an attempt to crawl into his own body and turn himself inside out. Barney combined Nauman, Beuys, Serra, Joan Jonas, strange materials and something so physical, dense and unknowable that he created his own mystic one-man movement.

Jeff Koons opens Made in Heaven at Sonnabend Gallery. The show features 31 works ranging from large silk-screened oil paintings to marble and glass sculptures depicting Koons and his wife, Ilona Staller, the Italian parliamentarian and porn star known as *la Cicciolina* (Little Fleshy One) having sex. Koons says, "I've always tried to exploit myself to the fullest." The show creates a sensation but the art world rejects Koons, believing he has taken his ideas of exploitation too far. He is left out of all international surveys, including Documenta. Yet in Arolsen just outside of Kassel, where Documenta was held, Koons erected *Puppy*, a 43-foot-tall topiary sculpture of a West Highland Terrier executed in 60,000 living flowers. The piece steals almost all the thunder from Documenta.

Jim Shaw mounts Thrift Store Paintings at Metro Pictures Gallery. This sprawling collection of more than 200 thrift store paintings done by mostly anonymous amateurs is attacked by critics, including British writer Adrian Searle, who complained that "the paintings are awful, indefensible, crapulous... these people can't draw, can't paint...". Numerous artists, nevertheless, see that this supposedly terrible exhibition opened the door to hundreds of unnamed figurative genres.

For his eye-peeling New York debut at the Daniel Newberg Gallery, Italian artist Rudolf Stingel emptied the space and covered the entire floor in a bright orange rug. "I wanted," he said, "to be against a certain way of painting." He went on to cover rooms in aluminium foil and allow visitors to carve the walls. One of the more retinally extreme painters to emerge since Pop Art and Ad Reinhardt.

1992
John Currin's paintings of buxom girls, sick women and fallen fops signalled the end of big art movements once and for all. Like many artists of his generation, Currin ignored the vaunted history of Abstraction and Modernism in favour of a free-ranging "I'll use whatever I want" approach that involved Durer, Courbet, Norman Rockwell, ads from magazines and pictures from Jugs. From this point on artists are free of art history.

Rirkrit Tiravanija exhibits *Untitled (Free)* at 303 Gallery. The work consisted of Tiravanija placing all the contents of the gallery in the main space, then setting up a makeshift kitchen in what had been the dealer's office. For the entire month, Tiravanija or an assistant served free Pad Thai to whoever stopped in. Like Gonzalez-Torres, Tiravanija found a way to make an object and also give it away for free. He is the George Washington and Johnny Appleseed of Relational Aesthetics.

For his exhibition at Dia, Robert Gober created a room with a painted forest mural, sinks, old newspapers featuring images of himself in a wedding gown and boxes of rat poison. It was like walking into a fantasy of the news in paradise and hell. You were locked in and shut out; the water was always running; the clues were all there but you were left with the feeling of wonder. The "not-knowing parts" that Nauman talked about all those years before came back with a vengeance. The

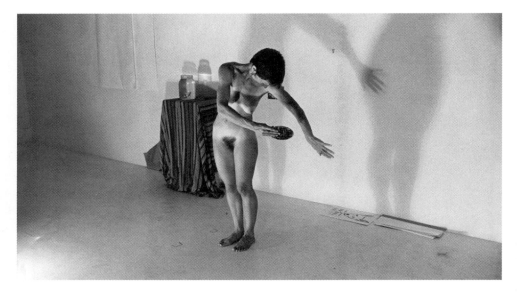

installation marks the beginning of many gallery-filling efforts by the artists of the next decade.

1993

As the art market collapse is in full swing, the *Washington Post* reports that "in the last two years some 70 commercial galleries have closed in Manhattan." That same year, as visitors entered the 1993 Whitney Biennial, curated by Elizabeth Sussman, they were handed Daniel J Martinez's button emblazoned with some or all of the slogan, "I Can't Imagine Ever Wanting To Be White." The show is dubbed "the political biennial" and lambasted by critics as "awful," "grim," "flimsy," "pious," "sophomoric" and "DOA." However, the show, maybe the most memorable of its ilk, proved that New York criticism often gets things initially wrong, and included numerous artists who went on to have major careers, among them Matthew Barney, Janine Antoni, Sophie Calle, Andrea Fraser, Coco Fusco, Rene Green, Byron Kim, Zoe Leonard, Glen Ligon, Jack Pierson, Fred Wilson, Charles Ray, Sadie Benning and Lorna Simpson.

At a dinner given for Anselm Kiefer, after his opening at Marianne Goodman Gallery, raw food is served to the *crème-del-a-crème* of the art world as they sit at long white tables atop a floor covered with white sand, as actors mimed dance. The decadent dinner marks the last gasp of 1980s hubris. As we entered the dining hall, artist David Salle looked at me and said, "They're going to kill us all." And then he left.

The cover of the *New York Times Magazine* features Pace art dealer Arnold Glimcher with his so-called "art world all-stars", all middle-aged white men, including John Chamberlain, Donald Judd, Chuck Close, Robert Mangold, Joel Shapiro, Robert Ryman, George Condo and the over-the-hill Jim Dine. The WAC (Women's Action Coalition) marches in front of Pace gallery wearing gorilla masks and latex dildos. Soon thereafter, Pace takes on Elizabeth Murray and Kiki Smith. Ah, guilt and shame.

The solo debut of Maurizio Cattelan at Danny Newburg Gallery lasts less than a week. Cattelan leaves the gallery empty except for a glass chandelier and a live donkey. Children are allowed to ride the donkey. Artists in the SoHo building object to the animal being housed there and ask that the show be closed. Cattelan goes on to combine shock, humour and wit in sculptures involving a tipped over pope, a praying Adolf Hitler and a stuffed horse hanging from the ceiling.

1994

After the stock market collapse in the late 1980s, a new generation of artists and dealers takes the stage. Dealers include David Zwirner, Gavin Brown, Andrea Rosen, Matthew Marks, Anton Kern, Marianne Boesky, Paul Morris, Brent Sikkema and Frederic Petzel. That year the first Gramercy Park International Art Fair, organised by dealers, is held at the Gramercy Park Hotel. Between 10,000 and 15,000 people see the 32 galleries installed on three floors of the hotel. The fair eventually turns into the behemoth known as the Armory Show and the age of the art fair is commenced.

Kara Walker's debut at The Drawing Center consists of a wall-filling black-paper silhouette frieze depicting characters from the Antebellum South killing, having sex with and wooing one another. Walker begins her march into the id of the American imagination and the buried history of race as she merges art, anger, laughter and a fierce intelligence with self-hate, self-love, guilt and reverie.

Elizabeth Peyton's New York debut is staged by dealer Gavin Brown in room 828 of the Chelsea Hotel. Visitors asked for the key to the room at the front desk, went upstairs and saw 21 small-to-medium sized black-and-white charcoal and ink drawings of dandies, Napoleon, Queen Elizabeth, Ludwig II and others. Peyton's style was a combination of Karen Kilimnik, Florine Stettheimer and fashion illustration, and opened the door to numerous artists who wanted to approach drawing in similarly un-angsty ways. The show was spellbinding.

In the early 1990s, Jason Rhoades combined the scatter art of Cady Noland, the formalism of Felix Gonzalez-Torres, the relational aesthetics of Rirkrit Tiravanija and the complex narrative structures of Matthew Barney and cross-wired it with testosterone-driven topsy-turvy orgies of narrative, Ikea-gone-mad, and the Chicken Ranch come to life. Rhodes' collage-assemblage kitchen-sink esthetic opened the flood gates to numerous room/atrium filling installations and exert a major pull on artists today.

1996

British art star Damien Hirst has his first show at Gagosian. Americans are treated to the full-on

spectacle of cut up animals, spinning paintings, a giant ashtray filled with smoked cigarette buts and mobile tanks filled with more dead animals. As America is withdrawing from its raging 1980s, British artists are all the rage, and raging all over the place.

1997
Willem de Kooning dies. Having suffered from Alzheimer's disease since the late 1980s, his late paintings were lyrical icebergs of interlocking lines and planes of cool pastel colours.

1998
Vanessa Beecroft stages *Show*, a one-night performance at the Guggenheim, in which 20 models, nude or in Gucci bikinis, wearing spiked heels, stand in formation for two hours. The art world stands staring at them as they stare back at the art world. Thus, Beecroft creates a perfect mirror for the experience of looking at art: You stare at it and it just stands there, hopefully doing something for you in the process. Not only does Beecroft seem to suggest that both the art and the audience are vulnerable, she illustrates how the art takes pleasure in being looked at. Talk about post-feminism.

Thomas Krens presents Art of the Motorcycle at the Guggenheim, in part "made possible by BMW".

British artist Rachel Whiteread unveils her first public sculpture in New York, a full sized translucent cast resin water tower atop a building in SoHo. Poetic yet incongruous, Whiteread's *Water Tower* powerfully represents a need for public sculpture to be physically present yet, paradoxically, ephemeral. Whiteread is one of the few visual artists who are better in public than in private galleries.

1999
The Guggenheim Museum mounts a 400-plus work retrospective of Norman Rockwell. A phalanx of museum directors, curators and populist theorists make Rockwell the latest postmodern fad, an everyman artist that everyone can understand. I agree with what

Rockwell said about his work, that it was just "feel-good""story-pictures." My advice was and still is, "Just say no."

Ten days before Charles Saatchi's collection, Sensation, opened at the Brooklyn Museum, angry mayor Rudolf Giuliani demanded that the show be cancelled because he objected to the elephant dung and pornographic photographs in Chris Ofili's The *Holy Virgin Mary*. The mayor promised to withhold $7.2 million in museum funding and called the show "sick". An editorial in the *New York Times* says Giuliani "promises to begin a new Ice Age in New York's cultural affairs". The museum sticks to its guns and leaves the painting up. However, 72-year-old Dennis Heiner, an offended Roman Catholic, who believed the painting was "blasphemous," defaced a quarter of the painting with paint.

2000
The Guggenheim presents Giorgio Armani after the Italian designer reportedly promises the museum a $15 million gift.

The Swiss artist Pipilotti Rist debuts at Luhring Augustine Gallery in Chelsea with a soup-to-nuts installation of furniture, food, video, murals and music. It is the beginning of the installation extravaganzas that would evolve into the so-called "Festivalism" of the big international exhibitions. Rist's ways with colour, sound and imagery, however, made her a magical, almost out-of-body artist.

2001
Olafur Eliasson takes Robert Smithson's ideas about the scale and the impact of outdoor earth works and brings them indoors with an exhibition at Tanya Bonakdar in which he creates a room within the gallery with no ceiling. Later, Eliasson would go on to produce one of the most successful indoor pieces of all time when he created an abstract sun in the Turbine Hall of the Tate Museum in London. Over 1,000,000 visitors saw and were wowed by the piece. I was one of them.

2002
With Chelsea growing by leaps and bounds, spaces getting bigger and grander all the time, and the art

world growing more professional everyday, artist Maurizio Cattelan and curators Massimiliano Gioni and Ali Subotnick open the Wrong Gallery, "the smallest gallery in New York," in a doorway. All it was an expensive looking glass and metal door but it was a font of the old take-back-the-streets attitude of the East Village days. One show consisted only of Adam McEwen's printed sign that said, "Fuck Off We're Closed".

2004
Having opened a 292,000-square-foot space in upstate Beacon, NY, the year before Dia, under director Michael Govan, who was mentored by Gugg director Thomas Krens and is now the director of the Los Angeles Museum of Art, unforgivably closes down Dia's West 22nd Street building. Thus, Govan oversaw the loss of the first space in Chelsea—one of the most important exhibition sites in the world. This is the most lamentable misstep in New York exhibition history.

2005
12–27 February: Christo and Jeanne-Claude and hundreds of assistants unfurl *The Gates*, the largest—and to me, the worst—public art project ever mounted in New York. Stretching along 23 miles of Central Park footpaths, the glitzy project consists of around 7,500 saffron-coloured panels. The estimated cost is around $20 million, funded supposedly by the Christos. Everyone in the city seemed to come out, have a good time and then forget about this ultimately absolutely forgettable spectacle.

2006
In the 2006 Whitney Biennial, the 25-year-old Ryan Trecartin collapsed the aesthetics of the 1990s into a 1,000-headed synthesized singularity that is already affecting artists everywhere. Trecartin condensed queer theory, computer graphics, wild colour, video, psychedelia, the aesthetics of Jack Smith, Stan Brakhage and Kenneth Anger into what feels like a new kind of speeded-up collaborative, a carnival sculptural-video circus combine that is already breathing life into the art world.

CANADIAN CULTURAL POLICY: A METAPHYSICAL PROBLEM
KEN LUM

First presented at the apexart International Conference, Wroclaw, Poland, in 1999. First published in *On Cultural Influence: Collected papers from apexart International Conferences 1999–2006*, New York: apexart, 2006

A quip from former Canadian Prime Minister Mackenzie King contends that too much geography rather than too little history afflicts Canada. Add to this the racial and ethnic diversity of the Canadian population, and how to forge and project Canadian culture becomes particularly difficult. This is a problem that is rooted in paradox due to the multi-cultural composition of Canada's population being, to a significant degree, a consequence of its social engineering of culture that began in full force immediately after the Second World War, developing in two principal stages.

The first stage was marked by the establishment of the Royal Commission on National Development in the Arts, Letters and Sciences in 1949, better known as the Massey-Lévesque Commission. Massey-Lévesque was a massive two year inquiry that had as its purpose the setting of Canadian cultural policy, including the principles of governance upon communications, film, television and arts agencies. It was instrumental in the establishment of many of Canada's now sacrosanct institutions including the National Library, the National Film Board and The Canada Council for the Arts. While Massey-Lévesque's report was liberally sprinkled with praise for Canada's "variety and richness of Canadian life" that "promises a healthy resistance to the standardisation which is so great a peril to modern civilisation", it was in fact a document of the intellectual anxieties of Canada's ruling Anglophone elite worried about the ascending signs of regional discontent to which they believed themselves historically designated to resolve.[1] Despite the constituting, albeit racially problematic, principle of Canada as a nation founded by two peoples, the English and the French, the Canadian federation has traditionally been a compact between the centre and the regions. The centre is represented by the ruling Anglophone elite of Ontario along with a number of appointed Quebecois *aide de camps*, and the regions would comprise the rest of Canada including Québec. The task of the commission as it defined it was a difficult one, how to construct an identity for a nation that was comprised of isolated regions of diverse histories and to which the threat of American influences was always present.

The second stage was represented by the formal adoption in 1971 of the Multiculturalism Policy and its attendant Canadian Multicultural Act. The federal multicultural programme formalised support for the idea of Canadian identity as constituted in its diversity of cultures, an idea that was only implicit in Massey-Lévesque. Multicultural diversity was designed to be the basis of the cultural pillar of Canada's foreign and domestic policy. In many ways, its logic is the inverse of Massey-Lévesque. The aim of Massey-Lévesque was about building institutions that would unify a compartmentalised nation and about underlining Canada's historical roots in Europe, primarily Britain and France, as a means to deflect Canadians from the pernicious influences of American culture.

Multiculturalism, on the other hand, is about supervising Canada's compartmentalised character by diluting the primacy of Canada's English and French roots as a means to inflect a more congenial and less materialistic version of America culture. The point that Canadian society has become over time increasingly like American society was made profusely clear during the 1992 George Bush versus Bill Clinton US presidential campaign. When then President Bush made a plea to Americans for a kinder, gentler America, political wags in both the United States and Canada were quick to reply that Canada is that kinder, gentler America.

Multiculturalism came to parallel Canada's multilateralist voice on the international stage of politics; the former would strengthen the legitimacy of the latter. Hand in hand, a multicultural domestic policy and a multilateral international policy would ensure Canadian influence through a wide spectrum of forums such as the United Nations, the Arctic Council, NATO, La Francophonie, The British Commonwealth and various Asia-Pacific organisations. Canada would be the primary habitus of the enlightened, democratic state, a respected and credible mediator between entities of power and entities on the margins. Multiculturalism would represent the triumph of the discourse of the

citizen and demonstrate to the world the true cosmopolitanism of Canada. Domestically, it represented a political accommodation of the old Anglophone elite to an emerging Francophone elite. Conveniently, the country would continue to be led and administered by the perspectives of the old Anglophone elite, after all, multiculturalism was their idea!

Prime Minister Pierre Elliott Trudeau aggressively promoted the idea of a national culture constituted by its cultural pluralism. He argued that: "Uniformity is neither desirable nor possible in a country the size of Canada. We should not even be able to agree upon the kind of Canadian to choose as a model, let alone persuade most people to emulate it."[2] To those who argue that multiculturalism is a dangerous recipe for a fractiously decentralised state, Trudeau's response was to make a virtue of the paradox. In 1970, to the Annual Meeting of the Canadian Press, Trudeau argued "Canada has often been called a mosaic but I prefer the image of a tapestry, with its many threads and colours, its beautiful shapes, its intricate subtlety. If you go behind a tapestry, all you see is a mass of complicated knots. We have tied ourselves in knots, you might say. Too many Canadians only look at the tapestry of Canada that way. But if they would see it as others do, they would see what a beautiful, harmonious thing it really is."[3]

By no means were debates about multiculturalism solely a Canadian concern. According to the late French social philosopher Michel de Certeau, the idea of giving voice to minority cultures was a salient feature of the events of May 1968. De Certeau believed in the 'exemplary value' of the immigrant to the French State. In language with striking parallels to the Canadian Multiculturalism Act, he said in his seminal book *The Capture of Speech*: "By becoming more open and more tolerant with regard to immigrants, we would also learn how to relativise our codes of conduct, our way of understanding 'high culture', and this would allow us to confer on anonymous inventions the arts of practical creation and everyday culture, and on what is made by

BRIAN JUNGEN
Prototype for New Understanding #7
1999, Nike athletic footwear
Collection of Joe Friday, Ottawa, courtesy Catriona Jeffries
Gallery, Vancouver and Carleton University Art Gallery
photo: David Barbour

practitioners of everyday life their own cultural role."[4] De Certeau also argued for public assistance and regional endowments to minoritarian and regional cultures, again in language similar to officially ratified policy in Canada.

Canadian intellectuals beginning in the post-Second World War administration of Louis St Laurent and continuing through to that of Pierre Trudeau theorised that Canada's own cultural landscape would develop to resemble what inevitably the global cultural landscape would become. As such, Canada would occupy the high ground of the world's future. What is more is that multiculturalism would have the political advantage of an idea born out of difference with the United States. In lieu of America's melting pot, Canada advanced the image of the Canadian

mosaic. Rather than a culture rooted in individual sameness, Canada's society would be rooted in consensus from difference. Or at least that was the idea. What Canada did not anticipate was a world in which nations would redefine their particular cultural and foreign interests in fundamental ways. It did not anticipate a world in which private actors would become such a threat to public functions, nor did it anticipate the resurgence of the United States in monopolising the world's foreign policy. Lastly, Canada did not anticipate that its agenda of multiculturalism would be resisted by the turns of history itself as concerns about demographic balance have deepened rather than abated.

The critical socio-historical period of time during which the contemporary discourse of

Canadian culture was produced spans from the 1950s through to the beginning of the 1970s. Undoubtedly there were many formative events in the history of Canadian culture predating this period that can be cited; for example, the founding of Canada's first public radio broadcasting in 1932. But the 20 years of the 1950s and 1960s represented two decades in which an unprecedented number of cultural propositions passed into legislation with the mandate of fostering, promoting and defending Canadian cultural production and services. During this period the federal government of Canada passed the National Film Act, the recommendations of the Royal Commission on National Development in the Arts, Letters and Sciences, the Broadcasting Act, the Canada Council Act, the recommendations of the Report of the Royal Commission on Publications, the Canadian Film Development Corporation Act and the Telesat Canada Act, which established a crown corporation to exclusively provide satellite communications services to Canadians.[5]

Canada has the ambiguous fortune of sharing its border with the United States of America, the world's largest producer of cultural commodities. The high standard of living enjoyed by most Canadians is a consequence of Canada's vassal economic relationship with its southern neighbour. In matters of culture, Canada cannot make decisions without looking over its shoulder, as Canadians are ever conscious of the imperatives of their geopolitical location. In the immortal words of former Canadian Member of Parliament Robert Thompson:"The Americans are our best friends—whether we like it not."[6]

To American eyes, cultural sovereignty is little more than another thorny issue in the litigious world of economic and trade negotiations. The degree to which cultural issues are entangled with trade issues that in turn spill into questions of national sovereignty can be illustrated with a recent ruling by the World Trade Organization against the European Community in favour of the United States on the matter of bananas. Americans cited the victory as it sought punitive

actions against Canada for its legislation against so-called "split-run" magazines that siphon off advertising revenue from smaller Canadian publications by satellite printing twice an issue of, say, *Time* magazine to accommodate advertisements from Canadian sources. Canada objects to "split-run" magazines because they undermine the viability of Canada's publications industry while catering mostly exclusively to American or foreign editorial content.[7]

Canadian cultural policy, from its inception, was guided by many elements of the Old Left's criticism of America's society of unfettered capitalism. Canada has always been socially democratic in its organisation of its capitalist economy. Canadian intellectuals have traditionally worked in concert with the national government to formulate an intermediary position for Canada between left and right ideologies, first and third worlds. As a contiguous neighbour of the United States, it was necessary for Canada to define its liberalism deftly, with an incomplete character. It was an ascending view that by the late 1960s conventional Left/Right divisions and definitions had been displaced by the idea of global conquest by one or the other superpower. This was a political view shared by many countries including communist ones, the most important being China, a country Canada formally recognised during the Trudeau administration to the then consternation of the United States and well in advance of the same decision later adopted by many Western nations. The formulation for Canadian cultural policy, therefore, both in its domestic and external uses, had to be a metaphysical formulation without direct reference to specific political resolution or commitment.

Under these paradoxical conditions in which the level of general wealth to Canadians is assured by its highly interlocked economy with the United States but at the expense of a deep moral compromise to Canada's cultural integrity, Canada devised to constitute itself heterogeneously. Such a metaphysical response to the moral hankering of nationalism owed much to the spryly articulated ideas of Canadian thinkers such as Harold Innis and Marshall McLuhan. During the two decades immediately following the Second World War, Innis and McLuhan propelled Canada to a leadership role in transportation and communications theory. Both were intellectually indebted to the liberal-pragmatist perspectives of John Dewey, Max Weber and Emile Durkheim. In the case of McLuhan, there was never a glint of despair and foreboding in his views about Canada's place in a technologically revolutionising world, at least not until the end of the 1960s, when the project of developing a new cultural infrastructure was fully in place.[8]

McLuhan's thoughts about a future Global Village of electronically rendered synchronic relations and about the degree to which reality is shaped by the effects of media have proven brilliantly prescient. While cautious about the possible dangers posed by changing technologies, McLuhan was generally positive in his outlook of its applications. He wrote in 1961 that: "The compressional, implosive nature of the new electric technology is retrogressing Western man back from the open plateaus of literate values and into the heart of tribal darkness, into what Joseph Conrad termed 'the Africa within'."[9] Such an idea was taken as a directive by Canadian policymakers to ensure that Canada maintained a position of mediation between an increasingly communications-based modernity that signalled the advent of what has come to be known as globalisation and fundamentalist reactions which could lead to the return of ultra-nationalist sentiments. Presaging such a role for Canada and the implementation of multiculturalism as a policy of state, McLuhan said: "Individual talents and perspectives don't have to shrivel within a detribalised society; they merely interact within a group consciousness that has the potential for releasing far more creativity than the old atomised culture. Literate man is alienated, impoverished man; detribalised man can lead a far richer and more fulfilling life—not the life of a mindless drone but of the participant in a seamless web of interdependence and harmony."[10] Also in 1961, McLuhan predicted during an address to the Humanities Association of Canada, that the arts and sciences in Canada would experience an era of unprecedented accomplishment.[11] Many Canadians, including the burgeoning numbers of separatist nationalists in Québec shared McLuhan's optimism albeit with different objectives in mind.

That same year saw the publication of Jane Jacobs' seminal book, *The Death and Life of Great American Cities*, one of the most influential books in the history of urban studies.[12] Her indictment of the failure of urban life in America, which she attributed to a general moral failure in American society as a whole, was a case lesson for Canadians who by and large lived in far safer and cleaner cities. Many of the problems confronting the United States seemed to elude Canada. While the razing of Pruitt-Igoe, the poster child of America's failed housing projects, evoked the twin scourges of poverty and racism, Canada showed off Habitat at Expo '67, an innovative and supposedly inexpensive housing solution for the world.[13] McLuhan's complaint that "Canada is a bore" seemed a small price to pay in exchange for a sense of smug superiority over Canada's superpower neighbour. Canadians felt prideful of their country and of their Prime Minister Lester Pearson, who had won a Nobel Peace Prize in 1957 for his role in mediating the end of the Suez Crisis. The Pearson achievement was taught to Canadian schoolchildren as an example of the manner to which Canada should seek self-definition, through support for multi-lateralism in its outward voice and multiculturalism in its domestic voice.

The apogee of Canadian self-confidence came in 1967 in Montréal during Expo '67 with its utopian theme of Man and His World. In the centenary year of Canada's founding, a world class exposition took place that projected a remarkable range of ideas on improving the future of humanity through the use of new and emerging electronic advances. The spirit of Canadians McLuhan, Innis, Glenn Gould, Moshe Safdie and Lester Pearson permeated the fair, not to mention Americans Buckminster Fuller, Alvin Toffler and Lewis Mumford, of whom the National Film

Board of Canada had produced six films based on his ideas about the history of urbanity. By 1967, McLuhan was in monthly consultations with Lester Pearson to which Pierre Trudeau was an important member of Pearson's inner cabinet.[14] The optimism of the centennial celebrations carried over into 1968 with the election of the youthful and worldly Trudeau while the conclusion of the "love year" of 1967 in the United States ushered in one of the most violently radicalised and apocalyptic years in American history. It became a Canadian cliché of 1968 to mention the stories of Canadians watching American cities burn from the comforts of their homes just across the border. That same year, Jane Jacobs would herself make the move to Canada, settling in Toronto, a city she has consistently praised for its urban fabric. To Canadians, the future could not seem brighter. This applied to Québec as well where the future seemed assured despite often divisive and vigorous debates among that province's intelligentsia about how best to fulfil Québec's rendezvous with destiny.[15]

Unlike Canada today, passenger train travel was still important in 1967 and many Canadians traveled by rail to the Montréal exposition. For those who could not visit the fair, the fair would come to them. An important adjunct to Expo '67 was several so-called "Confederation Trains" that traversed the nation in every direction that the cross-continental railway tracks would lead them. The bridging of the Canadian expanse by train is an important symbol of almost mythical dimension in the narrative of Canada. The "Confederation Trains", redolent in mythical connotations of Canadiana, were in essence an updated version of the Agit-Prop trains of the early Soviet period. Symbolically, they presaged the establishment of a nationwide network of art collectivities emanating from the centre and extending to the farthest margins. They also issued the hope of a future released from regional tensions, including regional nationalism, through a horizontally syndicated state that could respond to all parts of the country and all minority groups within it in non-hierarchical and non-conforming ways.

The operating framework for art in Canada was developed, in part, as a critique of the American art system. At precisely the time when the infrastructure for Canada's publicly funded artists' gallery network was nearing completion in the early 1970s, there was much concurrent debate about the collapse of art in a social environment which blamed Modernist concepts and rationalisations for the many failings in America's urban life. In art, the early 1970s heralded the arrival of high modernism's point of *reductio ad absurdum*. Conceptual Art's iconoclastic aesthetic politics was as much a critical response to the mounting phenomenon of globalisation and its pressures to disperse previously concentrated cultural discourses as it was a symbol of what Jean-François Lyotard has referred to as "universal finality".[16]

The idea of the end of art or, at least, of the old system of art, appealed to those Canadians who saw this as an historical occasion for Canada to advance a better model, one in which Canadian art and culture could be appreciated through domestically developed criteria. Paradoxically, the Canadian model could serve as an example to the world. Certain nationalists of Canada have expressed the hope that within such an indigenously produced model, aesthetic formalism would cease to be of significant interest to Canadian artists, citing it as an asocial characteristic endemic to contemporary American art. In language that unwittingly echoes the justification for socialist realism, Canadian writer Tom Henighan has argued that art-for-art's sake movements would be of less importance in the absence of a flagrantly materialist environment and a powerful elite of private patrons. Canada's art system would encourage the development of aesthetic heterogeneity and cultural diversity. Canadian art would escape the contradictions of foreign-developed ideas of high culture and the "social corruption of capitalism".[17]

In 1969, the Nova Scotia College of Art and Design in Halifax emerged as the most important art education institution in Canada with a reputation that transcended into the international art arena. Its programme was deeply supportive of Conceptual Art and the school kept a residency studio in New York City.[18] In terms of national identity, it was a time of supreme self-confidence among Canadian artists who were generally open to those features of the new American and European art that could proffer lessons for Canadian art. On the other side of the country that same year, Image Bank was founded in Vancouver. Again, its development was a response to an American model, namely Ray Johnson's New York Correspondence School.[19] Again, Canadian artists would take from American art what offered useful lessons for Canadian art. It is important to be reminded here just how late was the idea of modern and contemporary art in arriving and establishing a modicum of national consciousness in Canada. Prior to the 1950s, artistic modernity in Canada still meant an attachment to landscape painting and other traditional cultural norms of art.

Image Bank borrowed its title from a statement by Claude Levi-Strauss: "The decision that everything must be taken account of facilitates the question of an image bank."[20] Its spirit consistent with André Malraux's concept of a museum without walls, sans Malraux's standard bearer framing of high culture, Image Bank sought to extend art through the postal and other communications systems such as the Telex. It stated its goals in almost Baudrillardian terms sans the double meanings: "As artists we are information, resource, image banks concerned with data covering the spectrum from cultural awareness to professional knowledge… understanding the overall image into potential has enabled us to develop formats which allow maximum involvement while remaining impartial to the specific kinds of information in process, creating a valid information economy."[21]

What is noteworthy here is the parallelism between national artistic development and national economic policy, a conflation that has never met with much concern among Canadian

RODNEY GRAHAM
Torqued Chandelier Release
2005, 35mm silent colour film, 5:00, purpose built
projector, screen
Courtesy the artist and Lisson Gallery

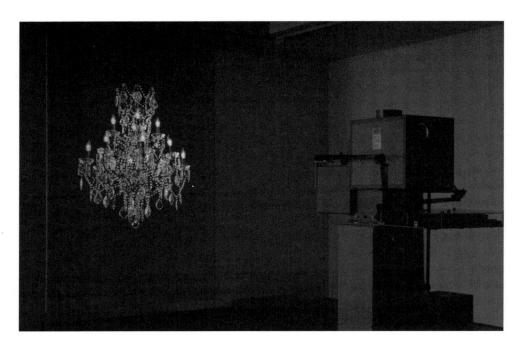

artists, all too eager to accept government largesse without critical reflection of its possible constraints on artistic independence. The American artist Vito Acconci has written that: "The electronic age redefines public as a composite of privates." Acconci worried about the dystopian side of the promise of communications, the image and the spectacle. He worried about the electronic age taking control out of individual hands and placing it: "in the will of the other, whether that other is called God or Magic or The Corporation or The Government". [22] In Canada, the conventional view among most artists, with regard to the question of art and culture, is that the government is good.

And why not? Canadian artists knew a good thing when they saw it. The first artist run centre opened in Toronto in 1971 and within a decade expanded to nearly every part of the country. Almost entirely assisted by public funds, these venues from their inception would highlight multimedia art, performance, installation art, some feminist and racially based art and other art with a socially critical point of view. [23] Many were endowed with the most advance video and computing equipment of the time. Canadian artists would be drawn to these centres in lieu of private galleries which were few in number and generally conservative in what they exhibited.

In a perfect cradle to coffin scenario, a Canadian artist in 1980 could conceivably receive a financial grant from the government to produce work, which could then be shown in an artist run space from which the artist would receive an exhibition fee and perhaps a residency stipend. The artist could get to the place of exhibition with assistance from a Travel Grant. Afterwards, the artist could make a submission to the Canada Council Art Bank to purchase the exhibited art. A jury comprised of other artists, each representative of a region in Canada, would make a decision about purchase. If at some future time, the artist would like to repurchase work sold to the Art Bank, he or she need only pay the original purchase price plus a supplementary charge for storage, maintenance and administration for the period the work was

kept in the Art Bank. The important point is that at every stage of this hypothetical but highly possible scenario, Canadian artists are the ones to don the hats of the curator, the critic and the collector. In the name of a non-hierarchical system of artistic measurement, Canadian artists would be evaluated first and foremost by Canadian artists, peer groups in effect, without the need to rely on expert opinions from non-artists. An adverse effect of all of this intended or otherwise, has been a concomitant weakness in terms of the quality, size and dedication of Canada's corps of curators and art critics. To wit, the complete absence of any book that critically and theoretically addresses in a historically comprehensive manner developments in Canadian art over the last 30 years. [24]

No one has understood the complexities of the contemporary art situation in Canada more than General Idea has. If good art must express an understanding to the life and times of the environment from which it emerged, then General Idea are perhaps the most important Canadian artists of the multicultural era. The art of General Idea has been a consistent expression of all the best and worst characteristics of Canadian artistic

culture, including its bureaucratic proclivities. With the utmost in self–conscious aplomb and grant writing skills, the art activities of General Idea have mirrored the logic of the Canadian cultural infrastructure in all its branches from publications to art production centre. Bureaucracy loves nothing better than to see its own image extended, even if the terms of that extension include mockery. Fittingly, for all its attributes, General Idea always remained but a conception, an invented cultural corporation that in many ways does not exist and never did exist. The same might be said of Toronto, Canada's "de facto" art centre. Speaking in praise of the artistic culture in his home base of Toronto, AA Bronson, a member of General Idea stated: "As for Toronto's diversity, it is clear that Toronto has no specific regional characteristics. It is rather a mosaic of regional characteristics from other parts of the country, here thrust into discontinuous disarray. Toronto is the only Canadian city in which the art scene is continually fracturing, and thrives by that fracturing." [25] Bronson's malapropism is a testament to what Canadian historian Jack Granatstein has quoted from Gad Horowitz as "Multiculturalism is the masochistic celebration

of Canadian nothingness."[26] In difference to Trinh T Minh Ha's notion of "the Centre is a Margin", Canada's artistic centre is neither a centre nor a margin; it is but a centrifuge, a study for specialists in chaos theory.[27]

Today, Canadian culture is beleaguered and everything from multiculturalism to foreign aid and to public support for cultural institutions such as the venerable Canadian Broadcasting Corporation is up and readied for dismantling, reduced by funding cuts to skeletal frames. Worse is the bankruptcy of ideas regarding a retort and a new *raison d'être* that could provide discursive weight to countering the attacks and not merely defending from them.[28] Defenders of the old status quo err in the belief that the re-establishment of former levels of funding would solve all woes. For example, the temporary reprieve from further funding cuts of institutions such as the Canada Council has not meant that the ideological wars against such institutions have gone away. Global multi-culturalism has become a global marketplace of culture, a point perpetuated constantly by Hollywood, Disney and McDonald's, and despite good intentions, it is a development Canada alone can not stand against.

Why this is happening has much to do with the logic of capitalist developments and the collapse of a credible left voice in the world scene. But perhaps it also has something to do with the contradictions in Canadian cultural policy, contradictions that can no longer withstand the weight of the Realpolitik of globalisation. The numerous official acts and legislation involved in the development and defence of Canadian cultural services were intended as a bulwark against what Canadians perceived as the dangerous mass appeal and marketing prowess of American perspectives. The majority of Canadians saw support for federally assisted cultural entities as indispensable services that assured the protection of their cultural interests. Even more impressive is the fact that there has not been a single Canadian artist of consequence in the last 30 years who has not benefited significantly from Canadian government financial assistance in one manner or another, not a single one. Of course, *en contrapartie*, this is also a measure of the degree of insinuation by the government into cultural affairs.

In a world in which cultural issues are increasingly arbitrated under the rules of the World Trade Organization or economic pacts such as the North American Free Trade Agreement, Canada's insistence on the right to exert sovereignty over cultural matters is now viewed with ascendant objection by *laissez-faire* economists as a line-in-the-sand against global free trade. In addition, by revoking the hegemonic assumptions of Canada's two founding nations document, that is, as a country founded by the English and the French, multiculturalism was intuitively counter-discursive. Multiculturalism as a national policy is inherently hostile to the idea of 'nation' while paradoxically it sponsors an idea of essential differences between cultural groups. Franz Fanon has written extensively about the dialectical linkage between nation and culture, that the absence of the former necessarily leads to the emaciation of the latter.[29] As a result, Canadian cultural actions have become increasingly defensive and paralysed, philosophically confused about how best to escape the textual traps set by not only the discourses inscribed in the General Agreement on Tariffs and Trade (GATT), the World Trade Organisation (WTO) and other trade and economic contracts but by its own historical and rhetorical contradictions. *Que faire?* For one thing, recognise the problem of non-identity between cultural politics and social conditions. In 1965, in the midst of rising Canadian triumphalism regarding Canada's cultural and intellectual identity, John Porter published his seminal book *The Vertical Mosaic*.[30] Porter's book was a sweeping and highly detailed analysis of social and economic inequality in Canada; it has since become the primer for subsequent Canadian sociological studies. As implied by the book's title, Canada's official rhetoric of a cultural mosaic masks the pernicious degree to which Canadian society is vertically conceived and administered, from the top down. As a somewhat inverted but analogous comparison, the organisational functioning of Canadian art and culture appears non-hierarchical and horizontally efficacious but what is masked is the protean and assimilative character of its Officialdom.

Lawrence Meir Friedman has decried the rootless and atomised character of American life in terms of a "horizontal society" in extremis.[31] The anomie of contemporary American life is linked to a visual culture dominated by the corporate ethos, a connection that Friedman repeatedly points out but is unable to blame. As Canadian society evolves to bare greater resemblance to the social detachment of American society, Canadian art and culture continues to not only play out but to assertively defend, on behalf of the State, the old rhetoric of an increasingly phlegmatic and false Canadian polity.[32]

ADDENDUM

I should think that at this point in time in the context of a globalised contemporary art scene the question of defining art as an outcome of national character is outdated. It was always a problematic question to begin with since any answer would have been a function of a nation's sense of officialdom. Lawren Harris' programmatic edict that the natural landscape of Canada constitutes what is peculiar to Canadian art elides the many disjunctures and contestations that vexed Canadian national identity at the beginning of the twentieth century. The question is doubly problematic because it implies the conflation of culture with national identity. This invariably leads to notions of "shared values" or "common social purpose". Such terms become the province of those vested with power and influence to define a national identity. Far from being inclusive terms they provide a justification for the othering of those who do not conform.

Marshall McLuhan saw the lack of an identity as a distinctively Canadian attribute. He declared that, "Canada is the only country in the world that knows how to live without an identity." Arthur Erickson argued that Canada's lack of national identity would "prove to be our strength in the next century as the world moves toward a humanity-wide consciousness". He suggests that by having

STAN DOUGLAS
Walhachin
2006, laserchrome print, 185 x 215 x 6 cm
Courtesy the artist and David Zwirner, New York

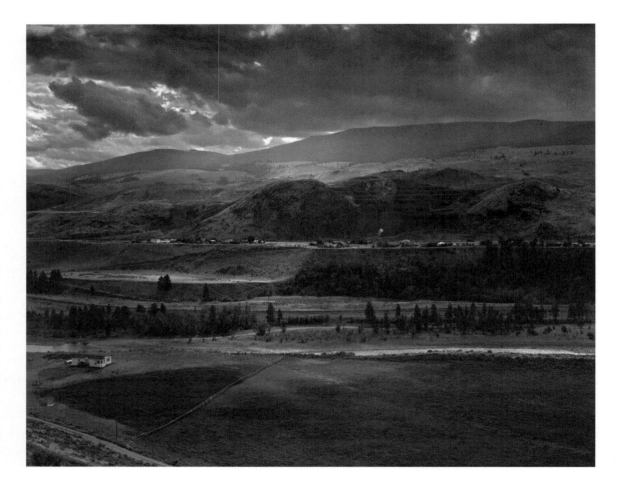

"no history of cultural or political hegemony—
almost no history at all to hinder us—we are
welcomed over all other nations. We are more open
to, curious about, and perceptive of other cultures."

As I have tried to argue, the lack of a strong identity
as an attribute could not be resolved within the
political framework and historical constitution
of Canada. Ironically, much contemporary art,
including by leading Canadian artists, are asserting
just this viewpoint of McLuhan and Erickson,
producing art in the context of increasingly
complex and globalised contingencies.

1 *The Royal Commission on National Development in the Arts, Letters and Sciences*, Chapter Two: The Forces of Geography, Government of Canada 1949-1951, Section 11.

2 Trudeau, PE, *The Essential Trudeau*, Toronto: McClelland & Stewart, 1998, p. 146. The full passage is: "Uniformity is neither desirable nor possible in a country the size of Canada. We should not even be able to agree upon the kind of Canadian to choose as a model, let alone persuade most people to emulate it. There are surely few policies potentially more disastrous for Canada than to tell all Canadians that they must be alike. There is no such thing as a model or ideal Canadian. What could be more absurd than the concept of an "all Canadian" boy or girl? A society that emphasises uniformity is one which creates intolerance and hate. A society which eulogises the average citizen is one which breeds mediocrity. What the world should be seeking, and what we in Canada must continue to cherish, are not concepts of uniformity but human values: compassion, love, and understanding."

3 Trudeau, *The Essential Trudeau*, p. 177.

4 Certeau, M de, *The Capture of Speech*, Minneapolis: University of Minnesota Press, 1997, p. 135. Much of de Certeau's book is an analysis of the events of May 1968 with the central perspective that the events represented a collective demand for personal emancipations extending to previously unheard or unrecognised voices, a development that would lead to what he hoped would be a new culture in France.

5 National Library of Canada website at www.nlc-bnc.ca.

6 Granatstein, J, York University Faculty of Arts Research Fiches at website: huma.yorku.ca For an historical accounting of Canadian anti-Americanism, see: Granatstein, J, *Yankee Go Home?*, Toronto: HarperCollins, 1996.

7 Hansard, "Foreign Publisher Advertising Services Act", *Parliament of Canada*, no. 140, 22 October, 1998.

8 Marchand, Marshall McLuhan, *The Medium and the Messenger*, Toronto: Vintage Canada, 1989, p. 219. Marchand here discusses McLuhan's thinking that television may not "cool" people down but may exacerbate social tensions by its tendency to imbue images with iconic significance.

9 McLuhan, M and F Zingrone (eds), *The Essential McLuhan*, Toronto: House of Anansi Press, 1995, p 258. This quote is from McLuhan's famous 1961 interview in *Playboy* magazine in which he discusses many of the social issues afflicting Western society including racism, US politics, changing sexual mores, social unrest and violence.

10 McLuhan, *The Essential McLuhan*, p. 259.

11 Marchand, *The Medium and the Messenger*, p. 159.

12 Jacobs, J, *The Death and Life of Great American Cities*, New York : Vintage Books, 1993.

13 For an exclusively semiotic analysis of the controversy surrounding the Igor-Pruitt housing project in St Louis, Missouri, see Charles Jenck's 1977 book, *The Language of Post–Modern Architecture*, 5th edition, New York: Rizzoli, 1987. Jenck's argues that the failure of Igor–Pruitt is owed to a problem of non–identity between the poor inhabitants of the project and the erudite architects. Elizabeth Birmingham, Lee Rainwater and others have criticised Jenck arguing that structural racism was a central issue for its failure. For more, see E Birmingham's excellent text "Reframing the Ruins: Pruitt–Igoe, Structural Racism, and African American Rhetoric as a Space for Cultural Critique", in *Positions*, 1998, No. 2.

14 Marchand, *The Medium and the Messenger*, p. 196.

15 See Pierre Berton's *1967: Canada's Turning Point*, Toronto: Seal Books, 1997 for a discussion of Québec nationalist sentiments erupting during the controversial visit of French President Charles De Gaulle to Expo 67 and his exhortation of "Vive le Québec libre!" Equally agitational was the publication of Pierre Vallières manuscript "White Niggers of America". Vallières' text was another clarion cry for the separation of Québec from Canada. It garnered significant sympathy from independence groups the world over, including many voices from non–aligned countries.

16 Lyotard, JF, *The Postmodern Condition: A Report on Knowledge*. Translated by G Bennington and B Massumi. Minneapolis: University of Minnesota Press, 1984.

17 Henighan, T, *The Presumption of Culture*, Vancouver: Raincoast Books, 1996, pp. 10–11, 63, 120–121.

18 AA Bronson, *From Sea to Shining Sea*, Toronto: The Power Plant Gallery for Contemporary Art, 1987, p. 42. Noted visitors to NSCAD include Joseph Kosuth, Michael Asher, Dan Graham, Jan Dibbets, John Baldessari, Jackie Winsor and others.

19 Bronson, *From Sea to Shining Sea*, p. 41.

20 Bronson, *From Sea to Shining Sea*, p. 41.

21 Bronson, *From Sea to Shining Sea*, p. 41.

22 Mitchell, WJT, *Art and the Public Sphere*, Chicago: University of Chicago Press, 1992, pp. 172–73.

23 As such, there was a particular look or at least approach to Canadian Art predicated on the idea of aesthetic dissemination, technical literacy and social concerns, primarily issues of identity through space and time. Somewhat ironically, as the New York and European Art World loses some of its drawing power due to dissemination of contemporary art interest in the rest of the world, it still retains its influence through a more horizontally conceived syndication of its structure. This contradiction, somewhat Canadian in character, has resulted in another irony. International Art now looks very much like Canadian Art has looked since the 1970s and 1980s, adopting many of the formal strategies long developed and employed by Canadian artists.

24 Dennis Reid's *A Concise History of Canadian Painting* of 1973 is the last useful book to examine comprehensively an important component of Canadian art, that of painting. It does not cover developments in Canadian painting beyond 1965.

25 Bronson, *From Sea to Shining Sea*, p. 12.

26 Granatstein, J, *Who Killed Canadian History?* Toronto: HarperPerennial, 1998, p. 108.

27 Trinh T Minh Ha, "No Master Territories", published in *The Post-Colonial Studies Reader*. London: Routledge, 1995, pp. 215–218. See Tony Manera's *A Dream Betrayed:*

28 *The Battle for the CBC*, for a measure of the incapacity of many of Canada's cultural mandarins to respond effectively to downsizing pressures. Tony Manera was the former head of the CBC. Also see Tom Henighan's *The Presumption of Culture* for an analysis of Donna Scott' s "indifferent" and "ineffectual" response to threats to the Art Bank. Donna Scott was head of the Canada Council Art Bank.

29 Fanon, F, chapter entitled "On National Culture" reprinted in *Colonial Discourse and Post-Colonial Theory: A Reader*, New York: Columbia University Press, 1994, pp 50–52. Chapter entitled "On National Culture" reprinted in *Colonial Discourse and Post-Colonial Theory: A Reader*, New York: Columbia University Press, 1994, pp 50–52.

30 Porter, J, *The Vertical Mosaic: An Analysis of Social Class and Power in Canada*, Toronto: University of Toronto Press, 1965.

31 Friedman, LM, *The Horizontal Society*, New Haven: Yale University Press, 1999.

32 For an interesting analysis of the cooptation of Canadian culture by administration, see Krysztof Wodiczko's presentation of June 14, 1983 to a Toronto art audience and later published in the April/May 1994 issue of *Parallelgramme*, the official journal of Canada's alternative gallery network.

BOUNDARY ISSUES:
THE ART WORLD UNDER THE SIGN OF GLOBALISM
PAMELA M LEE

First published in *Artforum*, November, 2003
Copyright *Artforum*

You could call it a pathology of self-definition. Either that or a severe case of "boundary issues". For close to ten years now, that ambient phenomenon known as the art world has been hit by what amounts to an identity crisis, more often than not figured under the sign of globalisation. Flip through the catalogues and magazines, survey the principal actors and bit players, track the ever-proliferating biennials—from Sao Paulo to Shanghai to Istanbul—and witness the art world's struggle to rethink its audiences and range of influence, its norms and procedures. But just how precisely has the art world addressed the conditions of "multiplicity, diversity, and contradiction"—the defining characteristics of the contemporary experience, according to Francesco Bonami—coextensive with the processes of globalisation? There is the lurking suspicion shared by many longstanding art-world participants that "the Global" has simply assumed the throne formerly held by likes of the Postmodern, the Multicultural, the Simulacra, and the informe (and not unlike the operations of formlessness, globalisation's neoliberal consequences may prove thoroughly abject).

I would argue that the way the art world conceives of itself determines its treatment of globalisation. Indeed, the conventional understanding of the term "art world" betrays a set of prejudices under threat by the very global conditions the contemporary art world seeks to represent. In common parlance, the "art world" signifies a society of individuals and institutions—a social, cultural, and economic world organised around museums, galleries, and the art press and the legions of artists, critics, collectors, curators, and audiences who have truck with such sites. The image of this world is typically one of gala openings and social privilege—at once a specialised community and the locations that community would occupy (the New York art world, for example, or the gallery scene in Los Angeles)—and decidedly Eurocentric in its orientation. So it makes perfect sense that the art world thus conceived would seem stricken by both geopolitical anxiety and a peculiar giddiness about the current state of global affairs. For one thing, as demonstrated by the numerous high-profile exhibitions on the topic, the art world now appears embroiled in a turf war, in which its official institutions (namely, museums, those loci of art-historical knowledge) are imagined to defend their proprietary interests from global "outsiders" and their curatorial incursions. By the same token, something of a colonial logic underwrites the expansion of the art world's traditional borders, as if the art world itself were gleefully following globalisation's imperial mandate.

We can hardly avoid using "art world" in the everyday sense of the term—it's simply too convenient, too deeply embedded in our vocabulary— but a brief look into its provenance as a philosophical term of art might be instructive in analysing the current struggle to effectively engage the global problematic. Perhaps the most influential postwar articulation was formulated by Arthur C Danto in 1964. Taking Warhol's *Brillo boxes* as his case study, Danto's essay "The Artworld" asked after the first principle of philosophical aesthetics: What separates a work of art from non-art, the readymade from the commodity? The art object, he argued, must exist in an "atmosphere of interpretation" with other artworks, which would in turn serve as comparative vehicles of interpretation. As he put

it, "To see something as art requires something the eye cannot decry—an atmosphere of artistic theory, a knowledge of history of art: an artworld." Danto argued that an object is granted the status of art if it can be conceptually linked to objects already deemed art; and a theoretical claim—an aesthetic theory—was required to justify that linkage. "There is no art without those who speak the language of the artworld," Danto reasoned. "The artworld stands to the real world in something like the relationship in which the City of God stands to the Earthly City." The art world, this Augustinian analogy implies, is a theoretical paradigm; and what comes to count as art today must necessarily find its "place" in that divine city. Like all good paradigms, however, the art world must be able to accommodate new languages and ideas in a perpetual state of conceptual readiness. "The world has to be ready for certain things," Danto wrote nearly forty years "so "the artworld no less than the real one."

Danto's approach proves useful in parsing the global problematic, as it underscores the need for a theoretical paradigm equal to the task of accommodating the vast changes witnessed in the art world and artistic production at large over the course of the past decade. But whether the art world is a theoretical atmosphere or an institutional elite (complete with the secret handshakes that grant membership into its society), the question remains: What happens to the art world when the world itself is progressively aestheticised under the regime of global spectacle? And, further, what happens if the art world's institutional context has expanded beyond measure, in excess of the nationally inscribed institutions of the "official" art world (i.e., Europe and the United States)? On the surface of things, the institutional art world claims no separation at all from the global "outside"; the language of crisis and contradiction underwriting our current transnational frenzy suggests that exactly the opposite is the case. Moreover, the ways in which the art world has generally represented issues around globalisation—as in last summer's Venice Biennale or in the Whitney Museum of American Art's The American

Effect—suggest that a troubling distance between the art world and the global order still remains.

No doubt a big part of the art world's problem in treating the global issue revolves not only around defining globalisation itself but around evaluating the political consequences that stem from its procedures. Fredric Jameson usefully, if broadly, defined globalisation as "the sense of an immense enlargement of world communication, as well as of the horizon of a world market", speaking to the post-war integration of communicative, economic, and geographical forces and oft-made claims about the collapse of traditional conceptions of space and time with the emergent geopolitical order. The art world's account of the term "globalisation", however, suffers from a certain fuzziness relative to its own practices. To be sure, the words "globalisation", "globality", "the global" and "globalism" (the "ism" here connoting either an ethos, an aesthetics, or a kind of period style—take your pick) bear the peculiar distinction of being both ubiquitous and

amorphous: ubiquitous because inescapable to any semi-informed world citizen and yet amorphous because subject to infinite shape-shifting, especially in the mainstream press. Of course, the student of the global knows full well that globalisation does mean many things, bound up at once in the rhetoric of galloping free markets and in the lingering specter of Marx, simultaneously producing homogenisation (read: Americanisation) and radical hybridity. What's more, the fallout of such processes has sparked ferocious debate concerning globalisation's political ends—whether or not it serves progressive or reactionary purposes. Where exactly should we stand vis-a-vis a New World Order that gives rise to the Battle in Seattle and to the so-called "War on Terror"? To the "multitude" and the Nike army alike? The lack of consensus around globalisation's terms and implications is arguably what endows it with both its acutely anxious charge and its capacity to be generalised to the point of meaninglessness. Like the art world's treatment of postmodernism

MARTHA ROSLER
O'Hare (Chicago)
1989, C-print, 67 x 102 cm
Courtesy the artist

two decades earlier, the semantic stalemate around globalisation is typically resolved by conceding to the plurality of its definitions. And that's part of the problem as well: In the art world's weakest iterations of the topic, it all seems like so much old-school pluralism, the bad dream of the postmodern that Hal Foster long ago characterised in terms of the world market. "The pluralist position," he presciently wrote, "plays right into the ideology of the 'free market.'" Globalisation, to follow this model, translates into "the far-flung from all over," an "anything goes" approach to recent art in which floating buzzwords "conflict," "tension," and "contradiction" may be enough to move some less than compelling product.

Typically, the ways in which the art world has addressed the global question rest with the logic of representation. Representation assumes several meanings in this context: It pertains, first, to the institutional visibility of the discourse around globalism, the degree to which museums, galleries, critics, artists, and cultural consumers feel the need to pay attention to the topic, and, second, to the diversity of artists, locations, and cultural perspectives increasingly included in the art world's discourse. It goes without saying that this is no small thing, neither the opening of the art world to artists typically shut out from it (i.e., artists from Asia, Africa, Latin America appearing in biennials located in Johannesburg, Tirana, and Havana) nor the instrumental role played by curators and critics in that very opening. For those once embroiled in the culture wars, such institutional arrangements in response to global demands for representation may recall the struggles over identity politics that marked the late 1980s and early 1990s. And what the multiculturalism episode taught us, for better or for worse, is that such gains are not only hard-won but also deeply precarious.

But by far the sort of "globalist" representation most easily assimilated by the art world is the imagery of globalisation. Lately we've seen our fair share of the aesthetics of passports and Coca-Cola: At the Venice Biennale alone we witnessed

Santiago Sierra's Spanish Pavilion, accessibly only to Spanish citizens with the documentation to prove it, and Kader Attia's vending machine that dispenses passports and soft drinks alike. If objects such as these represent articles of faith for the art world's global acolytes, the image of the airport and systems of transportation in general has become their summa. What better means to convey the expediency of markets, the freedom (or trauma) of placelessness, and the cultures of immigration and tourism than the alien space of the airport terminal? The kinds of pairings that result from this iconography doubtlessly underscore the business of "conflict" and "contradiction" emblematic of the global question, but too often, the superficial emphasis on image and theme comes at the expense of critical readings of the work. Shots of cargo containers by the Milanese artists' collective Multiplicity propose quite different things from an Allan Sekula series involving the same. You can lump together a picture of a tarmac by Andreas Gursky with a Martha Rosler photo of an airport lounge, but the comparison will be spurious at best, the kind of category error art historians rightfully brush off as "pseudomorphology".

The art world, in other words, has responded to contemporary geopolitics largely through representations of the global and its thematics. Its approach is a kind of globalism, what I earlier referred to as an aesthetic or "period style." But this tack offers a relatively limited picture of the sociopolitical situation, reflecting an art world that still sees itself as distinct from the "real" world "outside" it, analogous, say, to the way that a figure is positioned in relation to its ground. Apart from the nods we dutifully make to expanding networks of communication and the broad recognition that globalisation may change the way we go about our art history, we must keep in mind that globalisation is as much a process as a thing and that the "atmosphere of theory" which Danto identified as the "artworld" may move us closer to thinking critically about our relationship to those processes. Case in point: consider how we all contend with the banality of the airport (aside from its glossy image in the iris prints that regularly turn up at galleries). By now, any number of people have noted that citizenship in the art world is measured by the number of frequent-flier miles one chalks up in the service of the business. A few months ago,

I conversed with a well-known artist about his extensive international travel; and the staggering number of miles he sheepishly volunteered confirmed this thesis without his being familiar with it. The point, basic though it may be, is that activities constitutive of the art world's horizon are indivisible from the activities of globalisation itself. What we treat as a given to our *métier* is, in fact, immanent to the processes we usually associate with the emerging transnational order. And if it's a theory of immanence we're looking for, we might take a page from the most cherished manifesto of the antiglobalisation movement, Antonio Negri and Michael Hardt's *Empire*, 2000. Let's admit these are strange days when a book that makes ample reference to Spinoza, Machiavelli, Deleuze, and Duns Scotus accrues a kind of pop-culture stardom. Strange, too, is Negri's celebrity in art-world circles, given the book's relative quiet on the subject of art (the one art-historical reference in the book's 478 pages is—appropriately enough—Serge Guilbaut's canonical *How New York Stole the Idea of Modern Art,* 1983. Nevertheless, Negri's art-world acclaim was much in evidence at Documenta 11—for which he had contributed, with Hardt, an essay to one of its "platforms" on democracy—no less than at last summer's Venice Biennale, where the phantom presence of Empire was all-pervasive (and hardly a stone's throw from Padua, where the autonomist movement with which Negri was associated in the 1970s committed some of its most violent acts). Should we take the book's energetic rhetoric of multitudes and counter-Empire seriously, however, we need acknowledge the particular language of immanence it borrows from Spinoza and Deleuze. A theory of immanence stresses the here and now against the dialectical or transcendent; as it is thought through the logic of globalisation, it suggests that there is no longer any global "outside," no Archimedean point from which to survey the workings of globalisation with cool, critical distance. It bears saying that numerous critics have challenged Negri and Hardt on this point, but for the immediate purposes of discussing the art world, the plane of immanence finds metaphorical expression in a telling (and in this context, uncanny) turn of phrase. On the coming of counter-Empire, Hardt and Negri write, "This is the founding moment of an earthly city that is strong and distinct from any divine city."

One is loath (or at least seriously reluctant) to equate the workings of the art world with the multitude or the earthly city (and while some of us may well be self-identified cultural labourers or even simply workers, far too many others would seem to rule by sovereign decree). Regardless, the unintended reversal of Danto's Augustinian metaphor forces us to confront our methodological shortcomings on the global question, bringing the art world down to earth, so to speak. Indeed, our most urgent challenge is to account more critically for the way the art world has internalized the conditions of the global as its daily habitus: its institutional, political, and economic imperatives as well as its artistic and critical ones. And we need to productively rethink the "art world" as itself a mode of immanent global production, not just as a passive mirror reflecting the sweeping geopolitical changes thought to remain outside of it. Let me repeat Danto's words as an injunction to our own practices as artists, critics, curators, historians, and audience members: "The world has to be ready for certain things, the artworld no less than the real one." This "atmosphere compounded of artistic theories" must be ready for the day when the art world's traditional borders are indivisible from those of the global order we are inclined merely to portray.

ART IN THE FIELD OF ENGAGEMENT
MARTHA ROSLER

First published in *Artforum*, September, 2004 as "Out of the Vox: Art's Activist Potential"

Art with a political face typically gains visibility during periods of social upheaval."Marxism and art" of the 1970s and "political art" of the 1980s are among only the most recent labels for such work. A good proportion of artists typically aim their work into the thick of things, but institutional gatekeepers try to manage this political dimension of art, blunting artists' partisanship into a universalised discourse of humanistic ideals and individualised expression. Virtually all avant-gardes and art-world insurgencies, from Constructivism to Dada to Abstract Expressionism and beyond, have suffered this reinterpretation.

But the game changed again when curators with a bent toward geopolitics organised successive recent Documentas, confirming an international trend that legitimated some political expression in art, mostly work fitting the rubric of postcoloniality, but also collaborative and extra-institutional work, such as Park Fiction, Superflex, and Raqs Media Collective. (A commonly voiced witticism emerged, however, suggesting that to be a "postcolonial artist," you had to move to Europe and become a market artist; similar reframing problems attend "artworld-exogenous" importations, whether from artists working long term in local communities or graffiti artists and skateboarders.)

Generally speaking, a lack of clear political alignments—call it "artistic autonomy"—works well for most Western artists and their institutions. Who are we, after all? What are our allegiances? "Embourgeoisement"—in home, health, family, and leisure—has for many supplanted bohemianism, making it harder to identify too strongly with the dispossessed, the dejected, and the disenfranchised, let alone with those whose labour is exploited."Fine!" mutter those who observe how little use the organised Left has had for artists. But the total freedom of the artist in Western society also ineluctably signals total irrelevance, just as obsessive interiority speaks of social disconnection and narcissism, if not infantilism. The collapse of utopianism as a horizon has often deprived art of a philosophical or ethical back-story, allowing curators to treat whimsical activities—tartly termed "sponsored hobbies" by Russian curator Ekaterina Dyogot—as symbolic of autonomy, of artistic advance, or even of social transformation. Thin notions of communalism pass for social engagement, and weak interpretations of art as a gift freely given reduce the claims made for its socially transformative to a therapeutic "time out" for atomised individuals—the new post-bourgeois subject performing self anew every day.

I am at best ambivalent about the return of "political art" as a flat field of action or analysis. Fashionability makes work under this rubric susceptible to dismissal. Much worse, artists are hailed as merry pranksters, as some curators actively celebrate the frivolously empty riff—by what might be termed the Monkees of the artworld—on 1960s collectivism. Conversely, there is a sad superficiality in reducing art's political possibilities to agit prop, ignoring the debates about the instrumentalisation of art between Adorno, Brecht, Benjamin, and others. This thought recently drove me—and by odd chance, the young activist/artist reading group at 16 Beaver—to revisit Theodor Adorno's 1962 article "Commitment" in which art is said to provide a silence and reproach to the deformations of modernity: "Today every phenomenon of culture, even if a model of integrity, is liable to be suffocated in the cultivation of kitsch. Yet paradoxically in the same epoch it is to works of art that has fallen the burden of wordlessly asserting what is barred to politics."

One stumbles over "wordlessly asserting," over Adorno's expressed scorn for "information theory" in art, for much today depends on direct information retailing. Especially since the Seattle protests of 1999, many activist artists find they can't be bothered with the artworld and what art historian Chin-tao Wu has called its "enterprise culture." The end of Socialism as a comprehensible political framework means that "interventionism" looks to various inflections of anarchism (some much better theorised than others, some virulent toward artworld institutions of every stripe) or flies theory-blind. Electronic art forms have provided a moment of activism—as in "tactical media"—and often sophisticated political analysis, available online (of course) at a number of sites—"The revolution will be webcast!" writes Geert Lovink.

MARTHA ROSLER
Semiotics of the Kitchen (opposite)
1975, performance and video, 6:00
Courtesy the artist

GUERRILLA GIRLS
Guerrilla Girls Montage (below)
2006–2009
Copyright Guerrilla Girls, courtesy www.guerrillagirls.com

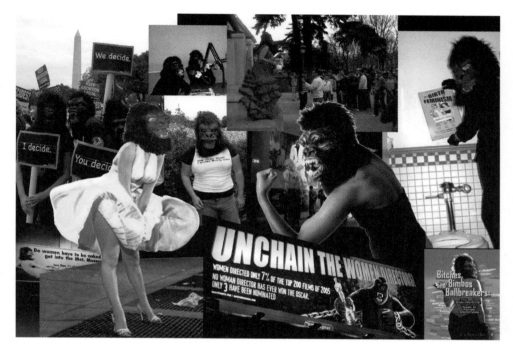

Activists and hacktivists have stepped into the space vacated by video, whose expansively utopian and activist potential has been depoliticised, as "video art," much like photography before it, was removed from wide public address by incarceration in museum mausoleum sites and in collectors' cabinets. In other words, by "success", which has often managed to suck out of it its living vitality in favour of its brand.

In the present context, the political work of the late 1960s through the 1970s—now purged of exigency and brought out of the closet by the market cycle— may be evaluated differently from its original meaning and context. Although this older work may be tinged with nostalgia for young artists likely to have encountered it in art history classes, it may offer a starting point to connect with, an ur-moment that all trends in art like to locate. What initially seemed attractive for its look becomes more compelling for its commitment.

At its best, Conceptual and other post-Pop forms of art led to a tremendously productive encounter between artists and the "life world," providing a space for deduction, exposition, and insight, as well as self-revelation and play. Play, including (postmodern) irony and parody and a subversion of officialdom, becomes more evident the closer one gets to the present—though it started with the Yippie guerrilla performances, as well as musical groups like the Mothers of Invention, the Fugs, and Country Joe and the Fish. Artists' groups of the 1960s and 1970s were mostly organised around public actions, adopting the protest style of the day. West Coast women, such as Suzanne Lacy and Leslie Labowitz or the Waitresses, were more likely to engage in civic-square performances. Many of the 1980s collectives in New York set up ad hoc shadow commercial-gallery structures, while others like PAD/D, REPOhistory, and Group Material were operating here and there within established institutions and more public venues. Groups bridging different times and practices range from the Bread & Puppet Theater to the Zapatistas (not an art group, of course, despite the public/ published profile of its spokesperson Comandante Marcos), the Guerrilla Girls and the

Critical Art Ensemble (now caught in the Orwellian web of the Patriot Act). Among the more recent examples are ATTAC, Ne Pas Plier, Las Agencias, Sub Rosa, the Yes Men, ®™Mark, Boat-people.org, Disobbedienti/Tute Bianche, and others operating as the dark matter of the counterpublic sphere, in the words of artist Greg Sholette. Media collectives include the long-lived Paper Tiger and Deep Dish and newer ones such as Whispered Media and the post-'99 Indymedias around the world, as well as pirate radio—I am leaving out the robust community art and public art movements in the US that have little interest in joining the more mandarin artworld, the one that, say, follows *Artforum* and also does not fit this group of providers of political public actions and spectacles. The practices of many such collectives—most of which might well refuse the artist label —range from left-wing pranks to strategically deployed vandalism and criminality (such as Yomango's choreographed shoplifting). The globalisation of the social-justice movement, the diffuse sites of social labour, and new communication technologies helped create communities that exist primarily through Listservs but finally wind up with feet on streets.

The question, then, is not, Is it art, but Whose art is it? And art for whom? The question is, What is art? If one is to believe, as I do, that art provides a different frame for interpreting experience (although clobbered in its reach by corporate media) and offering the possibility of intelligible political engagement, then the flattening of political art by trendiness or vital but short-term political exigencies is a missed opportunity. The recent turn to Kantian aesthetics mostly emanates from people seeking to renovate a decrepit aestheticism and quash unruly "politicised" practices, but some writers, such as Susan Buck-Morss, seem to be looking to Kant as Adorno did, to support a conviction that art offers a different way of knowing. I am no Kantian, so far. In a moment of unmistakable crisis, in all dimensions, cultural, political, and economic, in the US and the rest of the industrially developed world, and a terrible decline in the lives of those living in Africa and Asia, artists once again, in all self-aggrandisement, seek to reorient their audiences, forming them into public constituencies. Let us also try to figure out what it is about art that is more than what the art world's present regression suggests.

LESSONS OF THE CLASS OF 90: SITING RECENT ART IN LOS ANGELES
JAN TUMLIR

First published in *LA Artland: Contemporary Art from Los Angeles*, London: Black Dog Publishing, 2005

The generation of Los Angeles artists that rose to prominence in the early 1990s is well on its way to becoming the most successful and influential that this city has ever known. On this point about the "Class of 90" there is a developing consensus, though not on much else. Contemporary art is characterised by a wanton multimedia amorphousness that exceeds even the 1970s in its scope and grasp, and nowhere is this more true than on the West Coast where we can now say in earnest that "anything goes". Any sort of analysis concentrating on media, materials, techniques and so on is thereby doomed from the start to irrelevance. Neither is there much to be said on the question of style, or even general sensibility. Any attempt to deal with this work as an isolated phenomenon—as in the "sweet neglect" theory advanced by Lari Pittman and Terry R Myers, which has LA art flourishing not just in spite of a dearth of local collectors or any established system of critical appraisal, but precisely because of it—will progress swiftly from the general to the specific, bypassing most historical, social and economic factors in favour of the object, once again, "in and for itself".[1] However, should we choose instead to work our way backward so as to consider the object an outgrowth of its particular context— that is to say the context it is ostensibly produced for, the context it aims to fill—then certain points of consistency will become at once evident.

In this light, the litany of shortcomings that was once invoked to account for the failure of LA art can be seen more as a positive incentive. Yet it is not neglect per se that benefits local artists, allowing them to concentrate on "the essential" within a system of ever-greater atomisation and anomie, but neglect as a rallying point, binding disparate segments of the artworld around the common goal of building up an infrastructure from scratch. As much as the critical establishment—those (like Dave Hickey, David Pagel and Christopher Knight) who once made the pages of the local journal *Art Issues* into their united front—wants to dress up the new in the guise of the old, returning like something repressed in the intervening two or three decades of Conceptualist dominance (and thereby effectively repressing Conceptualism

instead), their brand of hard and fast revisionism is ultimately way out of synch with the fluid, protean nature of the art in this town. It is no longer theoretically feasible to bracket the realm of practical endeavour off from the other "creative" one. No matter how far and wide contemporary artists may search for inspiration—and the LA school is known to search farther and wider than most—the first concern of production remains context, and the same goes for reception. The first, the context of production, is the more "ideal" (in the Platonic sense) of the two, being the ground zero of the artistic process, but it is not without its own material determinants. For instance, an expansive warehouse studio may yield heroically scaled artworks, while a converted garage workshop will tend toward a more modest sort of output. Moreover, we may want to distinguish between the urban and suburban attitudes that inhere to these different locales, and their attendant bohemian and/or "bougie" connotations. The movement of capital through the physical fabric of the city impacts artists directly, and is directly impacted by them. The search for affordable workspace compels a migration toward the economic hinterlands, whatever they may be at any given time, which touches off the inevitable cycles of real-estate redevelopment and gentrification, eviction and relocation, and so on. It is a familiar story, one that describes the artist's spiraling trajectory throughout just about any big city, although here in LA where the borders between city and suburb, public and private, are subject to constant revision, we have our own special version of it. A famous TV ad for *The Los Angeles Times*, run at the start of the new millennium, sums up this uniquely conflicted sense of place in a succinct montage that opens on the neighbourhood idyll of a blissfully oblivious homeowner watering her front lawn, and then follows the spray to what looks like the flashpoint of an inner city riot.

The city lies between the studio and the gallery, surrounding them both as a common denominator, a general framework that is then subdivided into ever smaller and more specific frames. The context of reception seeks to insulate itself against this overarching influence with a

"white cube" aesthetic, and a persistent logic of autonomy or "art for art's sake". There is nothing implicitly wrong with this, of course; it is just an attempt to extend the open-ended conditions of the work's conception into the realm of display and exchange. Yet, if Conceptualism has taught us anything, it is that this "secondary" context is just as vivid and demanding as the first, and that its hold over production is all the more pervasive the more it is ignored. Rejecting the various emancipatory paradigms that defined the course of progressive art throughout the modern era as Utopian, mythic and basically oblivious to their own material realities, the "idea artists" would instead try to simply narrow the gap between intentional cause and objective effect within a conventional gallery and/or museum context. Of course, Conceptualism's aspiration toward a 100 per cent context-appropriate modus could only yield an aesthetic that was cryptic and bureaucratic in the extreme. This much is by now well established: the object of art was modelled directly upon the institution of art, which was in turn modelled directly upon the archive. Hence, a new art of information whose only concession to the art of the past is a certain residual self-reflexivity, that it be not only "of," but also "about," information as such.

This general game-plan remains vital for the generations that follow, disseminated as it is through the network of colleges, universities and art schools that dominates the area, and where the Conceptual credo holds firm. Frequently described as "Post-Conceptual" (a label that backhandedly attests to the staying power of whatever has supposedly been superseded), recent art from LA is above all hyper-educated. If it nevertheless appears to be coloured by an incipient intellectual sloth (rock on!) this should probably be seen as a reaction to an excess of learning rather than the lack thereof; the more educated it becomes, the more it adopts a posture of "dumbness". Likewise, the recent so-called "turn to beauty" (of Hickey, Pagel and Knight) hardly marks a point of authentic rupture with anything that has gone on before; to treat it as such smacks of rhetorical jockeying. The generation currently ascending cultivates the same practices of inclusivity and hybridisation that have

MARK BRADFORD
Untitled
2009, mixed media collage, 56 x 72 cm
Courtesy the artist

always been part of LA art, and to an even more delirious degree. The 2004 California Biennial, for instance, was full of interdisciplinary, cross-cultural offerings that extended the reach of art into such outlying fields as architecture and urban design (Peter Zeilner and Jeffrey Inaba's VALDES project), internet design (Amy Franceschini/ Futurefarmers), product design (Michelle Lopez), popular music (Mads Lynnerup), documentary film (Kerry Tribe), animation (Koto Ezawa), and so on, all the while resuscitating the full range of prior postmodern strategies that have characterised West Coast production over the past 40 years—everything from kustom kar kulture (Rueben Ochoa) to finish fetish (Kaz Oshiro), via Bay Area funk (Simon Evans)

and assemblage (Mark Bradford). On the one hand, then, the scene can be summed up by those famous words of EM Forster: "only connect". One must always try to bear in mind the intricate web of references and citations, of historical continuities and working-throughs, that subtends every new

cultural development in this town. On the other hand, however, one must also acknowledge the impact of environment in a more basic and immediate sense; that is to say the material environment of Los Angeles, which, to confirm a cliché, often seems anything but material.

Outwardly, that is, history does not seem to count for much in Los Angeles. No pride of place reserved for the old, the patinated, the palimpsested. Out-of-towners are frequently shocked by the open disregard we show our historical landmarks, any of which can be sacrificed at a moment's notice to make way for a new parking lot, a few more lanes of freeway. Nothing here stands in the way of economic movement and mobility. No wonder, then, that Norman Klein has dubbed this city the very capital of forgetting.[2] The boulevards and streets cut right through the built environment, eroding history on every side and laying it to waste, like the mythical river Lethe.

Whether or not one agrees with the characterisation of Los Angeles as the first truly post-historical city, there can be no doubt that this is in effect what most of the world sees, making it the model for every other flickering way-station on the newly globalised circuit of art. London, Paris, Cologne, Havana, Johannesburg, Istanbul—the overriding perception is of the sameness of things, a wearing away of cultural difference so insidious and totalising that any mention of vernaculars should at once strike us as hopelessly nostalgic. A vernacular implies a certain formal resilience, and form does not last in LA. The ultra-pragmatic policy of this city's original planning commission, 1920, still seems entirely relevant in this regard: "A city plan should be prepared from the economic standpoint first, the social or human standpoint second, and the aesthetic viewpoint last."[3] Here, where buildings sometimes seem like merely bumps in the road, the fate of architecture is precarious at best, and yet it is precisely architecture that is on everyone's minds these days. On a recent trip to New York it was noted by more than one observer that LA's young artists are, for the most part, surprisingly well versed in this subject. They think a great deal about architecture and urban design, particularly as these apply to the city they live in, and perhaps most surprising of all, to its history. To those on the East Coast, who see LA as the antithesis to their own longer lasting urbanism, where architecture stands as a palpable crystallisation of time, this seems like a paradox. It is worth recalling, however, that there are probably more historians per square foot here than in any other city in the world, and if form does not last in this climate, some record of it surely will.

Perhaps the point is precisely to do away with the thing so as to make way for the idea—a distinctly anti-materialist tendency that seems to fly in the face of the commonly-held description of Los Angeles as a plastic paradise of rampant consumerism and idolatry. In general one could say that Angelenos have an enormously conflicted and paradoxical relation to things (to the determined "thing-ness" of things) and its artists perhaps even more so. A representative instance is provided by John Baldessari, who decided in 1970 to

send the entirety of his painterly corpus up in flames, exhibiting the outcome in a modest urn as though to commemorate his phoenix-like rebirth as a post-studio idea artist. Outwardly drastic, this gesture can also be read in purely practical terms; it is not compelled by a logic of vandalism so much as recycling. For starters, we can comfortably assume that the paintings he torched were not exactly "hot" to begin with. Economically speaking, at least, the urn simply suggests a more efficient use of space and personal resources. Bearing in mind its particular time-frame, poised between the lavish vista-visions of US art circa 1950–1960 and the leaner years to follow, it makes perfect sense.

Interestingly, however, Baldessari ultimately chose to override Conceptualism's anti-painting diktat. More, many more, paintings would follow in the wake of his ostensibly definitive gesture, but it would be too easy to put this down to a maverick (or better yet, mercenary) tendency. Clearly one cannot simply return to "business as usual" after a shakeup of this magnitude, since Baldessari had managed to erase not only a good part of his own artistic history, but the history that generally inheres to the medium. In effect, painting could no longer be counted on to provide a secure space or surface of inscription, at least not within this particular body of work. Its archival status had been violated, as it were, for good.

That the subsequent paintings would play upon language—and moreover, upon lettering, signage—in such a way as to highlight a zone of indeterminacy between handicraft and commercial fabrication is telling, and sets a crucial precedent, I believe, for a whole LA school of artist/scribes. The lines of influence can easily be traced from Baldessari and such figures as Ed Ruscha and Allan Ruppersberg to the second generation Conceptualists David Bunn, Stephen Prina and Larry Johnson, all of whom perform their own variations on the general theme of privatising the public archive.[4] Bunn, who continues to work with the card files of the Los Angeles Central Library that he "inherited" in 1993, on the eve of this institution's digital turn, provides the most literal instance of this incentive. His ongoing attempt

to derive from this largely bureaucratic source material a kind of concrete poetry, however, is shared by both Prina and Johnson. For example, Prina has done much the same by appropriating the archival holdings of his Cologne gallery, Galerie Max Hetzler, 1991, just as Johnson, for his part, continues to appropriate those telling snippets of industrial signage and promotional verbiage that form the chattering backdrop of everyday life in LA. This practice continues in the work of Frances Stark, Dave Muller and Mungo Thomson, among many others; its meaning and purpose altered as much by their distinct sensibilities as the times they inhabit.[5] Especially revealing in the case of this last group is the emergence, alongside the poetic sensibility already noted, of an increasingly "personalised", or at least "physicalised", aesthetic. Stark, Muller and Thomson have all nurtured a distinct mode *écriture*, once more prioritising the work of the hand as a viable means of transcription.

Time is indeed of the essence in the work of all the above artists. The question that inevitably arises— why bother to physically render mechanically or

electronically generated information?—will not accept a single, final answer. From a present-day vantage, it has already lost its explicitly Pop or Conceptual connotations. The original moment of collision between artisanal and industrial cultures is here distantly echoed, but it is no longer the main event. Somewhere along the line as pluralism and sheer heterogeneity reaches critical mass, annexing every last enclave or holdout of consistency to its own fractured scheme, there begins a vast process of cultural reassessment. Even the simplest statements must now be broken down and sounded out, their meanings reestablished, as it were, from the ground up. Within the text drawings and paintings of Stark, Muller and Thomson, for instance, one gets the distinct impression that something is being built. One letter, word, sentence after another, text layers the available surface like bricks; an edifice of information is raised up incrementally as if to immediately undergo an equally incremental dismantling.

Baldessari's late paintings emerge from the urn and never stop pointing back toward it as a potential

fate. It is the emblem of their ultimate eradication and an archive in itself. The urn contains, and thereby also becomes, art: an idea of art-as-container. This idea resembles the one advanced by Conceptual Art, except for the fact that the container in this case is a common household item, belonging more to the mantle and hearth than the bureaucratic crypt. Of course, Baldessari could not possibly have foreseen the conditions that would extend his gesture from the Situationist 1960s into the simulationist 1980s, and then further, augmenting its appropriateness every step of the way. No doubt it is significant that both decades close on a bum note as recession takes hold, both times stifling this city's potential to develop a "world-class" art scene just as it was about to happen. As the "ultimate commodity", in Adorno's estimation, art is also the first item to get crossed off the list of basic necessities when times get tough. And the artworld follows suit: inasmuch as it can serve as a barometer of financial speculation on the very frontier of real-estate redevelopment, so too does it sound the first warning of economic downturn. When an area nurtured on a rich cultural regime expands to a point where it can no longer sustain its founding bohemia, and artists begin losing their lofts to design offices and pricey boutiques, that is the first sign. The second arrives close behind as, one after another, galleries begin to shut their doors to the public; at this point, all but the most deeply entrenched will be advised to seek cover. In the 1970s, such a state of affairs encouraged a "return to authenticity". In the absence of any viable system of distribution, artists could safely dispense with the commercial posturing that was so characteristic of an earlier pop moment, and resume whatever it was that got them involved in this business to start with. Work became so easy or difficult that its only chance for exposure would have to be state-subsidised: either through the not-for-profit artist-run spaces like LACE, or the museum system as such. Within this climate of mounting economic indifference, it is easy to see how Conceptualism developed its sullen bureaucratic biases. As noted, the generations that follow revisit this experience in the somewhat attenuated form of their schooling. CalArts is known to this day for training artists to enter into immediate conflict with the institutional

hand-that-feeds (which it did ever more lavishly throughout the "boom-times" of the 1980s). When this system collapsed in turn (for the Class of 90, to whom I will now turn, this happened right on time for graduation), "authenticity" was pretty much out of the question—there were massive student debts to repay.

This situation is unprecedented. The sense of having been conned, somehow, was pervasive and devastating and yet, just like a hangover, it could not be articulated, and would find no sympathetic audience anywhere anyway that was not inclined to write it off as privileged whining. Following Ralph Rugoff's ultra-chic "exposé" of CalArts celebrating the art school as a happening "scene" in a 1989 issue of *Vogue*, the magazine articles kept coming: Dennis Cooper's "Too Cool for School" in *Spin*, 1997, Andrew Hultkrans'"Surf and Turf" in *Artforum*, 1998, Deborah Solomon's "How to Succeed in Art" in *The New York Times Magazine*, 1999. On the one hand, these raised the prospect of graduate education, for West Coast artists, to an indispensable rite of passage, while on the other hand, lambasting the whole idea with ever-increasing venom. A gradual souring of the editorial tone can be traced from the first of these articles, which could easily pass for art school advertising, to the last, which indicts art school careerism as the simultaneous cause and effect of the utter corruption of US culture overall. For those who experienced this turn as a kind of "bait and switch" strategy, having bought the art school rap at a premium without preparing for the inevitable payback time, ambivalence is the only answer. If there is any sort of consistent psychological tenor to be discerned in the art that results—stoic, guarded, but underneath almost hysterically sensitive—it might have something to do with these very real economic pressures. The Class of 90 turn inward in public, which is to say that they never really let down their guard. The air of confrontation and critique hangs heavy—another legacy of the intellectualism of the 1970s and 1980s—but its purpose is oddly dispersed, so that while it seems to touch everything and everyone in its midst, it does this so lightly that it might as well be touching no one and nothing at all.

This attitude is perplexing, and all the more so when one considers how long it has survived in the absence of any distinct doxa. The "institution of art" that previous generations had the privilege to critically undermine was now truly in shambles. This new generation—the Class of 90—basically had to develop their work "from either end", production and reception at once. They had to concentrate not just on the object, that is, but the context as well—the space of display, the announcements and ads, the opening, the drinks, and so on. This is the culture that Dave Muller's work commemorates even as it participates within it; a culture already well underway when Three Day Weekend, his convivial party/showspace, first opened its doors in 1994. Much like the gallery he mounted while still a student in his CalArts studio, Three Day Weekend is an exercise in casual curation, responding more to social connection and community building than any strict thematic agenda. Accordingly, its gradually evolving, hyper-intuitive program also provides, at any given moment, a partial glimpse of the new court taking shape around the artist while simultaneously shaping him. Tracking Muller's "rake's progress" through the world, Three Day Weekend has cropped up in a succession of downtown lofts and, more recently, his Highland Park home (as well as, via home and gallery exchange, in Houston, Vienna, Tokyo, Malmö, London and Berlin). Throughout it all, the artist has maintained the role of a beatific host, MC and DJ in one, while always generating a hand-made poster for the affair, this being simultaneously a "gift" to all involved and a unique instance of his own work. With the quick rise up the artworld ladder of Muller and his numerous friends and colleagues, the liberal-democratic interpretations that clung to this practice at the outset have come to include murmurs of careerism and in-club exclusivity—but this only makes it more interesting. In effect, the argument concerning the asymmetry of these two realms of production and reception, which was precisely the critical starting point for Conceptual Art, was rendered close to moot by the end of the 1980s. Increasingly, that is, both would be domesticated.[6]

Tidy up a warehouse loft, apply a fresh coat of paint, and it can easily pass for gallery space—not so a garage, and still less the living or bedroom of a regular apartment or house. But in the late 1980s and early 1990s this is exactly what happened: artists who had moved out of the urban industrial sector (which now enfolded their dwindling production schedules in the logic of a cruel joke) and back into the suburbs, began to show their own work and that of their friends, in situ, so to speak. There are of course precedents for this move, notably the feminist collective Womanhouse, an off-shoot of the CalArts Feminist Art Program spearheaded by Judy Chicago and Miriam Schapiro in 1972. Located in an abandoned residential building, this space provided a context-specific backdrop for a series of performances dealing with subjects such as domesticity and "women's work" that the more conventional artworld tended, at the time, to pointedly overlook. Womanhouse was a response to an experience of marginalisation, which might also be said for these latter instances, except that here it no longer touches on any specific gender, race or class—here it is the economic marginalisation of an entire artistic community that is at stake. Artists from the San Fernando Valley to Silverlake dusted off their old volumes of Bachelard, and turned to the appropriate sections— what, for instance, might it mean to exhibit in a kitchen, a bathroom? All at once these spaces became options, and not just for a minimalist "White Cube" style makeover, but rather, right from the start, this turn was seized as an opportunity to generate some auspicious confusion.

This certainly was the idea behind Bliss, a modest Craftsman house in South Pasadena that was opened to the public in late 1987 as an on and off exhibition space by three Art Center alumni— Kenneth Riddle, Gayle Barklie and Jorge Pardo. Although their earliest shows had been casual, impromptu affairs, mostly confined to the garage, the gauntlet was officially thrown down with The Neighbourhood Art Show, 1987, which featured the work of some art school colleagues juxtaposed with a motley assortment of items gathered from the neighbours "within a one block radius of Bliss (who had been invited) to include anything they

had made or that was important to them".[7] Of course, a fair number of the exhibitions mounted at Bliss could just as easily have been shown in a conventional gallery, but the ones that counted took the specificity of the space firmly into account. Jorge Pardo's first solo outing, for instance, included a table that had been routed out to accommodate several small handmade cameras, in effect allowing it to photograph itself. The resulting images were displayed on the walls surrounding the table in question, thereby "joining the subject and object of photography", in Pardo's words.[8] The notion of an everyday, utilitarian object acquiring an arty inferiority via the photograph is of course integral to just about every piece of his that would follow. Moreover, the use of a photo-mechanical paradigm to revisit, in a virtual sense, a range of sculptural issues, formerly the domain of the solid and real, would prove enormously productive, and not just for Pardo, but for the whole school of West Coast "neo-constructivism" (for lack of a better term) that was emerging around him.

Questions of utility, design for life and/or lifestyle, have long served to shape the evolution of Los Angeles art. For instance, the marriage of painterly concerns and industrial materials and techniques that yielded some seminal examples of Light and Space and finish fetish work in the 1960s would have been (and no doubt was) right at home in any number of space-age bachelor pads. This work branched out to other forms of production, and occasionally wound up "out on a limb", the results verging on kitsch eye-candy, the art equivalent of the lava lamp, but those were the stakes in this particular game. If the 1990s generation has nurtured a fetish for this period and all its inflated biomorphic accoutrements, it goes beyond aestheticist nostalgia; no doubt the look is cool and fashionable, but more importantly it represents a genuine hybrid potential that once more seems ripe for exploitation. Another Bliss artist to take advantage of this state of affairs was Pae White, who transformed the space into a "virtual garden", colliding her organic, planting materials (bonsai trees, sunflowers, etc) with elements of patently artificial "hardscaping", most notably a DeWain Valentine/ Craig Kaufman-style Plexiglas cube, tinted a hot,

fluorescent pink, enclosing a working fountain.[9] A collection of humidifiers sculpturally mounted on pedestals completed the convulsive makeover of this monument to American domesticity into a psycho-sexual hothouse, while also inaugurating White's own ongoing exploration of the categories of interior and exterior, private and public, in regard to the self as well as the various structures that surround and contain it. The reversal and conflation of qualities inherent to either side continued apace in the contributions of Jennifer Steinkamp and, even more explicitly, Diana Thater, whose 1992 piece Up to the Lintel included a video projection of the house's interior upon its facing windows, and thereby served to turn it literally inside-out.[10]

It can be safely assumed that the unique conditions of display that Bliss foisted upon its visiting artists, many of them just out of school, helped to determine the particular set of concerns that are at the crux of what is presently known as the Art Center aesthetic. Providing an invaluable testing ground for the sort of interdisciplinary art and design merger that is promised in that school's brochure, but so rarely in fact delivered upon, Bliss no doubt played a key role in promoting the Art Center cause throughout the 1990s, and securing its artworld rep to this day. The results are wide-ranging, touching upon all areas of current practice: sculpture, video, photography, as mentioned, but also painting, where a certain 1960s/1970s period style has become almost de rigueur. In the work of Fandra Chang, Linda Bessemer, Habib Kherdyar, Adam Ross, Carl Bronson, Michael Gonzales, among others, a streamlined Minimalist aesthetic is revisited DIY-style, with materials straight from the local home improvement outlet. A marriage made in heaven, apparently, it quickly developed into a style in its own right, claiming new adherents to this day. However, here again, we find that it is a marriage of necessity first, one that is directly conditioned by a new suburban/ domestic paradigm of reception and display. Quite possibly the prototype, Bliss was soon joined by a whole network of like-minded spaces, each with its own particular area of concentration or expertise, and just as eager to pick up the ball that had been dropped by the "official" gallery system.

One such space was The Guest Room. Established in January of 1991 by artist Russell Crotty with his wife and designer Laura Gruenther, this was basically a spare bedroom on the second floor of an old Victorian house in the Rampart area of Los Angeles that they were renting at the time. Although it was only in operation from January 1991 until April 1992, The Guest Room proved to be uniquely successful, as almost all of its exhibiting artists went on to make lasting careers in the field. Here again the most effective shows were those that responded directly to the specific nature of the space: to its original purpose, to its formal layout and to its given location, whether in socioeconomic or psychogeographic terms. For artists interested in such matters, the challenge would consist not simply in adapting one's output to the domestic context (i.e. making furniture or decoration) or adapting the context (and such things as furniture or decoration) to the condition of art. From the outset, that is, this new context would allow for the extension of a Conceptual methodology past the institutional rut it had worked itself into. If Conceptual Art's "escape attempts", as Lucy Lippard famously put it, had been aborted at the symbolic stage, then here was a chance to follow them through to "The Real". [11]

Frances Stark's 1991 Guest Room installation *Total Babe* (her first in LA) stands out in this regard, precisely for seeming so absolutely banal at first glance. She had furnished the space with a bed, a smallish throw rug beneath it and some roll-up blinds on the windows—nothing out of the ordinary. It took a closer look to reveal the fine lines of text that had been inscribed into these items, painstakingly, with needle and thread. Instead of any sort of in depth reading, I will limit myself to noting the use of language in this case as a kind of virtual veneer, compelling the gentlest break with the determined utility of the object. While they might seem outwardly unrelated, Frances Stark and Jorge Pardo do share this strategy of enfolding the everyday object within a recursive sort of representational *mise-en-abyme* either by way of a literary or photographic paradigm, but in a manner so casual that it never gets completely swallowed or subsumed. It always retains a measure of autonomy

as a non-art object, or an object one does not know exactly what to do with. Pardo describes this condition as "speculative", a philosophical opening up or unfolding of thing-ness that is not without practical consequence. [12]

This condition could not have originated anytime or anywhere else; it requires absolutely, in the words of the Art & Language group, "a background of normalcy", that is to say a setting which is itself private, utilitarian, and aesthetically as far removed as possible from the pristine void of the "White Cube". [13] The conventional found object was essentially incapacitated by the process of recontextualisation; as art, its function was strictly limited to a criticality aimed squarely at the structures that would contain it. Here, this logic is partly reversed: to begin with, the object is always partly re-made, but more importantly, its reconstitution as art involves a radical diffusion of purpose. The 1990s inaugurated the period of *détente* that continues to hold between the once-opposed aims of hyper-alienated 1980s-era simulationism, with its hatred of the hand-made, and the much more easy-going and affirmative personal poetics of 1960s assemblage. However, to characterize this turn as a re-turn, as critic Ma Lin Wilson, among many others, has done, from the logic of "reading" art that dominated the 1970s and 1980s and back to good old-fashioned "looking" is just magical thinking, since the gap between things and words is here effectively closed. [14]

So many of the visitors to Bliss or The Guest Room—or, for that matter, Bill Radawek's Domestic Setting, or certain incarnations of Charles LaBelle's roving Nomadic Site project, or Stephen Berens' and Ellen Birrell's Project X, or the succession of storage and motel room shows that grew out of the 1980s—reported experiencing the same sense of uncertainty as to what was art and what was not, what was to be scrutinised and what was to be passed by, what could be touched, moved, sat on, etc., and what was implicitly off-limits. This subtly skewed ambience made for a high degree of self-consciousness on the part of an audience who now had to consider the totality of a situation they once could take for granted. Accordingly, discussions

touched on the shape of a fixture or outlet, the view out the window or the movement of shadows across the walls, just as often as the art *per se*. And the art, if and when it was discussed, generally found its way out of any preestablished frame of reference to become part of this moment, this place, and just as essentially arbitrary, differential, relational as anything else that was there. As the century drew to a close, so many exhibitions mounted here and abroad by LA artists remained in dialogue with those originating conditions. Jorge Pardo unveiled *4166 SeaView Lane*, his sculpture-that-is-also-a-home, to the public on 11 October, 1998, and he has gone on to design several more houses for his most adventurous patrons. T Kelly Mason, whose last show at Marc Foxx in September 1999 included a direct reference to an installation he mounted at Bliss almost ten years earlier continues to dwell productively on the politics of home-improvement. Architecture and the Modernist "design for life" remain central concerns of Sam Durant as well, only now they are explored within the streamlined interiors of venues like Blum & Poe. Much the same can be said for Frances Stark whose 1999 show at Marc Foxx included *All My Chairs on Cartons*, a work that does just what its title suggests—to put her private space on public view. Also begun in 1999 is Pae White's ongoing series of "spider-web paintings", each of which is the outcome of a unique "collaboration" between the artist and her backyard menagerie of insects. Jacci den Hartog and Laura Cooper both teach classes on art and gardening, and apply their lessons to their own work—the result of two imaginations that had once been encouraged to wander out into the yard. In effect, there are as many LA artists out there making work about the architectural interior as its exterior landscape. It is almost as if the object had to travel for a time outside the gallery to rediscover some modicum of social purpose; that is, how it might operate in an actual (as opposed to idealised) space, where some people live and others visit, where people meet, talk, drink and plan what to do next. Of course, this is just the sort of space where art has always wound up, the final leg of the journey that begins in the studio, yet for the Class of 90 it was this slight skewing of the itinerary that made all the difference. [15]

1 Myers, Terry R, "Art School Days", *Sunshine & Noir, Art in LA, 1960–1997*, Humlebaeck: Louisiana Museum of Modern Art, 1997, p. 202.

2 Klein, Norman, *The History of Forgetting: Los Angeles and The Erasure of Memory*, London: Verso, 1997.

3 Dear, Michael, "In the City, Time Becomes Visible: Intentionality and Urbanism in Los Angeles, 1781–1991", in *The City, Los Angeles and Urban Theory at the End of the Twentieth Century*, Allan J Scott and Edward W Soja, Berkeley, CA:University of California Press, 1996, p. 91.

4 This is merely a representative sample, spanning a range of positions, a range of art schools: Bunn teaches at USC, Prina at Art Center and Johnson at Otis.

5 Again, sampled by school: Stark studied at Art Center, Muller at CalArts and Thomson at UCLA.

6 See, in this regard, the writings of Daniel Buren and the Art & Language group.

7 Joyce, Julie, "Neutral Grounds/Fertile Territory: A History of Bliss", *True Bliss*, Los Angeles: LACE, 1997, p. 6.

8 Joyce, "Neutral Grounds", p. 9.

9 Joyce, "Neutral Grounds", p. 12.

10 See Jane McFadden's essay in this volume for a further discussion of this work.

11 Lippard, Lucy, "Escape Attempts", *Reconsidering the Object of Art, 1965–1975*, Los Angeles: The Museum of Contemporary Art, 1995.

12 Pardo is very emphatic in his attempts to adapt a language normally associated with business practices, such as "speculative", to poetic ends. Together with "virtual", however, the term also hints at the impact of the new information technologies. It would probably require a separate paper to outline the impact of the digital revolution on this generation; suffice it to say, for now, that by furnishing these artists with almost unlimited reserves of memory, it also served to exponentially augment the range of possible meanings that might be sustained by any one thing.

13 Baldwin, Michael and Charles Harrison, et al, "Memories of the Medicine Show", in *Art & Language, New Series*, no. 2, June, 1997.

14 Wilson, Ma Lin, "Coming to Our Senses", *Art Issues*, no. 45, November/December, 1996, pp. 18–21.

15 As it happens, in 1999 as well, Jorge Pardo and Pae White would perform a "sensitive remodeling" of a bankrupt gift shop on Chung King Road in Chinatown for their Art Center colleagues Giovanni Intra and Steve Hanson, both of whom had decided to open a gallery there. Carrying over the name that graced the former storefront, this became the now notorious *China Art Objects*, at the very flashpoint of an emerging "Chinatown Scene". Drawing many of the central protagonists of the 1990s back together, Chinatown, in a sense, closes the loop between DIY chutzpah and entrepreneurial spirit. At the same time, there is more to it than that—a whole other story, in fact, that deserves to be told in detail elsewhere.

WHEN THOUGHT BECOMES CRIME
CRITICAL ART ENSEMBLE

Courtesy of Critical Art Ensemble

HOW DID IT COME TO THIS?

Only a perverse authoritarian logic can explain how CAE can at one moment be creating the project *Free Range Grain* for the At Your Own Risk exhibition at Schirn Kunsthalle in Frankfurt, reconfiguring it for The Interventionists exhibition at Mass MoCA in a second moment, and then suddenly have a CAE member in FBI detention. The US Justice Department has accused us of such shocking crimes as bioterrorism, health and safety violations, mail fraud, wire fraud, and even murder. Now, as we retool *Free Range Grain* for the Risk exhibition at the Glasgow Centre for Contemporary Art, the Surreal farce of our legal nightmare continues unabated.

Of course, we always knew that cultural interventionist work could have serious consequences. And over the years, predictably, CAE has been denounced (and threatened) by all varieties of authority: cops, corporate lawyers, politicians, all types of racists, and church groups—even the Archbishop of Salzburg. But to be the target of an international investigation that involves the FBI; the Joint Terrorism Task Force; the ATF; the Department of Homeland Security; the Department of Health and Safety; numerous local police agencies; and even Canadian, Norwegian, and German federal investigators goes far beyond the pale. As of this writing, CAE member Steven Kurtz, and one of our long-time collaborators, University of Pittsburgh geneticist Robert Ferrell, are fighting the insanely real threat of being sent to federal prison.

So how did we create such a vortex of Kafkaesque legalistic repression? In the *Free Range Grain* project, for instance, CAE simply used molecular biology techniques to test for genetically modified food in the global food trade. We want(ed) this interventionist performance to demonstrate how the "smooth space" of global trade enables the very "contaminations" the authorities say it guards against. Now we, along with our colleagues on the CAE defense team, have been trying to understand why the authorities have taken such a reactionary position in regard to our art practice. We have come up with many reasons; we can address only a few in this brief article.

The first reason, we believe, involves the discourse in which we framed our project. By viewing the scientific process through the lens of the capitalist political economy, we disrupted the

legitimised version of science as a self-contained, value-free specialisation. The powers that be would have science speak for itself, within and about itself. This insularity is akin to Clement Greenberg's idea of letting art history explain the production of art, or Emile Durkheim's use of "social facts" to explain the social. But any discourse exists within larger historical and political contexts. It seemed self-evident for us to place competing discourses in conversation, and to show the socioeconomic ideologies at work in food production. From the perspective of authority, however, we were being subversive, deviant. For those who wish to preserve the autonomy of science, citizens can discuss scientific structure, method, materials, etc., as long as they do not refer to the political or economic interests that impinge on scientific research. A biology club can talk about cells, but if it goes beyond the institutionalised boundaries of the life sciences, look out for the feds.

The second challenge we posed came from our amateur approach to life science knowledge systems, experimental processes, acquisition of materials, etc.. An amateur can be critical of an institution without fear of recrimination or loss of status or investment. An art professor, for example, will probably not tell students that art school is a pyramid scheme into which they will pour a lot of capital, feed the higher-ups, and probably get very little if anything in return. That criticism is more likely to emerge from outside the power structure (or from disgruntled ex-students). In science, where the financial stakes

CRITICAL ART ENSEMBLE
Evidence
2004, single-channel video with appropriated news
footage of the FBI raid on Steve Kurtz's home
Courtesy the artists

are much higher, any criticism of resources may well result in funding cuts—a situation one can ill afford in such a capital-intensive discipline. So it takes an outsider to science—a creative tinkerer—to rattle the cage of the discipline's most dearly held assumptions and practices.

With special regard to the institutional financing of science, the amateur reveals the profit-driven privatisation of a discipline that is purportedly—mythologically—open to all. By undertaking research as if science were truly a forum in which all may participate according to their abilities and resources, CAE angers those who manipulate scientific activity through capital investment. The financial stakes are so high that the authorities can imagine only one motivation for critical, amateur research, particularly if it is conducted at home outside of systems of surveillance/discipline. If that research intends to expose, disrupt, or subvert the meta-narratives that put scientific investigation in the service of profit, the amateur investigator must want to produce terrorist acts.

In the paranoid political climate of the United States, American authorities leap all too easily from ideological criticism to terrorism. Moreover, CAE's legal battle reveals that the government has made thinking into a crime: A citizen can be arrested without having committed any act of terror or without having done anything illegal at all. Former US Attorney General John Ashcroft has unofficially reformed law enforcement policy and practice according to the Bush administration's idea of "preemptive war". He has argued that if indicators—any type of dissent in relation to the interests of the investing classes or "national interest"—suggest that a person or group could do something illegal, then they should be arrested, detained, deported, or otherwise persecuted with the full resources of all repressive state agencies. Apparently, the US Justice Department is now trying to make CAE into an example of what can happen to citizens whose only "crime" is having thoughts of dissent enacted within the sphere of legality and with the alleged protection of constitutional rights.

For experimental art, political art, tactical media, and independent media in the United States (and to some degree in other nations), the implications of Steven Kurtz's arrest are profound. The repressive forces of the state are directly targeting producers of cultural interventionist work. In past decades, policymakers have often leaned on political artwork through financial penalties such as rescinding artist's grants, folding federal arts programs, and economically squeezing out the spaces that exhibit subversive work.[2] Now, these attacks on civil grounds have undergone a horrific paradigm shift, and individual artists are being charged with criminal activity. The persecution works slowly and insidiously, through silencing artists, looting their work and their research, and constraining their movement. We are no longer seeing cultural conflict in action, but a proto-fascist attack upon open source management of expression itself.

1 The set of theses presented in this document were collectively developed through a series of lectures given by the CAE Defense Team. Contributors include Doug Ashford, Gregg Bordowitz, CAE, Natalie Jeremijenko, Claire Pentecost, and Lucia Sommer. Special thanks to Karen Schiff for editing.
2 The New York Council for the Humanities recently rescinded a grant awarded to the City University of New York for its series on academic freedom because Steve Kurtz was one of the invited speakers!

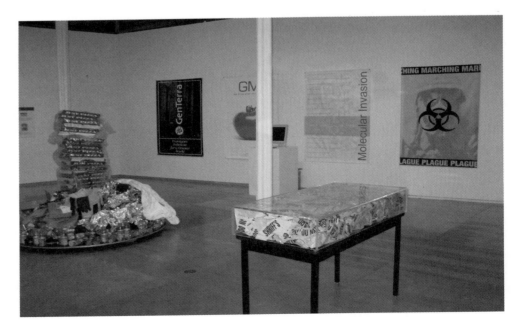

CONTRIBUTORS

CRITICAL ART ENSEMBLE

Critical Art Ensemble are a performance and installation art collective exploring the intersections of art, technology, radical politics and critical theory.

PAMELA M LEE

Pamela M Lee is a professor of art history at Stanford University. Her work focuses on art, theory and criticism of late modernism with a historical focus on the 1960s and 1970s. Her writing has appeared in a number of journals and magazines including *Artforum*, *October*, *Grey Room* and *Texte zur Kunst*.

KEN LUM

Ken Lum is a Canadian artist, writer and curator of Chinese heritage. Lum is also the head of the Graduate Programme in Studio Art at the University of British Columbia and a faculty member at Milton Avery Graduate School of the Arts–Bard College.

MARTHA ROSLER

Martha Rosler is a widely respected artist, writer and activist whose work has been exhibited internationally. Rosler currently teaches at Rutgers University, New Jersey.

JERRY SALTZ

Two-time Pulitzer Prize in Criticism finalist Jerry Saltz's articles and essays appear in numerous magazines and newspapers internationally. He is also the senior art critic for the *New York Magazine* and teaches at Columbia University, the School of the Art Institute of Chicago, and The School of Visual Arts; alongside guest lecturing internationally.

JAN TUMLIR

Jan Tumlir is an independent curator, writer and a founding member of the Los Angeles based art quarterly *X-tra*. He is a frequent contributor to various journals and magazines, including *ArtForum*, *Flash Art* and *Frieze*. Tumlir teaches critical theory at the Art Center College of Design and the University of California, Los Angeles.

MICHAEL WILSON

Michael Wilson is an independent arts writer, editor, curator and artist. He has written for a variety of publications including *Art Monthly*, *Artforum* and *Modern Painters*; and has contributed to exhibition catalogues published by the Venice Biennale, the Lisson Gallery, and MoMA PS1.

ARTIST BIOGRAPHIES

ALLORA AND CALZADILLA
American, founded in 1994 by Jennifer Allora and Guillermo Calzadilla
Live and work in San Juan, Puerto Rico
JENNIFER ALLORA
American, b. 1974 in Philadelphia, Pennsylvania
EDUCATION
1996 University of Richmond, Richmond, USA
1999 Whitney Independent Study Program, New York, USA
2003 Massachusetts Institute of Technology, Cambridge, USA
GUILLERMO CALZADILLA
Cuban, b. 1971, Havana, Cuba
EDUCATION
1996 Escuela de Artes Plásticas, San Juan, Puerto Rico
1998 Skowhegan School of Painting and Sculpture, New York, USA
2001 Bard College, New York, USA
SELECTED GROUP EXHIBITIONS
2010 São Paulo Biennial, São Paulo
2010 Fourth Plinth Commission, The 2010 shortlist exhibition, The Foyer,
 St Martin-in-the-Field, Trafalgar Square, London, UK
2009 Performa 09, New York, USA
SELECTED SOLO EXHIBITIONS
2010 Performance 9, MoMA, New York, USA
2009 Allora and Calzadilla, Temporare Kunsthalle Berlin, Berlin, Germany
2008 Allora and Calzadilla—Never Mind That Noise You Heard, Stedelijk Museum,
 Amsterdam, The Netherlands

MATTHEW BARNEY
American, b. 1967 in San Francisco, USA. Lives and works in New York, USA
EDUCATION
1991 Yale University, New Haven, USA
SELECTED GROUP EXHIBITIONS
2010 The Modern Myth: Drawing Mythologies in Modern Times, MoMA, New York, USA
2010 Houdini: Art and Magic, The Jewish Museum, New York, USA
2010 Focus on Artists: 75th anniversary, San Francisco Museum of Modern Art,
 San Francisco, USA
SELECTED SOLO EXHIBITIONS
2010 Matthew Barney: Prayer Sheet with the Wound and the Nail, Schaulager,
 Basel, Switzerland
2008 Matthew Barney: Mitologie Contemporanee, Fondazione Merz, Turin, Italy
2007 Matthew Barney: Mönchehaus museum für moderne Kunst, Goslar, Germany
2007 Matthew Barney: Drawing Restraint, Serpentine Gallery, London, UK
2005 Matthew Barney: Drawing Restraint, 21st Century Museum of Contemporary
 Art, Kanazawa, Japan

BERNADETTE CORPORATION
American, founded in 1994 by John Kelsey, Bernadette van Huy, Antek Walczak
Live and work in New York, USA and Paris, France
SELECTED GROUP EXHIBITIONS
2009 The Malady of Writing: A project on text and speculative imagination,
 Museu d'Art Contemporani de Barcelona (MACBA), Barcelona, Spain
2008 Business as Usual, Museum of Contemporary Art, Detroit, USA
2007 USA: American Video Art at the Beginning of the Third Millennium,
 The Second Moscow Biennale of Contemporary Art, Moscow, Russia
SELECTED SOLO EXHIBITIONS
2008 Bernadette Corporation Josef Strau, Kunsthalle Zürich, Switzerland
2007 Multiplyplex, Kunstlerhaus Stuttgart, Stuttgart, Germany
2007 Bernadette Corporation, How to Cook a Wolf, Kunsthalle Zurich, Switzerland

THE CENTER FOR LAND USE INTERPRETATION
American, founded in 1994 by Matthew Coolidge. Live and work in Culver City, USA
PROGRAMMES AND PROJECTS: EXHIBITS
2010 Urban Crude: The Oil Fields of the Los Angeles Basin, CLUI, Los Angeles, USA
2009 The Trans-Alaska Pipeline: A CLUI Photoscape Presentation, CLUI, Los Angeles, USA
2008 Birdfoot: Where America's River Dissolves into the Sea, CLUI, Los Angeles, USA
2007 Pavement Paradise: American Parking Space, CLUI, Los Angeles, USA
2004 Emergency State: First Responder and Law Enforcement Training Architecture,
 CLUI, Los Angeles, USA

JOHN CURRIN
American, b. 1962 in Boulder, USA. Lives and works in New York, USA
EDUCATION
1984 Carnegie Mellon University, Pittsburgh, USA
1986 Yale University, New Haven, USA
SELECTED GROUP EXHIBITIONS
2009 Mary Magdalene, The Metropolitan Opera, New York, USA
2008 Diana and Actaeon—The Forbidden Sight of Nudity, Stiftung Museum Kunst
 Palast, Düsseldorf, Germany
2008 Bad Painting. Good Art, MUMOK, Vienna, Austria
2006 In The Darkest Hour There May Be Light. Works from Damien Hirst's
 Muderme Collection, The Serpentine, London, UK
SELECTED SOLO EXHIBITIONS
2010 John Currin: New Paintings, Gagosian Gallery, New York, USA
2003 John Currin, The Museum of Contemporary Art, Chicago, USA
2003 John Currin, The Serpentine, London, UK
1995 John Currin, ICA, London, UK

DEXTER SINISTER

American, founded in 2006 by Stuart Bailey and David Reinfurt

Live and work in New York, USA

STUART BAILEY

British, b. 1973, York, UK

EDUCATION

1994 University of Reading

2000 Werkplaats Typografie

DAVID REINFURT

American, b. 1971, New York, USA

EDUCATION

1993 University of North Carolina

1999 Yale University, New Haven, USA

SELECTED GROUP EXHIBITIONS

2009 Talk Show, ICA, London, UK

2008 Whitney Biennial, New York, USA

2007 Wouldn't it be nice..., Centre D'Art Contemporain Geneve, Geneva, Switzerland

SELECTED SOLO EXHIBITIONS

2010 Shannon Ebner and Dexter Sinister, Frieze Art Fair, London, UK

2009 Dexter Sinister (carte blanche), Contemporary Art Museum St Louis, St Louis, USA

MARK DION

American, b. 1961 in New Bedford, USA. Lives in Beach Lake, PA and works internationally

EDUCATION

1982 University of Hartford School of Art, West Hartford, USA

1984 School of Visual Arts, New York, USA

2003 University of Hartford School of Art, West Hardford, USA

SELECTED GROUP EXHIBITIONS

2011 The Luminous Interval: an exhibition of the D Daskalopoulos Collection, Guggenheim Bilbao, Bilbao, Spain

2011 The Smithson Effect, Utah Museum of Fine Arts, Salt Lake City, USA

2010 Beyond/In Western New York 2010: Alternating Currents, Albright-Knox Art Gallery, Buffalo, USA

SELECTED SOLO EXHIBITIONS

2011 Ship in a Bottle, Public commission for Port of Los Angeles Waterfront Enhancement Project, Cabrillo Way Marina, San Pedro, USA

2011 The South Florida Wildlife Rescue Unit, Miami Art Museum, Miami, USA

2010 The Marvellous Museum, Oakland Museum of California, Oakland, USA

2008 Recent Endeavors: New Works by Mark Dion, Atlantic Center for the Arts, New Smyrna Beach, USA

STAN DOUGLAS

Canadian, b. 1960, Vancouver, British Columbia. Lives and works in Vancouver, Canada

EDUCATION

1982 Emily Carr College of Art, Vancouver, Canada

SELECTED GROUP EXHIBITIONS

2011 Streetlife and Homestories, Museum Villa Stuck, Munich, Germany

2010 Haunted: Contemporary Photography/Video/Performance, Guggenheim Museum, New York, USA

2010 Art at Work: Corporate Collecting Practices Today, Part One, Art Gallery of Mississauga, Canada

SELECTED SOLO EXHIBITIONS

2010 Stan Douglas: Klatsassin, Kamloops Art Gallery, Canada

2009 Stan Douglas: Klatsassin, Vancouver Art Gallery, Canada

2005 Stan Douglas: Inconsolable Memories, Joslyn Art Museum, Omaha, USA

2002 Journey into Fear, Contemporary Art Gallery, Vancouver, Canada

MARCEL DZAMA

Canadian, b. 1974 in Winnipeg, Manitoba, Canada. Lives and works in New York, USA

EDUCATION

University of Manitoba, Canada

SELECTED GROUP EXHIBITIONS

2011 All Cannibals!, la maison rouge, Paris, France

2011 From the Collection: Unreal, Vancouver Art Gallery, Canada

2010 Cue: Artists' Videos, Vancouver Art Gallery, Canada

SELECTED SOLO EXHIBITIONS

2011 Marcel Dzama: A Game of Chess, Gemeentemuseum, The Hague, The Netherlands

2011 Marcel Dzama, Kunstverein Braunschweig, Braunschweig, Germany

2010 Marcel Dzama: Of Many Turns, Musee d'art Contemporain de Montreal, Canada

2008 Edition 46—Marcel Dzama, Pinakothek der Moderne, Munich, Germany

ROE ETHRIDGE

American, b. 1969, Miami, USA. Lives and works in New York, USA

EDUCATION

1995 The College of Art, Atlanta, USA

SELECTED GROUP EXHIBITIONS

2010 New Photography 2010: Roe Ethridge, Elad Lassry, Alex Prager, Amanda Ross-Ho, MoMA, New York, USA

2009 ICA Collection: In the Making, ICA Boston, Boston, USA

2008 Whitney Biennial, Whitney Museum of American Art, New York, USA

SELECTED SOLO EXHIBITIONS

2006 Apple and Cigarettes, Gagosian Gallery, Beverly Hills, USA

2005 Momentum 4: Roe Ethridge, ICA, Boston, USA

2003 Roe Ethridge: Junction, Clough-Hanson Gallery, Rhodes College, Memphis, USA

ANDREA FRASER

American, b. 1965 in Billings, Montana. Lives and works in New York, USA

EDUCATION

1984 School of Visual Arts, New York, USA

1985 Whitney Museum of American Art Independent Study Programme, New York, USA

1986 New York University, New York, USA

SELECTED GROUP EXHIBITIONS

2010 Women Who Move Art, The National Museum of Art, Norway

2010 Pop Life, The National Gallery of Canada, Ottawa, Canada

2009 Paying Homage, Contemporary Art Gallery, Vancouver, Canada

SELECTED SOLO EXHIBITIONS

2010 Official Welcome, MoMA, New York, USA

2009 Performance, Centre Pompidou, Paris, France

2005 Official Welcome, Los Angeles Museum of Contemporary Art, Los Angeles, USA

TOM FRIEDMAN

American, b. 1965, St Louis, Missouri, USA. Lives and works in Conway, USA

EDUCATION

1988 Washington University, St Louis, USA

1990 University of Illinois, USA

SELECTED GROUP EXHIBITIONS

2010 Eplogo, Museu de Arte Zapopan, Guadalajara, Mexico

2010 Undone. Making and Unmaking in Contemporary Sculpture,
 Henry Moore Institute, Leeds, UK

2010 Going International, The Flag Art Foundation, New York, USA

SELECTED SOLO EXHIBITIONS

2010 Up in the Air, Magasin 3, Stockholm Konsthall, Stockholm, Sweden

2009 REAM, Saint Louis Art Museum, Saint Louis, USA

2004 Tom Friedman, South London Gallery, London, UK

ELLEN GALLAGHER

American, b. 1965 in Providence, USA. Lives and works in Rotterdam, The Netherlands and New York, USA

EDUCATION

1984 Oberlin College, Oberlin, Ohio, USA

1987 SEA (Sea Education Association), Woods Hole, USA

1989 Studio 70, Ft. Thomas, Kentucky, USA

1992 School of the Museum of Fine Arts, Boston, USA

1993 Skowhegan School of Painting and Sculpture, New York, USA

SELECTED GROUP EXHIBITIONS

2011 Underwater, Tullie House, Carlisle, UK

2010 elles@centrepompidou, Centre Pompidou, Paris, France

2010 On Line: Drawing Through the Twentieth Century, MoMA, New York, USA

SELECTED SOLO EXHIBITIONS

2009 An Experiment of Unusual Opportunity, South London Gallery, London, UK

2007 Coral Cities, Tate Liverpool, Liverpool, UK

2005 Ellen Gallagher: Murmur and DeLuxe, Museum of Contemporary Art, Miami, USA

2005 DeLuxe, Whitney Museum of American Art, New York, USA

ROBERT GOBER

American, b. 1954 in Wallingford, USA. Lives and works in New York, USA

EDUCATION

1974 Tyler School of Art, Philadelphia, Pennsylvania, USA

1976 Middlebury College, Middlebury, Vermont, USA

SELECTED GROUP EXHIBITIONS

2011 Contemporary Collecting: The Judith Neisser Collection,
 The Art Institute of Chicago, USA

2010 Radical Conceptual, Museum fur Moderne Kunst, Frankfurt, Germany

2010 Collecting Biennials, Whitney Museum of American Art, New York, USA

SELECTED SOLO EXHIBITIONS

2010 Slides of a Changing Painting, Museum of Contemporary Art, Denver, USA

2007 Robert Gober: Work 1976–2006, Schaulager, Basel, Switzerland

2003 Robert Gober Displacements, Astrup Fearnley Museum of Modern Art, Oslo, Norway

RODNEY GRAHAM

Canadian, b. 1949 in Vancouver, Canada. Lives in Vancouver, Canada

EDUCATION

1969 University of British Columbia, Vancouver, Canada

SELECTED GROUP EXHIBITIONS

2010 Kurt, Seattle Art Museum, Seattle, USA

2010 Precarious Age, Museum of Contemporary Art, Sydney, Australia

2008 Made Up. International 08 Exhibition, Liverpool Biennial, Liverpool, UK

SELECTED SOLO EXHIBITIONS

2010 Rodney Graham—Through the Forest, Hamburger Kunsthalle, Hamburg, Germany

2010 Possible Abstractions, Museu Picasso, Barcelona, Spain

2007 Rodney Graham, Lobbing Potatoes at a Gong, Bawag Foundation, Vienna, Austria

2005 Rodney Graham: A Little Thought, Vancouver Art Gallery, Vancouver, Canada

WADE GUYTON

American, b. 1972 in Hammond, Indiana, USA. Lives and works in New York, USA

EDUCATION

1995 University of Tennessee, Knoxville, USA

1998 Hunter College, New York, USA

SELECTED GROUP EXHIBITIONS

2010 Neugierig? (Curious?), Exhibitionhall of the Federal Republic of Germany, Bonn, Germany

2009 Space as Medium, Miami Art Museum, Miami, USA

2009 Fax, The Drawing Center, New York, USA

SELECTED SOLO EXHIBITIONS

2010 Wade Guyton, Museum Ludwig, Cologne, Germany

2009 Wade Guyton, Museum Dhondt-Dhaeners, Deurle, Belgium

2005 Color, Power & Style, Kunstverein in Hamburg, Hamburg, Germany

RACHEL HARRISON

American, b. 1966 in New York City, New York, USA. Lives and works in New York, USA
EDUCATION
1989 Wesleyan University, Middletown, USA
SELECTED GROUP EXHIBITIONS
2010 The Original Copy: Photography of Sculpture, 1839 to Today, MoMA, New York, USA
2010 Abstract Resistance, Walker Art Center, Minneapolis, USA
2008 Whitney Biennial, Whitney Museum of American Art, New York, USA
SELECTED SOLO EXHIBITIONS
2009 Consider the Lobster, Center for Curatorial Studies, Hessel Museum, Frankfurt, Germany
2006 Sometimes it Snows In April, The McAllister Institute, New York, USA
2004 New Work, San Francisco Museum of Modern Art, San Francisco, USA
2004 Posh Floored as Ali G Tackles Becks, Camden Art Centre, London, UK

ARTURO HERRERA

Venezuelan, b. 1959 in Caracas, Venezuela. Lives and works in Berlin, Germany and New York, USA
EDUCATION
1982 University of Tulsa, Oklahoma, USA
1992 University of Illinois, Chicago, Illinois, USA
SELECTED GROUP EXHIBITIONS
2011 Keeping it Real: An Exhibition in 4 Acts: Material Intelligence, Whitechapel Gallery, London, UK
2010 Nature, Once Removed: The (Un)Natural World in Contemporary Drawing, Lehman College Art Gallery, New York, USA
2009 Contemporary Drawings Collection, MoMA, New York, USA
SELECTED SOLO EXHIBITIONS
2011 Arturo Herrera: Les Noces, Americas Society, New York, USA
2010 Arturo Herrera: Home, Haus am Waldsee, Berlin, Germany
2009 Arturo Herrera: Castles, Dwarfs, and Happychaps, The Aldrich Museum, Ridgefield, USA

SUSAN HILLER

American, b. 1940 in Tallahassee, Florida. Lives and works in London, UK
SELECTED GROUP EXHIBITIONS
2010 Moving Images. Artists and Video_Film, Museum Ludwig, Cologne, Germany
2010 Never the Same River (Possible Futures, Probable Pasts), Camden Arts Centre, London, UK
2009 Moby Dick, CCA Watts Institute, San Francisco, USA
SELECTED SOLO EXHIBITIONS
2011 Susan Hiller: Enquiries/Inquiries, Tate Britain, London, UK
2009 Susan Hiller: The J Street Project, The Jewish Museum, San Francisco, USA
2007 The Curiosities of Sigmund Freud and Other Works, Moderna Museet, Stockholm, Sweden
2004 Susan Hiller: Recall—A Selection of Works 1969–2004, Baltic Centre for Contemporary Art, Gateshead

RONI HORN

American, b. 1955 in New York, USA. Lives and works in New York, USA and Reykjavik, Iceland
EDUCATION
1975 Rhode Island School of Design, Providence, USA
1978 Yale University, New Haven, USA
SELECTED GROUP EXHIBITIONS
2011 Without Destination, Reykjavik Art Museum, Reykjavik, Iceland
2011 Unforgettable: Selections from the Emily Fisher Landau Collection Fisher Landau Center for Art, Long Island City, USA
2010 Pictures by Women: A History of Modern Photography, MoMA, New York, USA
SELECTED SOLO EXHIBITIONS
2011 Roni Horn, Hamburger Kunsthalle, Hamburg, Germany
2010 Roni Horn aka Roni Horn, ICA, Boston, USA
2009 Roni Horn aka Roni Horn, Tate Modern, London, UK

JONATHAN HOROWITZ

American, b. 1966 in New York, USA. Lives and works in New York, USA
EDUCATION
1987 Wesleyan University, Middletown, USA
SELECTED GROUP EXHIBITIONS
2010 Moving Images: Artists and Video/Film, Museum Ludwig, Cologne, Germany
2009 Beg, Borrow and Steal, Rubell Family Collection, Miami, USA
2008 Sudden White, Royal Academy of Arts, London, UK
SELECTED SOLO EXHIBITIONS
2010 Minimlist Works from the Holocaust Museum, Dundee Contemporary Arts, Dundee, UK
2009 Jonathan Horowitz: And/Or, MoMA PS1, New York, USA
2009 Apocalypto Now, Museum Ludwig, Cologne, Germany
2003 Silent Movie, Martix 151, Wadsworth Atheneum Museum of Art, Hartford, USA

MARTIN KERSELS

American, b. 1960 in Los Angeles, USA. Lives and works in Los Angeles, California, USA
EDUCATION
1984 University of California, Los Angeles, USA
1995 University of California, Los Angeles, USA
SELECTED GROUP EXHIBITIONS
2010 2010 Whitney Biennial, Whitney Museum of American Art, New York, USA
2009 Second Nature: The Valentine Collection at the Hammer, UCLA Hammer Museum, Los Angeles, USA
2008 Index: Conceptualism in California from the Permanent Collection, Museum of Contemporary Art, Los Angeles, USA
SELECTED SOLO EXHIBITIONS
2008 Martin Kersels: Heavyweight Champion, Santa Monica Museum of Art, Santa Monica, USA
2007 Martin Kersels: Heavyweight Champion, Tang Museum of Art, Saratoga Springs, USA
2002 Bracelet, Peggy Phelps Gallery, Claremont Graduate University, Claremont, USA

GLENN LIGON

American, b. 1960 in New York, USA. Lives and works in New York, USA

EDUCATION

1980 Rhode Island School of Design, Providence, Rhode Island, USA

1982 Wesleyan University, Middletown, Connecticut, USA

1985 Whitney Museum Independent Study Program, New York City, New York, USA

SELECTED GROUP EXHIBITIONS

2011 Collecting Biennial, Whitney Museum of American Art, New York, USA

2010 Hide/Seek: Difference and Desire in American Portraiture,
National Portrait Gallery, Washington DC, USA

2009 Exposed: Revealing Sources in Contemporary Art, Delaware Art Museum,
Delaware, USA

SELECTED SOLO EXHIBITIONS

2011 Glenn Ligon: America, Whitney Museum of American Art, New York, USA

2005 Glenn Ligon: Some Changes, The Power Plant, Toronto, Canada

2001 Stranger, The Studio Museum in Harlem, New York, USA

SHARON LOCKHART

American, b. 1964 in Norwood, Massachusetts. Lives and works in Los Angeles, USA

EDUCATION

1993 Art Center College of Design, Pasadena, USA

1991 San Francisco Art Institute, San Francisco, USA

SELECTED GROUP EXHIBITIONS

2010 Publics and Counterpublics, Centro Andaluz de Arte Contemporaneo, Seville, Spain

2010 MOVE: Choreographing You, Hayward Gallery, London, UK

2009 Dance with Camera, Institute of Contemporary Art, Philadelphia, USA

SELECTED SOLO EXHIBITIONS

2010 Podwórka, The Power Plant, Toronto, Ontario, Canada

2009 Lunch Break, neugerriemschneider, Berlin, Germany

2008 Sharon Lockhart, Kunstverein, Hamburg, Germany

2006 Arthur M Sackler Museum, Harvard College, Cambridge, USA

CHRISTIAN MARCLAY

American, b. 1955 in San Rafael, USA. Lives and works in London, UK and New York, USA

EDUCATION

1977 Ecole Superieure d'Art Visuel, Geneva, Switzerland

1978 Cooper Union, New York, USA

1980 Massachusetts College of Art, Boston, USA

SELECTED GROUP EXHIBITIONS

2010 Sound & Vision, Art Institute of Chicago, USA

2010 In the Days of the Comet, British Art Show 7, Nottingham Contemporary,
Nottingham, UK

2009 Yokohama International Arts & Media Festival, Yokohama, Japan

SELECTED SOLO EXHIBITIONS

2010 Festival, Whitney Museum of American Art, New York, USA

2009 Christian Marclay, MoMA PS1, New York, USA

2006 The Bell and the Glass, Moderna Museet, Stockholm, Sweden

KERRY JAMES MARSHALL

American, b. 1955 in Birmingham, USA. Lives and works in Chicago, USA

EDUCATION

1978 Otis Art Institute, Los Angeles, USA

SELECTED GROUP EXHIBITIONS

2010 Production Site: The Artist's Studio Inside-Out, Museum of Contemporary Art,
Chicago, USA

2009 30 Americans, Rubell Family Collection, Miami, USA

2009 Slow Movement or: Half and Whole, Kunsthalle, Bern, Germany

SELECTED SOLO EXHIBITIONS

2010 Kerry James Marshall, Vancouver Art Gallery, British Columbia, Canada

2009 Art in the Atrium, Museum of Modern Art, San Francisco, USA

2005 Along the Way, Camden Arts Centre, London, UK

2003 One True Thing: Meditations on Black Aesthetics, Museum of Contemporary Art,
Chicago, USA

PAUL MCCARTHY

American, b. 1945, Salt Lake City, USA. Lives and works in Los Angeles, USA

EDUCATION

1968 University of Utah, Salt Lake City, Utah, USA

1969 Sand Francisco Art Institute, San Francisco, USA

1973 University of Southern California, Los Angeles, USA

SELECTED GROUP EXHIBITIONS

2011 What's New, Pussycat?, Torrance Art Museum, Torrance, Canada

2011 The Luminous Interval, Guggenheim Museum, Bilbao, Spain

2010 Off the Wall: Part 1—Thirty Performative Actions,
Whitney Museum of American Art, New York, USA

SELECTED SOLO EXHIBITIONS

2009 Contemporary Trends in Video Art—Paul McCarthy, Salt Lake Art Center,
Salt Lake City, USA

2008 Central Symmetrical Rotation Movement—Three Installations, Two Films,
Whitney Museum of American Art, New York, USA

2006 Paul McCarthy—Head Shop / Shop Head, Moderna Museet, Stockholm, Sweden

JOSEPHINE MECKSEPER

German, b. 1964, in Lilienthal, Germany. Lives and works in New York, USA

EDUCATION

1990 Hochschule der Kunste, Berlin, Germany

1992 California Institute of the Arts, Valencia, USA

SELECTED GROUP EXHIBITIONS

2010 CONTACT Toronto Photography Festival, Museum of Contemporary Canadian Art,
Toronto, Canada

2010 Contemplating the Void, Guggenheim Museum, New York, USA

2009 FAX, The Drawing Center, New York, USA

SELECTED SOLO EXHIBITIONS

2010 Josephine Meckseper, Blaffer Gallery, The Art Museum of the University of Houston, USA

2009 Josephine Meckseper, Ausstellungshalle zeitgenössische Kunst Münster, Germany

2009 Josephine Meckseper: Recent Films, Indianapolis Museum of Art, Indianapolis, USA

JULIE MEHRETU

Ethiopian, b. 1970 in Addis Ababa, Ethiopia. Lives and works in New York, USA

EDUCATION

1991 University Cheik Anta Diop, Dakar, Senegal

1992 Kalamazoo College, Michigan, USA

1997 Rhode Island School of Design, Providence, USA

SELECTED GROUP EXHIBITIONS

2010 Subversive Abstraction, Whitechapel Gallery, London, UK

2009 Automatic Cities, Museum of Contemporary Art San Diego, USA

2009 Extreme Frontiers, Urban Frontiers, Institute of Contemporary Art, Valencia,

SELECTED SOLO EXHIBITIONS

2010 Notations After The Ring, Arnold & Marie Schwartz Gallery, Metropolitan Opera House, New York, USA

2009 Grey Area, Guggenheim Museum, Berlin, Germany

2008 City Sitings, North Carolina Museum of Art, Raleigh, USA

MATT MULLICAN

American, b. 1951 in Santa Monica, USA. Lives and works in New York, USA

EDUCATION

1974 California Institute of the Arts, Valencia, USA

SELECTED GROUP EXHIBITIONS

2010 Shudder, The Drawing Room, London, England

2010 For the blind man in the dark room looking for the black cat that isn't there, Museum of Contemporary Art of Detroit, Detroit, USA

2009 Vraoum!, La Maison Rouge, Paris, France

SELECTED SOLO EXHIBITIONS

2011 Matt Mullican, Haus der Kunst, Munich, Germany

2010 Matt Mullican, Institut d'Art Contemporain, Villeurbanne, France

2009 Matt Mullican, Plug In ICA, Winnipeg, Canada

2008 Matt Mullican: A Drawing Translates the Way of Thinking, The Drawing Center, New York, USA

TONY OURSLER

American, b. 1957 in New York, USA. Lives and works in New York, USA

EDUCATION

1979 California Institute of the Arts, California, USA

SELECTED GROUP EXHIBITIONS

2010 Off The Wall: 30 Performative Actions, Whitney Museum of American Art, New York, USA

2009 Subversive Spaces: Surrealism and Contemporary Art, Whitworth Art Gallery, Manchester, UK

2006 Whitney Biennial, Whitney Museum of American Art, New York, USA

SELECTED SOLO EXHIBITIONS

2006 Good Vibrations: Visual Arts and Rock Music, Palazzo delle Papesse, Sienna, Italy

2005 Dispositifs, Jeu de Paume, Paris, France

2005 Seven Months of My Aesthetic Education (Plus Some), Metropolitan Museum of Art, New York, USA

2002 Tony Oursler, Museo d'Arte Contemporanea, Roma, Italy

RAYMOND PETTIBON

American, b. 1957 in Tucson, USA. Lives and works in California, USA

EDUCATION

1977 UCLA, Los Angeles, USA

SELECTED GROUP EXHIBITIONS

2010 International 10, Liverpool Biennial, Liverpool, UK

2010 The Artist's Museum, Museum of Contemporary Art, Los Angeles, USA

2010 Collecting Biennials, Whitney Museum of American Art, New York, USA

SELECTED SOLO EXHIBITIONS

2010 Raymond Pettibon: The Punk Years (1978–86), Florida Atlantic University Schmidt Center Gallery, Boca Raton, USA

2006 Raymond Pettibon, Centro de Arte Contemporáneo de Málaga, Malaga, Spain

2006 Raymond Pettibon: Whatever It is You're Looking for You Won't Find It Here, Kunsthalle Wien, Vienna, Austria

2005 Raymond Pettibon, Whitney Museum of American Art, New York, USA

PAUL PFEIFFER

Hawaiian, b. 1966 in Honolulu, Hawaii. Lives and works in New York, USA

EDUCATION

1987 San Francisco Art Institute, San Francisco, USA

1994 Hunter College, New York, USA

1998 Whitney Museum of American Art Independent Study Program, New York, USA

SELECTED GROUP EXHIBITIONS

2010 Light Breaks Where No Sun Shines, Bortolami at The Webster, Miami, USA

2010 Anonymous Sculptures, Kunstmuseen Krefeld, Krefeld, Germany

2010 Hard Targets, Wexner Center for the Arts, Columbus, USA

SELECTED SOLO EXHIBITIONS

2009 The Saints, Hamburger Bahnhof, Berlin, Germany

2009 Perspektive Machine, BAIBAKOV Art Projects, Moscow, Russia

2008 Monologue, MUSAC, León, Spain

2005 Morning After the Deluge, Museum of Art at Middlebury College, Middlebury, USA

RICHARD PRINCE

American, b. 1949 in Panama Canal Zone, Republic of Panama. Lives and works in New York, USA

EDUCATION

SELECTED GROUP EXHIBITIONS

2010 The Modern Myth: Drawing Mythologies in Modern Times, MoMA, New York, USA

2006 Surprise, Surprise, ICA, London, UK

2005 Superstars: From Warhol to Madonna, Kunsthalle Wien and Kunstforum Wien, Vienna, Austria

SELECTED SOLO EXHIBITIONS

2008 Richard Prince: Continuation, Serpentine Gallery, London, UK

2007 Richard Prince: Spiritual America, Guggenheim Museum, New York, USA

2007 Richard Prince: Panama Pavilion, Venice, Italy

2006 Richard Prince: Canaries in the Coal Mine, Astrup Fearnley Museum, Oslo, Norway

MARTHA ROSLER

American, b. 1943 in New York, USA. Lives and works in Brooklyn, New York, USA

EDUCATION

1965 Brooklyn College of the City University of New York, New York, USA

1974 University of California, San Diego, USA

SELECTED GROUP EXHIBITIONS

2011 State Of Mind: New California Art Circa 1970, Orange County Museum of Art, Orange, USA

2010 Shrew'd: Smart and Sassy Survey, Sheldon Museum of Art, Lincoln, USA

2009 Still Revolution, Museum of Contemporary Canadian Art, Toronto, Canada

SELECTED SOLO EXHIBITIONS

2011 Point and Shoot, Stedelijk Museum's Hertogenbosch, Hertogenbosch, The Netherlands

2010 Martha Rosler: As If, GAM Torino, Torino, Italy

2009 If You Lived Here Still, *e-flux*, New York, USA

2008 Martha Rosler Library, Site, John Moores University's School of Art and Design, Liverpool, UK

JIM SHAW

American, b. 1952 in Midland, USA. Lives and works in Los Angeles, USA

EDUCATION

1974 University of Michigan at Ann Arbor, Michigan, USA

1978 California Institute of the Arts, California, USA

SELECTED GROUP EXHIBITIONS

2010 The Artist's Museum: Los Angeles, Artists 1980–2010, Los Angeles County Museum of Art, Los Angeles, USA

2010 Skin Fruit: Selections from the Dakis Joannou Collection, New Museum, New York, USA

2009 Depression, Marres Centre of Contemporary Culture, Maastricht, The Netherlands

SELECTED SOLO EXHIBITIONS

2010 Left Behind, CAPC Musée d'art Contemporain, Bordeaux, France

2007 The Donner Party, MoMA PS1, New York, USA

2003 O, Magasin Center of Contemporary Art, Grenoble, France

CINDY SHERMAN

American, b. 1954, in Glen Ridge, USA. Lives and works in New York, USA

EDUCATION

1976 State University College, Buffalo, New York, USA

SELECTED GROUP EXHIBITIONS

2011 The Deconstructive Impulse: Women Artists Reconfigure the Signs of Power, 1973–1991, Neuberger Museum of Art, Purchase, USA

2010 Pictures by Women: A History of Modern Photography, MoMA, New York, USA

2009 Into the Sunset: Photography's Image of the American West, MoMA, New York, USA

SELECTED SOLO EXHIBITIONS

2011 Cindy Sherman: Works from Friends of the Bruce Museum, Bruce Museum, Greenwich, USA

2005 Cindy Sherman: Working Girl, Contemporary Art Museum, St Louis, USA

2004 The Unseen Cindy Sherman-Early Transformations 1975/1976, Montclair Art Museum, Montclair, USA

MICHAEL SNOW

Canadian, b. 1929 in Toronto, Ontario, Canada. Lives and works in Toronto

EDUCATION

1952 Ontario College of Art

SELECTED GROUP EXHIBITIONS

2009 1969, MoMA PS1, New York, USA

2007 Projections, The University of Toronto Art Centre, Toronto, Canada

2006 Acting the Part: Photography as Theater, Musee des Beaux-Arts du Canada, Ottawa, Canada

SELECTED SOLO EXHIBITIONS

2010 Recent Snow, Power Plant Contemporary Art Gallery, Toronto, Canada

2005 Stillness, Film and Media Gallery, MoMA, New York, USA

2002 Instant Snow, Centre Pompidou, Paris, France

2002 Corpus Callosum, Film Forum, New York, USA

FRANCES STARK

American, b. 1967 in Newport Beach, USA. Lives and works in Los Angeles, USA

EDUCATION

1993 Art Center College of Art and Design, Pasadena, USA

SELECTED GROUP EXHIBITIONS

2010 Restless Empathy, Aspen Art Museum, Aspen, USA

2010 The Page, Kimmerich, New York City, New York, USA

2009 Old. Tired. Horse., ICA, London, UK

SELECTED SOLO EXHIBITIONS

2010 But What of Frances Stark, Centre for Contemporary Art, Glasgow, UK

2009 But What of Frances Stark, Nottingham Contemporary, Nottingham, UK

2008 Frances Stark: The New Vision, Portikus, Frankfurt/Main, Germany

2007 The Fall of Frances Stark, van Abbe Museum, Eindhoven, The Netherlands

JESSICA STOCKHOLDER

American, b. 1959 in Seattle, USA. Lives and works in New Haven, USA

EDUCATION

1982 University of Victoria, Canada, USA

1985 Yale University, New Haven, USA

SELECTED GROUP EXHIBITIONS

2010 Palacio de Cristal, Museo Reina Sofía, Madrid, Spain

2009 Embrace!, Denver Art Museum, Denver, USA

2009 Painting and its Environs, Palacio de Sástago, Zaragoza, Spain

SELECTED SOLO EXHIBITIONS

2010 Peer Out to See, Museo Reina Sofia, Madrid, Spain

2007 Jessica Stockholder, Wadsworth Atheneum Museum of Art, Hartford, USA

2005 Jessica Stockholder, Kissing the Wall: Works, 1988-2003, Blaffer Art Gallery, University of Houston, Houston, USA

2003 Jessica Stockholder: TV Tipped Toe Nail and the Green Salami, Musée d'art Contemporain de Bordeaux, Bordeaux, France

SARAH SZE

American, b. 1969, Boston, Massachusetts, USA. Lives and Works in New York

EDUCATION

1997 School of Visual Arts, New York, USA

1991 Yale University, New Haven, USA

SELECTED GROUP EXHIBITIONS

2010 Contemplating the Void: Interventions in the Guggenheim Museum Rotunda, Guggenheim Museum, New York, USA

2010 Transformative, Museum of Contemporary Art, Tokyo, Japan

2009 The Spectacle of the Everyday, Tenth Biennale de Lyon, Lyon, France

SELECTED SOLO EXHIBITIONS

2011 Infinite Line: Sculpture, Drawings and Prints of Sarah Sze, Asia Society, New York, USA

2009 Sarah Sze: Tilting Planet, Baltic Centre for Contemporary Art, Newcastle, UK

2010 Permanent installation, University of California, San Francisco Library, San Francisco, USA

2006 Corner Plot, Doris C Freedman Plaza commission for the Public Art Fund, New York, USA

RIRKRIT TIRAVANIJA

Argentinian, b. 1961, Buenos Aires, Argentina. Lives and works in New York, USA

EDUCATION

1981 Ontario College of Art, Toronto, Canada

1984 Banff Center School of Fine Arts, Banff, Canada

1985 School of the Art Institute of Chicago, USA

1986 Whitney Independent Studies Program, New York, USA

SELECTED GROUP EXHIBITIONS

2010 The Last Newspaper, The New Museum, New York, USA

2010 At Home/Not At Home, Hessel Museum of Art, New York, USA

2009 Drawings Collection, MoMA, New York, USA

SELECTED SOLO EXHIBITIONS

2009 Chew the Fat, Neurgerriemschneider, Berlin, Germany

2009 Rirkrit Tiravanija: Chew the Fat, Mildred Lane Kemper Art Museum, St Louis, USA

2009 A Long March, Centro de Arte Contemporaneo de Malaga, Malaga, Spain

2008 Demonstration Drawings, Drawing Center, New York, USA

RYAN TRECARTIN

American, b. 1981, Webster, Texas, USA. Lives and works in Philadelphia, USA

EDUCATION

2004 Rhode Island School of Design, Providence, USA

SELECTED GROUP EXHIBITIONS

2010 The More Things Change, San Francisco Museum of Modern Art, San Francisco, USA

2010 How Soon Now, Rubell Family Collection/Contemporary Arts Foundation, Miami, USA

2010 Liverpool Biennial of Contemporary Art, Liverpool, UK

SELECTED SOLO EXHIBITIONS

2010 Any Ever, The Museum of Contemporary Art, Los Angeles, USA

2010 Any Ever, The Power Plant, Toronto, Canada

2009 Kunsthalle Wien, Vienna, Austria

2008 Ryan Trecartin, Hammer Museum, Los Angeles, USA

OSCAR TUAZON

American, b. 1975 in Seattle, USA. Lives and works in Paris, France

EDUCATION

1999 Cooper Union for the Advancement of Science and Art, New York, USA

2003 Program/Cooper Union School of Architecture, Architecture/Urban Studies Program, New York, USA

2003 Whitney Museum of American Art Independent Study Program, Studio Program, New York, USA

SELECTED GROUP EXHIBITIONS

2009 Evento, CAPC, Bordeaux, France

2009 Display With Sound, IPS, Birmingham, UK

2007 Documenta 12 Magazine Projects, Kassel, Germany

SELECTED SOLO EXHIBITIONS

2010 Oscar Tuazon: My Mistake, ICA, London, UK

2010 Kunsthalle Bern, Bern, Switzerland

2010 Parc St Leger, Centre d'Art Contemporaine, Pougues-les-Eaux, France

2008 Kodiak, Seattle Art Museum, Seattle, USA

2006 Down By Law, The Wrong Gallery, Whitney Biennial, Whitney Museum of American Art, New York, USA

KARA WALKER

American, b. 1969 in Stockton, USA. Lives and works in New York, USA

EDUCATION

1991 Atlanta College of Art, Atlanta, USA

1994 Rhode Island School of Design, Providence, USA

SELECTED GROUP EXHIBITIONS

2010 Compass in Hand: Selections from the Judith Rothschild Foundation Contemporary Drawings Collection, MoMA, New York, USA

2009 Between Art and Life: The Contemporary Painting and Sculpture Collection, San Francisco Museum of Modern Art, San Francisco, USA

2008 Houston Collects: African American Art, Museum of Fine Arts, Houston, USA

2007 Venice Bienalle, Venice, Italy

SELECTED SOLO EXHIBITIONS

2008 The Black Road, CAC Malaga, Malaga, Spain

2008 Kara Walker, Museum Dhondt-Dhaenens, Deurle, Belgium

2007 Kara Walker: My Complement, My Enemy, My Oppressor, My Love, The Walker Art Center, Minneapolis, USA

2006 Kara Walker at the Met: After the Deluge, The Metropolitan Museum of Art, New York, USA

2004 Kara Walker: Grub For Sharks: A Concession to the Negro, Tate Liverpool, Liverpool, UK

JEFF WALL
Canadian, b. 1946 in Vancouver, Canada. Lives and works in Vancouver, Canada
EDUCATION
1970 University of British Columbia, Vancouver, British Columbia, Canada
1973 Courtauld Institute of Art, London, UK
SELECTED GROUP EXHIBITIONS
2010 Art of the 1980s: A Dusseldorf Perspective, K21 Dusseldorf, Germany
2010 Triumphant Carrot: The Persistence of Still Life, Contemporary Art Gallery, Vancouver, Canada
2008 The Tree: From the Sublime to the Social, Vancouver Art Gallery, Vancouver, Canada
SELECTED SOLO EXHIBITIONS
2010 Transit, Staatliche Kunstsammlungen, Dresden, Germany
2008 Jeff Wall: Exposure, Guggenheim Museum, Berlin, Germany
2008 Jeff Wall, Vancouver Art Gallery Collection, Vancouver, Canada
2007 Jeff Wall, The Museum of Modern Art, New York, USA

PAE WHITE
American, b. 1963 in Pasadena, USA. Lives and works in Los Angeles, USA
EDUCATION
1985 Scripps College, Claremont, California, USA
1990 Skowhegan School of Painting and Sculpture, New York, USA
1991 MFA Art Center College of Design, Pasadena, USA
SELECTED GROUP EXHIBITIONS
2010 Whitney Biennial, Whitney Museum of American Art, New York, USA
2009 Fare Mondi/Making Worlds, 53rd La Biennale di Venezia, Venice, Italy
2009 Contemplating the Void, The Guggenheim Museum, New York, USA
SELECTED SOLO EXHIBITIONS
2009 Lisa Bright and Dark, Taubman Museum of Art, Roanoke, USA
2008 Too Much Night, neugerriemschneider, Berlin, Germany
2006 In No Particular Order, Manchester Art Gallery, Manchester, UK
2004 Pae White, Hammer Museum, Los Angeles, USA

CHRISTOPHER WILLIAMS
American, b.1956 in Los Angeles. Lives and works in Cologne, Düsseldorf, Germany and Amsterdam, The Netherlands
EDUCATION
1981 California Institute of the Arts, Valencia, USA
1978 California Institute of the Arts, Valencia, USA
SELECTED GROUP EXHIBITIONS
2011 Anti/Form: Sculptures from the MUMOK Collection, Kunsthaus Graz, Graz, Austria
2010 A Shot in the Dark, Walker Art Center, Minneapolis, USA
2010 Gwangju Biennale: 10,000 Lives, Gwangju, South Korea
SELECTED SOLO EXHIBITIONS
2011 Christopher Williams, Museum Dhondt-Dhaenens, Deurle, Belgium
2010 Christopher Williams: For Example: Dix-Huit Leçons Sur La Société Industrielle (Revision 11), Staatliche Kunsthalle Baden-Baden, Germany
2010 Christopher Williams:. For Example: Dix-Huit Leçons Sur La Société Industrielle (Revision 10), Bergen Kunsthall, Bergen, Norway

FRED WILSON
American, b. 1954 in New York, USA. Lives and works in New York, USA
EDUCATION
1976 SUNY College, Purchase, New York, USA
SELECTED GROUP EXHIBITIONS
2011 Currents: Arts and the Environment, Courthouse Galleries, Portsmouth, USA
2010 The Global Africa Project, Museum of Art and Design, New York, USA
2009 The Dorothy Saxe Invitational, Contemporary Jewish Museum, San Francisco, USA
2009 Art at Colby: Celebrating the 50th Anniversary of the Colby College Museum of Art, Colby College Museum of Art, Waterville, USA
SELECTED SOLO EXHIBITIONS
2007 An Account of a Voyage to the Island Jamaica with the Un-Natural History of that Place, Institute of Jamaica Gallery, Kingston, Jamaica
2005 Fred Wilson: Black Like Me, The Aldrich Contemporary Art Museum, Ridgefield, USA
2005 Fred Wilson: So Much Trouble in the World—Believe it or Not!, Hood Museum of Art, Dartmouth College, Hanover, USA
2004 Fred Wilson: Site Unseen: Dwellings of the Demons, Museum of World Culture, Gothenburg, Sweden
2003 Fred Wilson: Aftermath, Berkley Art Museum and Pacific Film Archive, University of California, Berkley, USA

CHRISTOPHER WOOL
American, b. 1955 in Chicago, USA. Lives and works in New York, USA
EDUCATION
1972 Sarah Lawrence College, Bronxville, USA
1973 Studio School, New York, USA
SELECTED GROUP EXHIBITIONS
2010 Skin Fruit: Selections from the Dakis Joannou Collection, New Museum, New York, USA
2010 Changing Soil: Contemporary Landscape Painting (Za Fukei), Nagoya/Boston Museum of Fine Arts, Nagoya, Japan
2009 Warhol Wool Newman Painting Real, Kunsthaus Graz, Graz, Austria
2008 Oranges and Sardines: Conversations on Abstract Painting with Mark Grotjahn, Wade Guyton, Mary Heilmann, Amy Sillman, Charline von Heyl and Christopher Wool, Hammer Museum, Los Angeles, USA
SELECTED SOLO EXHIBITIONS
2009 Christopher Wool: Editions, Artelier Contemporary, Graz, Austria
2008 Porto-Köln, Museum de Arte Contemporanea de Serralves, Porto, Portugal
2006 Christopher Wool: East Broadway Breakdown, ETH (Swiss Federal Institute of Technology), Zurich, Switzerland
2006 Christopher Wool, Instituto Valenciano de Arte Moderno, Valencia, Spain
2004 Christopher Wool, Camden Arts Centre, London, UK

SELECTED BIBLIOGRAPHY

SUGGESTED READING

ALBERRO, ALEXANDER AND BLAKE STIMSON, *Conceptual Art: A Critical Anthology*, Cambridge, Massachusetts: The MIT Press, 2000

AUSLANDER, PHILIP, *Presence and Resistance: Postmodernism and Cultural Politics in Contemporary American Performance (Theatre: Theory/Text/Performance)*, Ann Arbor: University of Michigan Press, 1994

BROWN, MILTON W AND THERESA C BRAKLEY (eds), *American Art*, New York: Abrams, 1977

CARRUTHERS, GLEN AND GORDANA LAZEREVICH, *A Celebration of Canada's Arts: 1930–1970*, Toronto: Canadian Scholars Press, 1998

COHEN, WILLIAM, *Art in Our Time in Southern California: a Guide to the Documentation of Contemporary Art*, New York: Garland, 1986

COLES, ALEX AND DION, MARK (EDS), *Archaeology*, London: Black Dog Publishing, 1999

COLLISCHAN, JUDY, *Made in the U.S.A.: Modern/Contemporary Art in America*, Bloomington: iUniverse, 2010

DAILEY, MEGHAN AND NORMAN ROSENTHAL, *USA Today: New American Art from the Saatchi Gallery*, London: Royal Academy of the Arts, 2007

FOSTER, HAL, ROSALIND KRAUSS, YVE-ALAIN BOIS AND BENJAMIN HD BUCHLOH, *Art Since 1900: Modernism, Antimodernism, Postmodernism*, London: Thames and Hudson, 2004

FRIED, MICHAEL, *Art and Objecthood: Essays and Reviews*, Chicago and London: University of Chicago Press, 1998

GRAHAM, DAN, *Rock My Religion: Writings and Projects 1965–1990*, Massachusetts: The MIT Press, 1993

GRAHAM, DAN, *Two-Way Mirror Power: Selected Writings by Dan Graham on His Art*, Massachusetts: The MIT Press, 1999

HEARTNEY, ELEANOR, *Critical Condition: American Culture at the Crossroads (Contemporary Artists and their Critics)*, Cambridge: Cambridge University Press, 1997

JOSELIT, DAVID, *American Art Since 1945 (World of Art)*, New York: Thames and Hudson, 2003

KRAUS, CHRIS, JAN TUMLIR AND JANE MCFADDEN, *LA Artland: Contemporary Art from Los Angeles*, London: Black Dog Publishing, 2005

MACHIDA, MARGO, *Unsettled Visions: Contemporary Asian American Artists and the Social Imaginary*, Durham, NC: Duke University Press Books, 2008

METCALF, EUGENE, *Contemporary American Folk, Native, and Outsider Art: Into the Mainstream?*, Miami: Miami University Art Museum, 1990

O'BRIAN, JOHN, *Clement Greenberg: The Collected Essays and Criticism*, Chicago: University of Chicago Press, 1986 and 1993.

O'BRIAN, JOHN AND PETER WHITE, *Beyond Wilderness: The Group of Seven, Canadian Identity, and Contemporary Art (Arts Insights Series)*, Montreal: McGill-Queen's University Press, 2007

PHILLIPS, LISA, *The American Century: Art and Culture 1950–2000*, New York: Whitney Museum of American Art in association with WW Norton, 1999

ROBERTS, CATSOU AND LUCY STEEDS (eds), *Michael Snow, Almost Cover to Cover*, London: Black Dog Publishing, 2001

THE SAATCHI GALLERY, *Abstract America*, New York: Rizzoli, 2009

SIEGEL, KATY, *Since '45: America and the Making of Contemporary Art*, London: Reaktion Books, 2010

SOLLINS, SUSAN, *Art 21: Art in the Twenty First Century 5*, New York: Art 21, Inc, 2009

STILES, KRISTINE AND PETER SELZ, *Theories and Documents of Contemporary Art: A Sourcebook of Artist's Writings*, Los Angeles: University of California Press, 1996

WARREN, LYNNE, *Art in Chicago 1945–1995*, New York: Thames and Hudson, 1996

ESSAYS AND ARTICLES

BANKOWSKY, JACK, "Tent Communities: Jack Bankowsky on Art Fair Art", in *Artforum*, October 2005

BURTON, JOHANNA AND ISABELLE GRAW, "When Procedures Become Market Tools", in *Texte Zur Kunst 61*, June 2006

FOSTER, HAL, "Precarious", in *Artforum*, December 2009

FRIED, MICHAEL, "Art and Objecthood", in *Artforum*, June 1967

GILBERT, ALAN, "Startling and Effective: Writing Art and Politics after 9/11", in *Pores 2*, 2002

KOZLOFF, MAX, "American Painting during the Cold War", in *Artforum*, May 1973

LAWSON, THOMAS, "Last Exit: Painting", in *Artforum*, October 1981

MYERS, TERRY R, "Art School Days", in *Sunshine & Noir, Art in LA 1960–1997*, Humlebaeck: Louisiana Museum of Modern Art, 1997

ROSLER, MARTHA, "Video: Shedding the Utopian Moment", in *The Block Reader in Visual Culture*, London: Routledge, 1996

PIPER, ADRIAN, "Flying", in Piper, Adrian, *Out of Order, Out of Sight Volume One: Selected Writings in Meta Art 1968–1992*, Massachusetts: The MIT Press, 1999

SCOTT, KITTY, "The Top 100: An Introduction to the Art Metropole Collection" in *Art Metropole: The Top 100*, Ottawa: National Gallery of Canada, 2006

SEKULA, ALLAN, "Meditations on a Triptych" in Sekula, Allan, *Dismal Science: Photo Works 1972–1996*, Normal: Illinois State University, University Galleries, 1999

SMITHSON, ROBERT, "A Tour of the Monuments of Passaic", in *Artforum*, October 1967

WALL, JEFF, "Photography and Liquid Intelligence" in *Jeff Wall: Selected Essays and Interviews*, New York: MoMA, 2007

EXHIBITION CATALOGUES

BONAMI, FRANCESCO AND GARY CARRION-MURYARI, *2010: Whitney Biennial*, New York: Whitney Museum of American Art, Yale University Press, 2010

CURIGER, BICE, *Birth of the Cool: American Painting from Georgia O'Keefe to Christopher Wool*, Ostfildern-Ruit: Cantz, 1997

DESMARAIS, CHARLES, *Proof—Los Angeles Art and the Photograph, 1960–1980*, Laguna Beach: Fellows of Contemporary Art, 1992

HERMAN, LLOYD E, *Trashformations: Recycled Materials in Contemporary American Art and Design*, Bellingham: Whatcom Museum of History, 1998

HOROWITZ, NOAH AND SHOLIS, BRIAN, *The Uncertain States of America Reader*, New York: Sternberg Press, 2007

METCALF, EUGENE, *The Ties that Bind: Folk Art in Contemporary American Culture*, Cincinnati: Contemporary Arts Center, 1986

MUSEUM OF CONTEMPORARY ART, *This Is Not To Be Looked At: Highlights from the Permanent Collection of MOCA*, Los Angeles: MOCA, 2008

NATIONAL COLLECTION OF FINE ARTS (US), *Contemporary Art from Alaska*, Washington DC: Smithsonian Institution Press, 1978

HARTEN, JÜRGEN, DAVID A ROSS, *The Binational: American Art of the Late 80s*, Museum of Fine Arts, Boston, Städtische Kunsthälle Düsseldorf, DuMont, 1988

KRASKIN, SANDRA *Pioneers of Abstract Art: American Abstract Artists, 1936–1996*, Sidney Mishkin Gallery, Baruch College, 1996

DAILY, MEGHAN AND NORMAN ROSENTHAL, *USA Today: New American Art from the Saatchi Gallery*, London: Royal Academy of the Arts, 2007

PHILLIPS LISA AND BARBARA HASKELL, *The American Century: Art and Culture 1950–2000*, New York: Whitney Museum of American Art, 1999

WEBSITES

Art21 (PBS Mini series)
http://www.pbs.org/art21/

Artforum
http://artforum.com/

Art Basel Miami Beach
*http://www.artbaselmiamibeach.com/*Chicago Artists Resource
http://www.chicagoartistsresource.org/

Centre for Contemporary Canadian Art (CCCA) Canadian Art Database
http://www.ccca.ca/start.html?languagePref=en&

Database, online publications, articles, and links about artist run culture
http://arcpost.ca/

The Museum of Modern Art (MoMA), New York
http://www.moma.org/

MoMA PS1, New York
http://ps1.org/

The National Gallery of Canada
http://www.gallery.ca/

The Pulitzer Foundation for the Arts and Contemporary Art Museum St Louis Blog
http://www.2buildings1blog.org/

Welcome to Canadian Art
http://www.canadianart.ca/

Whitney Biennial
http://whitney.org/Exhibitions/2010Biennial

SELECT BIBLIOGRAPHY CITED IN THE BOOK

BISHOP, CLAIRE, *"The Social Turn: Collaboration and its Discontents"*, Artforum, vol. XLIV, no.6, February 2006

BRONSON, AA, *From Sea to Shining Sea*, Toronto: The Power Plant Gallery for Contemporary Art, 1987

FRIED, MICHAEL, *Why Photography Matters as Art as Never Before*, London and New Haven: Yale University Press, 2008

FRIEDMAN, *The Horizontal Society*, New Haven: Yale University Press, 1999

GREENBERG, CLEMENT, "Modernist Painting" in Greenberg, Clement, *Art and Culture*, Boston: Beacon Press, 1961

GREENBERG, CLEMENT, "Avant-Garde and Kitsch", *Partisan Review* 6:5, 1939

GUILBAULT, SERGE, *How New York Stole the Idea of Modern Art*, Chicago: University of Chicago Press, 1985

HENIGHAN, TOM, *The Presumption of Culture*, Vancouver: Raincoast Books, 1996

JAMESON, FREDERIC, "Postmodernism, or the Cultural Logic of Late Capitalism", in *New Left Review*, 1984

KLEIN, NORMAN, *The History of Forgetting: Los Angeles and the Erasure of Memory*, London: Verso, 1997

LIPPARD, LUCY, *Reconsidering the Object of Art, 1965–1975*, Los Angeles: The Museum of Contemporary Art, 1995

MARCHAND, PHILLIP, *Marshall McLuhan: The Medium and the Messenger*, Toronto: Vintage Canada, 1989

MITCHELL, WJT, *Art and the Public Sphere*, Chicago: University of Chicago Press, 1992

PORTER, JOHN, *The Vertical Mosaic: An Analysis of Social Class and Power in Canada*, Toronto: University of Toronto Press, 1965

SALTZ, JERRY, *Seeing Out Louder*, New York: Hard Press Editions, 2009

INDEX

A

ABC No Rio 193
Abject Art 19
Abstract Expressionism 19, 100, 150, 210
Acconci, Vito 23, 58, 100, 190, 191, 202
—"Antarctica of the Mind" 58
Addis Ababa 108
Adorno, Theodor 210, 211, 215
Afghanistan 134
African American 24, 97, 138
Agit-Prop 201
AIDS 193, 195
Ali, Muhammad 100
Allora and Calzadilla 30–33, 207
Alloway, Lawrence 191
Amarillo, Texas 191
An International Survey of Recent Painting and Sculpture 194
Anderson, Laurie 191, 193
—O Superman 193
Andre, Carl 190
Andrea Rosen Gallery 20, 195, 196, 200
Anger, Kenneth 197
Antoni, Janine 196
Antwerp 54
Appleseed, Johnny 195
Arcangel, Cory 23
Archbishop of Salzburg 219
Archimedean 209
Arctic Council 198
Armani, Giorgio 197
Armory Show 196
Art & Language 217
Art Bank 202
Art Basel Miami Beach 26
Art Center 216
Arte Povera 25
Artforum 21
Asia 190, 208
Astaire, Fred 34
ATTAC 211
Attia, Kader 208
Attie, Dotty 191
Avalanche Magazine 191
Avant-Garde 210
Aycock, Alice 191

B

Bachelard, Gaston 216
Baldessari, John 21, 22
Barbara Gladstone Gallery 195

Barklie, Gayle 216
Barney, Matthew 19, 40–43
Barr, Alfred 18
Bartlett, Jennifer 190
Basquiat, Jean-Michel 193, 194
Bath Iron Works, Maine 177
Batman 194
Battle in Seattle 207
Bay Area Funk 213
BBC World News 24
Bear, Liza 191
Beck, Glenn 18
Beecroft, Vanessa 197
Benglis, Lynda 191
Benning, Sadie 196
Berens, Stephen 217
Berlin 30, 215
Bernadette Corporation 22, 164–165
Beshty, Walead 20, 21
Bessemer, Linda 216
Beuys, Joseph 192, 193, 195
Bhopal 24, 25
Bickerton, Ashley 194
Bilak, Peter 51
Birrell, Ellen 217
Bishop, Claire 22
Bliss 216, 217
Blum & Poe 217
BMW 197
Boat-People.org 210
Boesky, Marianne 196
Bonami, Francesco 206
Bonanno, Mike 24
Borofsky, Jonathan 190
Box Elder County 23
Bradford, Mark 213
Brakhage, Stan 197
Brauntuch 192, 193
Bread & Puppet Theater 210
Brian O'Doherty 51
Broad Contemporary Art Museum 26
Broad, Eli 26
Broadcasting Act 199
Bronson, AA 202
Bronson, Carl 216
Broodthaers, Marcel 192
Brooklyn Museum 197
Brown, Gavin 196
B-side 193
Bunn, David 214
Burden, Chris 34, 191

Bureau of Alcohol, Tobacco, Firearms and Explosives (ATF) 219
Bush, George 44, 198
Bykert Gallery 190

C

Cable Gallery 194
CalArts 21, 215, 216
—CalArts Feminist Art Program 216
California Biennial 213
California Institute of the Arts 161
Calle, Sophie 196
Calvin, Brian 19, 20
Campus, Peter 190
Canada Council 198, 202, 203
Canadian Broadcasting Corporation 203
Canadian Multiculturalism Act 198
Caravaggio, Michelangelo Merisi da 108
Casey Kaplan Gallery 27
Cash Newhouse 193
Cattelan, Maurizio 192, 196, 197
Center for Land Use Interpretation 22, 52–53
Centre Georges Pompidou 146
Chamberlain, John 196
Chang, Fandra 216
Charlesworth, Sarah 193
Chicago, Judy 216
China 200
Chou, Min 194
Christo and Jeanne-Claude 197
City of God 207
Civilian Warfare 193
Clark, Larry 193
Clemente, Francesco 194
Clinton, Bill 198
Close, Chuck 190, 196
CNN 25
Coca-Cola 208
Colin De Land's American Fine Arts 195
Collyer brothers 26
Cologne 213, 214
Conceptual Art 20, 21, 24, 25, 34, 41, 44, 97, 150, 177, 190, 191, 195, 201, 207, 211, 212, 214, 215, 217
Confederation Trains 201
Conrad, Joseph 200
Constructivism 210
Cooper, Dennis 215
—"Too Cool for School" 215
Cooper, Laura 217
Coplans, John 191
Corcoran Gallery 195

Cortez, Diego 193
Country Joe & the Fish 210
Courbet 195
Craftsman house 216
Craig, Tony 192
Crewdson, Gregory 20
Critical Art Ensemble (CAE) 23, 25, 211, 219–220
Crotty, Russell 217
Culture Wars 194, 195, 208
Currin, John 19, 88–91, 195

D

Dada 210
Dakis Joannou 27
Dalrymore, Clarissa
Daniel Newberg Gallery 195
Danto, Arthur G 206, 207, 208, 209
—Danto's Augustinian metaphor 209
Darwin, Charles 54
David Zwirner Gallery 196
De Certeau, Michel 199
De Kooning, Willem 100, 197
De Maria, Walter 193
Deacon, Richard 192
Deep Dish TV Network 210
Defoe, Daniel 150
—Robinson Crusoe 151
Deitch, Jeffrey 27
Deleuze, Gilles 209
den Hartog, Jacci 217
Denis, Agnes 191
Department of Homeland Security 219
Dewey, John 200
Dexter Sinister 50–51
—Dot Dot Dot 51
—Just-In-Time Workshop and Occasional Bookstore 51
—Studio and Cube 51
—Uncertain States of America Reader 51
Di Benedetto, Steve 194
Dia Art Foundation 195
Dickinson, Emily 118
Dine, Jim 196
Dion, Mark 54–57
Disney 203
Disobbedienti 210
Documenta 195, 209
Doherty, Brian 51
Donen, Stanley 34
—Royal Wedding 34
Donnelly, Trisha 26
Douglas, Stan 186–187

Duchamp, Marcel 27, 193
Dumontier, Michael 115
Dunham, Carroll 19
Durant, Sam 217
Durer 195
Durkheim, Emile 200, 219
Dykstra, Rineke 192
Dyogot, Ekaterina 210
Dzama, Marcel 114–117

E
Earth Works 191, 197
East Coast 213
Edelson, Mary Beth 191
Eliasson, Olafur 197
Erickson, Arthur 203, 204
Ethridge, Roe 162–163
European Community 199
Evans, Simon 213
Expo '67 200, 201
—Habitat 200
Ezawa, Koto 213

F
Fab 5 Freddy 193
Fanon, Franz 203
Farber, Neil 115
FBI 25, 219
Federal Plaza 194
Ferrell, Robert 219
Festivalism 197
Finish fetish 213, 216
Finley, Karen 194
Flavin, Dan 191
Foster, Hal 208
Foxx, Marc 217
Franceschini, Amy 213
Francophone 198
Frankfurt 219
Fraser, Andrea 23, 48–49
Fried, Michael 20
—Why Photography Matters as Art as Never Before 20
Friedman, Tom 74–75
Fugs 210
Fuller, Buckminster 200
Fun 193
Fusco, Coco 196
Futurefarmers 213

G
Galerie Max Hetzler 214

Gallagher, Ellen 122–125
Gehry, Frank 48
General Agreement on Tarrifs and Trade (GATT) 203
General Idea 23, 202
Gilman, Claire 25
Gioni, Massimiliano 197
Girouard, Tina 191
Giuliani, Rudolf 197
Glasgow Centre for Contemporary Art 219
Glimcher, Arnold 196
Global Village 200
Globalisation 200, 201, 203, 206–209, 211
Gober, Robert 76–79, 195
Goldin, Nan 193
Goldstein, Jack 192, 193
Gonzales, Michael 216
Gonzalez-Torres, Felix 195, 196
Google 25
Gould, Glenn 200
Govan, Michael 197
Goya, Francisco 118
Graffiti 19, 24, 82, 192, 194, 210
Graham, Rodney 150–153
Gramercy Park Hotel 196
Gramercy Park International Art Fair 196
Granatstein, Jack 202
Green, Rene 196
Greenberg, Clement 219
Group Material 210
Gruenther, Laura 217
Grunge 20
Guggenheim Museum, Bilbao 48
Guggenheim Museum, New York 24, 48, 191, 192, 194, 197
Guilbaut, Serge 209
—How New York Stole the Idea of Modern Art 209
Gursky, Andreas 208
Guyton, Wade 126–127

H
Haacke, Hans 191
Halifax 201
Halley Two Research Station 58
Halley, Peter 194
Hammond, Harmony 191
Hammons, David 23, 193
Hans Holbein the Younger 150
Hardt, Michael 209
—Empire 209
Haring, Keith 193, 194
Harris, Lawren 203

Harrison, Rachel 72–73
Havana 208, 213
Hawaii 158
Heiner, Dennis 197
Henighan, Tom 201
Herrera, Arturo 82–83
Hickey, David 212
Hiller, Susan 154–157
Hollywood 34, 44
Holt, Nancy 23
Holzer, Jenny 193
Honolulu 158
Horn, Roni 184–185
Horowitz, Gad 202
Horowitz, Jonathan 132–133
House Beautiful Magazine 134
Houston 23, 192, 215
Huebler, Douglas 21
Hultkrans, Andrew 215
—"Surf and Turf" 215
Humanities Association of Canada 200
Hurtado, Luchita 112

I
Image Bank 201
Inaba, Jeffrey 213
Independent Study Program 58
Indymedia 210
Innis, Harold 200
Institutional Critique 24, 48
International With Monument 193
Invisible Committee 18
—The Coming Insurrection 18
Istanbul 206, 213

J
Jacobs, Jane 200, 201
—The Death and Life of Great American Cities 200
Jameson, Fredric 207
Jay Gorney Modern Art 193
Jensen, Alfred 192
Johannesburg 208, 213
Johanson, Chris 19
John D Rockefeller, Jr 54
Johns, Jasper 100, 193
Johnson, Larry 214
Johnson, Ray 201
Jonas, Joan 195, 196
Joshua Tree 23
Judd, Donald 191, 196

K
Kant, Immanuel 211
Kauffman, Craig 216
Keaton, Buster 34
Kentridge, William 192
Kern, Anton 196
Kersels, Martin 34–37
Kertess, Klaus 190
Kherdyar, Habib 216
Kiefer, Anselm 192, 193
Kilgallen, Margaret 19
Kim, Byron 196
King, Mackenzie 198
Kitchen 194
Klagsbrun, Nicole 194
Klein, Norman 213
Knight, Christopher 212
Koons, Jeff 19, 24, 194, 195
Kozloff, Max 191
Krauss, Rosalind 191
Krens, Thomas 194, 197
—Art of the Motorcycle 197
Kruger, Barbara 23, 194
Kunsthalle Bern 58
Kurtz, Steve 25, 219, 220
Kustom kar kulture 213

L
La Francophonie 198
LaBelle, Charles 217
Labowitz, Leslie 210
Lacy, Suzanne 210
Landers, Sean 19, 20
Langlois, Drue 115
Las Agencias 210
Latin America 208
Le Va, Barry 190, 192
Le Witt, Sol 190
Lee, Pamela M 206–209
Lennon, John 192
Leo Castelli Gallery 190
Leonard, Zoe 196
Letters and Sciences 198, 199
Levin, Kim 19
Levine, Sherrie 192, 194
Levi-Strauss, Claude 201
Lichtenstein, Roy 194
Life magazine 134
Light and Space 216
Ligon, Glenn 96–99
Linn, Maya 193

Lippard, Lucy 217
Lockhart, Sharon 176–179
London 54, 122, 213, 215
Longo, Robert 192, 193
Lopez, Michelle 213
Los Angeles 23, 26, 27, 34, 117, 118, 192, 197, 206, 212 213, 214, 216
—San Fernando Valley 216
—Silverlake 216
Los Angeles Central Library 214
Los Angeles County Museum of Art 26
Los Angeles Museum of Art 197
Luhring Augustine Gallery 197
Lum, Ken 18, 198–205
Lynnerup, Mads 213
Lyotard, Jean-François 201

M
Maccarone Gallery 58
Machiavelli, Niccolò 209
Malmö 215
Malraux, André 201
Man and His World 200
Mangold, Robert 190, 196
Manifesta 51
Mansion, Gracie 193
Mapplethorpe, Robert 193, 195
Marclay, Christian 142–145
Marden, Brice 191
Marianne Goodman Gallery 192, 196
Markonish, Denise 18
Marks, Matthew 196
Marshall, Kerry James 92–95
Martinez, Daniel J 196
Marx, Karl 207
—Marxism 210
Mary Boone Gallery 193, 194
Masheck, Joseph 191
Mason, T Kelly 217
Mass MoCA 219
Matta-Clark, Gordon 191, 192
McCarthy, Damon
McCarthy, Paul 34, 44–47
McDonald's 203
McEvilley, Thomas 194
McEwen, Adam 197
McGee, Barry 19
McLuhan, Marshall 18, 200, 201, 203, 204
McShine 194
Meckseper, Josephine 160–161
Mehretu, Julie 108–111

Meir Friedman, Lawrence 203
Messer, Tom 191
Metro Pictures Gallery 193, 195
Michelsen, Annette 191
Michigan 108
Milwaukee 24
Minh Ha, Trinh T 203
Minimalism 7, 20, 25, 44, 190, 192
Mojave Desert 23
MoMA PS1
—New Wave New York 193
Monroe, Marilyn 158
Montréal 200, 201
Morris, Robert 191
Morton, Ree 192
Mothers of Invention 210
Mudd Club 193
Muller, Dave 214, 215
Mullican, Matt 112–113
Multiculturalism Policy 198
Mumford, Lewis 200
Murray, Elizabeth 190, 196
Museum of Modern Art, New York (MoMA) 18, 146, 193, 194
—Primitivism in 20th Century Art: Affinities of the Tribal and the Modern 194
Myers, Terry R 212

N
Name, Billy 190
National Basketball Association (NBA) 158
National Film Act 199
National Film Board of Canada 200
National Gallery of Canada 18
NATO 198
Nature Morte 193
Nauman, Bruce 100, 190, 191
Ne Pas Plier 210
Negri, Antonio 209
Neo-Expressionism 194
Neo-Geo 194
New Math 193
New Museum of Contemporary Art 22, 25
—Free 22
—Rhizome 22
—Unmonumental 25
New World Order 207
New York 18, 20, 26, 27, 51, 58, 108, 134, 158, 190–197, 201, 206, 210, 213
—Beacon 197
—Central Park 197

—Chelsea 26, 196, 197
—East Village 193, 197
—Harlem 26
—Lower East Side 193
—Manhattan 25, 196
New York Correspondence School 201
New York Times 191, 196, 197, 215
—*New York Times Magazine* 190, 191, 196, 197, 215
Nike 207
Nobel Peace Prize 200
Noland, Cady 195, 196
Nomadic Site 217
North American Free Trade Agreement 203
Nova Scotia College of Art and Design 201

O
Obama, Barack 18, 97
Ochoa, Rueben 213
October 191
O'Doherty, Brian 51
—"Inside the White Cube" 51
—*Studio and Cube* 51
Ofili, Chris 197
Ono, Yoko 192
Ontario, Canada 198
Orozco, Gabriel 192
Oshiro, Kaz 213
Oursler, Tony 22, 146–149

P
PAD/D 210
Padua 209
Pagel, David 212
Palast der Republik, Berlin 30
Palin, Sarah 18
Paper Rad Collective 23
Paper Tiger 210
Pardo, Jorge 216, 217
Paris 58, 213
Park Fiction 210
Pat Hearn 193
Patriot Act 210
Paula Cooper Gallery 190, 192
Pearson, Lester 200, 201
Perot, Ross 193
Perugia 54
Pettibon, Raymond 20, 104–107
Petzel, Frederic 196
Pfeiffer, Paul 158–159
Philippines 158
Photography of Modern Life 193

Picasso, Pablo 20, 193
Pictures Art 194
Pierson, Jack 196
Piezo Electric 193
Pindell, Howardena 191
Piper, Adrian 23, 194
Pittman, Lari 212
Polke, Sigmar 193
Pollock, Jackson 97, 200
Pop Art 19, 20, 44
Pop, Iggy 34
Porter, John 203
—*The Vertical Mosaic* 203
Postcolonialism 210
Postmasters 193
Postmodern 19, 197, 206, 207, 208, 210, 213
Post-Pop 210
Powhida, William 27
—*How the New Museum Committed Suicide with Banality* 27
Prina, Stephen 214
Prince, Richard 100, 128–131, 191, 193
Project X 217
Pruitt-Igoe 200
Puppy 195
Pylypchuk, Jonathan 115

Q
Québec 198, 200, 201

R
Radawek, Bill 217
—Domestic Setting 217
Rainer, Yvonne 191
Rampart, Los Angeles 217
Raqs Media Collective 210
Ray, Charles 23
Reinhardt, Ad 195
Relational Aesthetics 24, 195, 196
Rene Block Gallery 192
REPOhistory 210
Report of the Royal Commission on Publications 198
Rhode Island 108
Richter, Gerhard 193
Riddle, Kenneth 216
Rinder, Lawrence 22
—Bitstreams 22
Rist, Pipilotti 197
River Lethe 213
River Thames 54
Robin Hood 194

Rockburne, Dorothea 190
Rockefeller, John D Jr 54
Rockwell, Norman 195, 197
Rosenblum, Robert 191
Rosler, Martha 134–137, 210–211
Ross, Adam 216
Rothko, Mark 192
Royal Commission on National Development in the Arts 198
Rubin, William 194
Rugoff, Ralph 215
Ruppersberg, Allan 214
Ruscha, Ed 214
Ryman, Robert 190, 196

S

Saatchi, Charles 197
—Sensation 197
Safdie, Moshe 200
Salle, David 196
Saltz, Jerry 18, 25, 190–197
San Francisco 19
Sao Paulo 206
Schapiro, Miriam 216
Scharf, Kenny 193
Schirn Kunsthalle 219
Schnabel, Julian 193
Schorr, Collier 194
Scotus, Duns 209
SCUM (Society for Cutting Up Men) 190
Searle, Adrian 195
Seattle 70, 207
Second World War 198, 200
Sekula, Allan 208
Senegal 108
Serra, Richard 194, 195
Serrano, Andrea 195
Shafrazi, Tony 193
Shanghai 206
Shapiro, Joel 196
Sharp, Willoughby 191
Shaw, Jim 84–87, 195
Sherman, Cindy 22, 172–175, 193
Shields, Alan 190
Sholette, Greg 210
Sibony, Gedi 25, 26
Sierra, Santiago 208
Sikkema, Brent 196
Silhouette 138
Simmons, Laurie 193
Simpson, Bennett 21

Simpson, Lorna 196
Simulacra 206
Slacker Art 19
Smith, Jack 192, 197
Smith, Kiki 193, 196
Smithson, Robert 191, 197
Snow, Michael 168–171
Solanas, Valerie 190
Solomon, Deborah 215
—How to Succeed Art 215
Sonnabend Gallery 191, 194, 195
Sonnier, Keith 191
South Pasadena 216
Spero, Nancy 191
Spin 215
Spinoza, Baruch 209
St Laurent, Louis 199
Staller, Ilona 195
Stark Frances 118–121, 214, 217
Steinbach, Haim 194
Steinkamp, Jennifer 216
Stingel, Rudolf 195
Stockholder, Jessica 70–71
Struth, Thomas 192
Student Mobilization Committee to End the War in Vietnam 190
Subotnick, Ali 197
Sub Rosa 210
Superflex 210
Surrealism 25, 112
Sze, Sarah 66–69

T

Tallahassee, Florida 25
Tanya Bonakdar Gallery 197
Tate Britain 54
Tate Modern 197, 112
—Turbine Hall 197
Telex 201
Thater, Diana 216
The Abby Aldrich Rockefeller Sculpture Garden 54
The Annual Meeting of the Canadian Press, 1970 198
The Bowery, New York 134
The British Commonwealth 198
The Canada Council Art Bank 202
The Drawing Center 196
The Guest Room 217
The Iraq War 44, 134, 161
The Joint Terrorism Task Force 219
The Massachusetts Museum of Contemporary Art 25

The Mission School 19
The National Film Board, Canada 198
The Pace Gallery 196
The Real Estate Show 193
The Royal Art Lodge 115
The Serpentine Gallery 51
—Uncertain States of America Reader 51
The Tea Party 18
The Vertical Mosaic 203
The Waitresses 210
The Yes Men 24
—The Yes Men Fix the World 24
Thompson, Robert 199
Three Day Weekend 215
Times Square Show 193
Tirana 208
Tiravanija, Rirkrit 64–65, 195, 196
Toffler, Alvin 200
Tokyo 215
Toronto 201, 202
Trecartin, Ryan 23, 38–39, 197
Tribe, Kerry 213
Troy, California 23
Trudeau, Elliott 198, 200
Trudeau, Pierre 199, 201
Tuazon, Oscar 58–59
Tucker, Maria 192
Tumlir, Jan 212–218

U

United Nations 198
University of California 34
University of Pittsburgh 219
US Justice Department 220
Utah 23

V

Vaisman, Meyer 194
VALDES project 213
Valentine, DeWain 216
Van de Welle, Mark 70
Vancouver 18, 150, 201
Varnedoe, Kirk 194
Venice Biennale 24, 30, 150, 207, 208, 209,
—Canadian Pavillion 1997 150
Vidokle, Anton 22
Vienna 215
Vietnam War 134
Village Voice 19
Vogue 215
Vox Populi 193

W

Walker, Kara 196, 138–141
Wall Street: Money Never Sleeps 27
Wall, Jeff 21, 150, 180–183, 192
War on Terror 207
Warhol, Andy 27, 133, 190, 194, 206
Washington Post 196
Washington, George 195
Weber, Max 200
Wegman, William 191
Weiner, Lawrence 23, 191, 192
Wendover 23
West Coast 34, 44, 210, 212, 213, 215, 216
Whispered Media 210
White, Pae 60–63, 217
Whiteread, Rachel 197
Whitney Biennial 196, 197
Whitney Museum of American Art 192, 207
Williams, Adrian 115
Williams, Christopher 21, 22, 166–167
Wilson, Fred 23, 24, 25, 80–81, 196, 206
Wilson, Ma Lin 217
Winnipeg 115
Winsor, Jackie 191
Winters, Robin 193
Womanhouse 216
Women's Action Coalition (WAC) 196
Wonder Valley 23
Wonder Woman 194
Wool, Christopher 100–103, 194
World Trade Organization 199, 203
Wrong Gallery 197

Y

Yes Men 23, 24, 210
Yomango 211

Z

Zapatistas 210
Zeilner, Peter 213
Zittel, Andrea 23
Zucker, Barbara 191
Zucker, Joe 190
Zuckerman Jacobson, Heidi 108

ACKNOWLEDGEMENTS

Many thanks to all those involved in the fourth volume of Black Dog Publishing's ARTWORLD series, *Contemporary Art in North America*. First and foremost our gratitude must go to the book's advisory panel—John Slyce, Neil Gall and Rut Blees Luxemburg—for generously donating their time and advice in helping to make this book what it is. Also, a particular thanks must go to Michael Wilson for his insightful introductory essay "Contemporary Art in the United States and Canada" and his words of advice.

Special thanks also to each of the artists featured and their representative galleries, who all generously donated material and offered encouragement towards the project. Thank you especially to the Gagosian, Metro Pictures, the Marian Goodman Gallery and Hauser and Wirth. Along with those who donated previously-published articles and essays that guide the reader in their exploration of North American art: Jerry Saltz, Pamela M Lee, Martha Rosler, Jan Tumlir, Critical Art Ensemble and Ken Lum; the latter of whom was suggested thanks to the advice of Kitty Scott.

Finally, a special thank you to those here at Black Dog— in particular to the book's designer Anna Stratigakis. In editorial, many thanks to Tom Howells and Sanna Mäenpää for their dedicated assistance throughout, along with help from Helen Ward.